IMPRINT

Catalog of the
17th International Symposium on Electronic Art
ISEA2011 Istanbul

This publication appears on the occasion of the ISEA2011 Istanbul,
17th International Symposium on Electronic Art,
14 September-20 November, 2011.

ISSN: 1071-4391
ISBN: 978-1-906897-19-2

SENIOR EDITOR AND ARTISTIC DIRECTOR Lanfranco Aceti
EDITOR AND CURATOR Özden Şahin
ASSOCIATE EDITOR Andrea Ackerman
ART DIRECTOR Deniz Cem Önduygu
ASSISTANT DESIGNER Zeynep Özel

ISEA 2011 ISTANBUL

**17th International Symposium on Electronic Art
ISEA2011 Istanbul**

14 September – 20 November, 2011
Istanbul, Turkey

The exhibition Uncontainable *was part of the
Official Parallel Program of the 12th Istanbul Biennial.*

UN-
CONTAIN-
ABLE

SENIOR EDITOR & ARTISTIC DIRECTOR Lanfranco Aceti
EDITOR & CURATOR Özden Şahin
ASSOCIATE EDITOR Andrea Ackerman

Uncontainable – ISEA2011 Istanbul: Some Thoughts After The Fact

When talking about ISEA2011 Istanbul one of the things I believe will remain as a legacy of the symposium is its magnitude. ISEA2011 was the most attended to date with almost 1500 attendees, the last count we had was of 1489, and it had over 100 artists – the ones we could account for – who participated and engaged with the city in multiple ways, authorized and non.

Overall ISEA2011 responded to the idea that we crafted for the event: a sprawling series of art events, exhibitions, initiatives, encounters, talks and performances that would reflect the sprawling uncontainable nature of the city of Istanbul. It was also about the 'uncontainable' nature of contemporary digital media which cross over physical borders and interfere with the local cultural order. These interferences may at times have generated conflicting relationships but in doing so also spurred development and innovative approaches.

ISEA2011 Istanbul proved how the lines and borders of contemporary national states present the observer with ideological and cultural frameworks that are no longer valid. Concepts of identity, cultural identifiers, nation state and belonging, as well as place and time, are challenged in both real and virtual contexts.

As Artistic Director for this exhibition – together with Özden Şahin, the Program Director – I wanted to showcase the complexity of contemporary social

ISSN 1071-4391 ISBN 978-1-906897-19-2

interactions and the role that technology is playing in redefining contemporary aesthetics.

The exhibition *Uncontainable* was part of the official Parallel Program of the 12th Istanbul Biennial, which allowed participating artists and curators to provide diverse perspectives on contemporary developments within fine arts aesthetics.

For this reason I am very grateful to all of the artists and delegates that supported ISEA2011 Istanbul through what at times was a difficult process in a difficult economic climate. Turkey does not have public funding for the arts – as for example in European countries – and ISEA2011 Istanbul was made possible by our solicitation of a long string of private sponsorships, institutional support and donors.

In the end the variety of the venues and programs provided a colorful framework that allowed artists to engage not only with one another and the public, but also with the Istanbul Biennial, the art market held during two wonderful boat journeys across the Bosporus, and with the city of Istanbul itself.

For the first time in the history of ISEA an electronic art exhibition program was officially part of the parallel program of an international biennial. The electronic exhibition and its artists were publicized in the press package of the 12th Istanbul Biennial, together with initiatives and events dotted across the city and internationally.

The art program was therefore conceived as an artistic itinerary across the city that placed art events in proximity to the major tourist attractions of the city, creating an electronic/new media/digital layering that interacted with the socio-political history of the city. The art program did not limit itself to the ISEA conference period – September 14 to 21, 2011 – but continued with its events until November 2011.

This catalog becomes a way to place an order to all of the events and activities, creating a record of the participating artists and the invited curators, for whose contributions I am extremely grateful. It is a snapshot of the city and of the event itself, which has signaled, we hope, a milestone in the history of the ISEA Foundation.

Lanfranco Aceti
Artistic Director and Conference Chair
ISEA2011 Istanbul

Istanbul, May 5, 2012

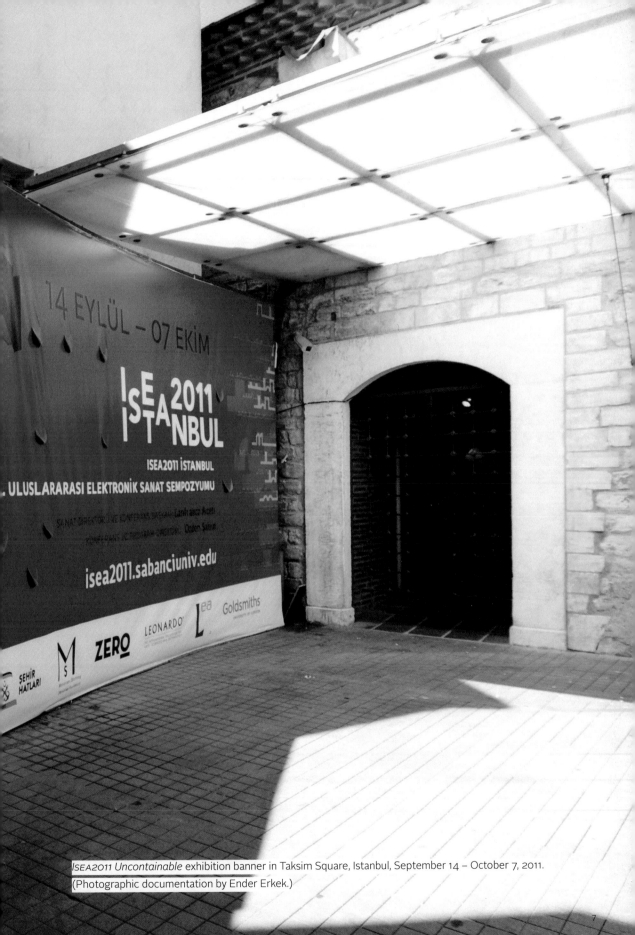

ISEA2011 Uncontainable exhibition banner in Taksim Square, Istanbul, September 14 – October 7, 2011.
(Photographic documentation by Ender Erkek.)

ISEA2011 Uncontainable, Istanbul, September 14 – October 7, 2011.
(Photographic documentation by Barbaros Gökdemir.)

ISEA2011 Uncontainable Curatorial Concept

The lines and borders of contemporary national states present the observer with ideological and cultural frameworks that are no longer valid. Concepts of identity, cultural identifiers, nation state and belonging as well as place and time are challenged in both real and virtual contexts.

In the 21st century the idea of creating cultural products that are solely a reflection of a localized and isolated space is without any logical foundation; it denies the reality of contemporary mediated lives and the reality of physical routes, that crossing the sea of information, reach diverse audiences in the four corners of the world.

For its exhibition ISEA2011 Istanbul intends to focus on the relationship between real and virtual as a process *en route* in the transformation of the artwork's multiple cultural contexts that are ungraspable in their complex interactions.

These are cultural practices "in an increasingly media-saturated world [...] where such technologies radically bring into question not just the way in which art galleries and museums operate, but the very notions of history, heritage, and even time itself upon which they are predicated." [1]

ISEA2011 Istanbul will be the locus where these different art signs and cultural products – expressions of the transformation of contemporary societies across the globe – will travel to and coexist for a period of time – in a state of continuous production and flux – across the historical, geopolitical and contemporary layers of the cityscape.

The contradiction of 'containing' the uncontainable will bring to light that the processes of contextualization, interpretation and re-contextualization of ideas and cultural productions, should no longer be conceived as static elements, but rather as evolutionary products of the transformation of envisaged futures and realities, as they move across geopolitical space and time.

Lanfranco Aceti
Artistic Director
ISEA2011 Istanbul

NOTE

1. Charlie Gere, "New Media Art and the Gallery in the Digital Age," *New Media in the White Cube and Beyond: Curatorial Models for Digital Art*, ed. Christiane Paul, 14 (University of California Press, Berkeley: 2008).

DISLOCATIONS

GEOMETRIE

UNCONTAINABLE: BROKEN STILLNESS

UNCONTAINABLE: HYP

UNCONTAINA

UNCONTAINABLE: TERRA VIRTUALIS

WORKI

UNCONTAINABLE: SIGNS OF LIFE

UNCONTAINABLE: THE WORLD IS EVERYT

NOT THERE GLITTER AN

INTERNATIONAL DIGITAL MEDIA, ANI

SOUTHERN OCEAN STUDIES

SENSUAL TECHNOLOG

PHILL NIBLOCK AND THOMAS AN

NAME READYMADE

ISSN 1071-4391 ISBN 978-1-906897-19-2

SO: AN AUDIOVISUAL PERFORMANCE

OF THE SUBLIME

RSTRATA

BLE: SECOND NATURE

TERRODROME: SIGNALS FROM OUTSIDE

G CONTINGENCIES

OBOT INCUBATOR

NG AND THAT IS THE CASE

GLORY: ABOUT THE LONGING FOR GLAMOUR

TION & MOVING IMAGES SCREENING

ART MARKET

ES NURU ZIYA ARTIST LOUNGE

ERSMIT PERFORMANCE

KURYE VIDEO: SPACE INVADERS

Uncontainable – ISEA2011 Istanbul 14–21 September 2011

 ISSN 1071-4391 ISBN 978-1-906897-19-2

ISEA2011 Uncontainable, Istanbul, September 14 – October 7, 2011.
(Photographic documentation by Özden Şahin.)

Uncontainable – ISEA2011 Istanbul 14–21 September 2011

 ISSN 1071-4391 ISBN 978-1-906897-19-2

ISEA2011 cards printed for the 12th İstanbul Biennial press package.
(Photographic documentation by Stephanie Paine.)

ISSN 1071-4391 ISBN 978-1-906897-19-2

Uncontainable – ISEA2011 Istanbul 14–21 September 2011

 ISSN 1071-4391 ISBN 978-1-906897-19-2

ISEA2011 ISTANBUL
THE 17TH INTERNATIONAL SYMPOSIUM
ON ELECTRONIC ART

Conference &
Exhibition
Program
14–21 SEPTEMBER 2011

ISEA2011 program booklets. (Photographic
documentation by Stephanie Paine.)

Uncontainable – ISEA2011 Istanbul 14–21 September 2011

ISEA2011 cards printed for the 12th İstanbul Biennial press package.

ISEA2011 exhibition poster on the boat pier. (Photographic documentation by Deniz Cem Önduygu.)

 ISSN 1071-4391 ISBN 978-1-906897-19-2

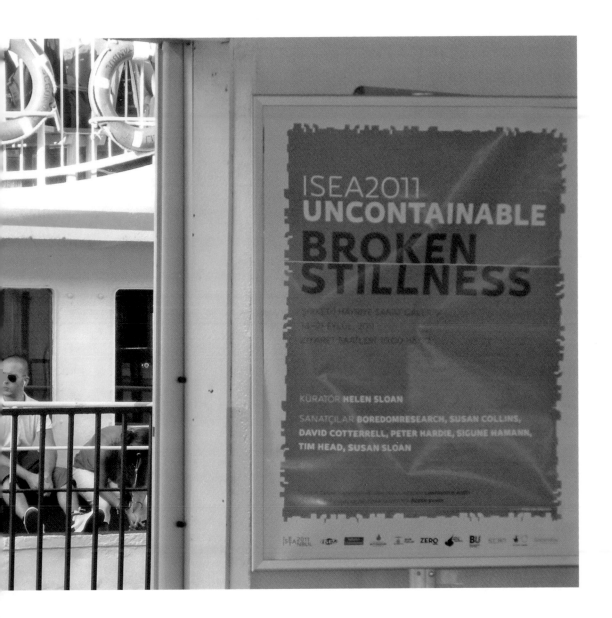

Uncontainable – ISEA2011 Istanbul 14–21 September 2011

ISEA2011 Uncontainable, detail from the artwork caption.
(Photographic documentation by Deniz Cem Önduygu.)

ISSN 1071-4391 ISBN 978-1-906897-19-2

ISEA2011 detail from the program booklet. (Photographic documentation by Stephanie Paine.)

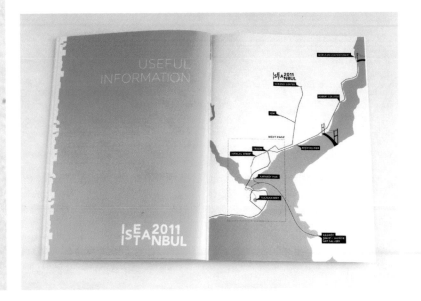

ISSN 1071-4391 ISBN 978-1-906897-19-2

Uncontainable – ISEA2011 Istanbul 14–21 September 2011

Detail from the ISEA2011 program booklet.
(Photographic documentation by Deniz Cem Önduygu.)

 ISSN 1071-4391 ISBN 978-1-906897-19-2

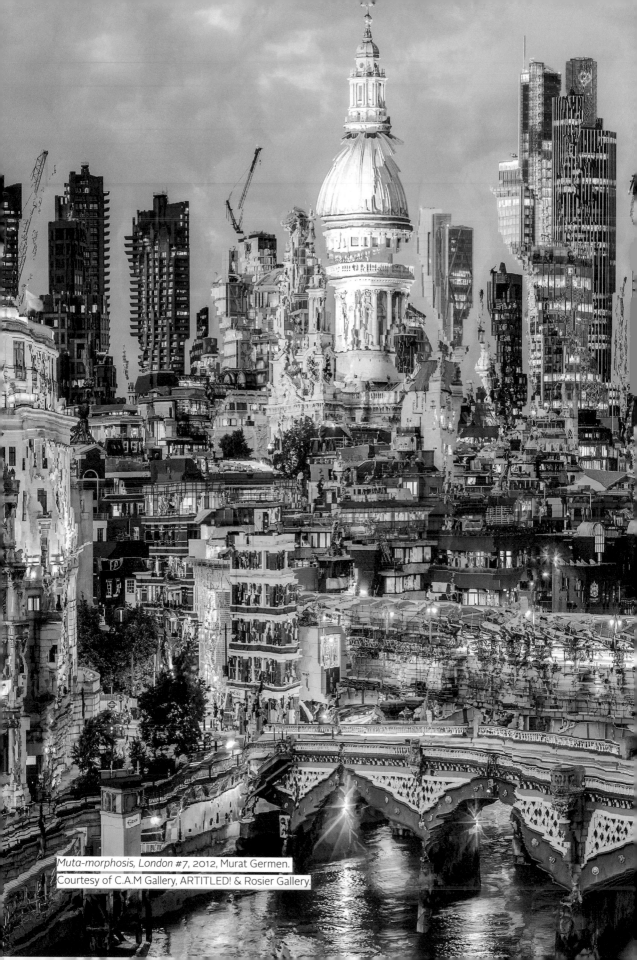

Muta-morphosis, London #7, 2012, Murat Germen.
Courtesy of C.A.M Gallery, ARTITLED! & Rosier Gallery.

ISEA2011
UNCONTAINABLE
&UNTITLED

TAKSİM CUMHURİYET SANAT GALERİSİ
14 EYLÜL–7 EKİM, 2011
ZİYARET SAATLERİ: 10:00–18:00

BAŞ KÜRATÖR/SENIOR CURATOR **LANFRANCO ACETI**
KÜRATÖR/CURATOR **ÖZDEN ŞAHİN**

SANATÇILAR/ARTISTS **THOMAS ANKERSMIT & PHILL NIBLOCK; ART IN PROCESS (BELLO BENISCHAUER & ELISABETH M. EITELBERGER); GAVIN BAILY, SARAH BAGSHAW & TOM CORBY; DAVID BOWEN; AYOKA CHENZIRA; PAOLO CIRIO; DARKO FRITZ; MURAT GERMEN; BARUCH GOTTLIEB; JANE GRANT; IAN HAIG; JANEZ JANŠA; KUUKI (GAVIN SADE AND PRISCILLA BRACKS); KAREN LANCEL & HERMEN MAAT; TEOMAN MADRA; YOTA MORIMOTO; KILIAN OCHS; ESTHER POLAK & IVAR VAN BEKKUM; DAAN ROOSEGAARDE; SCENECOSME (GRÉGORY LASSERRE & ANAÏS MET DEN ANCXT); TAMIKO THIEL, CEM KOZAR & IŞIL ÜNAL; PATRICK TRESSET; SANDER VEENHOF; PIETER VERHEES & JOHANNES WESTENDORP; NILS VÖLKER.**

SANAT DİREKTÖRÜ VE KONFERANS BAŞKANI /
ARTISTIC DIRECTOR AND CONFERENCE CHAIR
LANFRANCO ACETI

KONFERANS VE PROGRAM DİREKTÖRÜ /
CONFERENCE AND PROGRAM DIRECTOR
ÖZDEN ŞAHİN

ISSN 1071-4391 ISBN 978-1-906897-19-2

UNCONTAINABLE
&UNTITLED

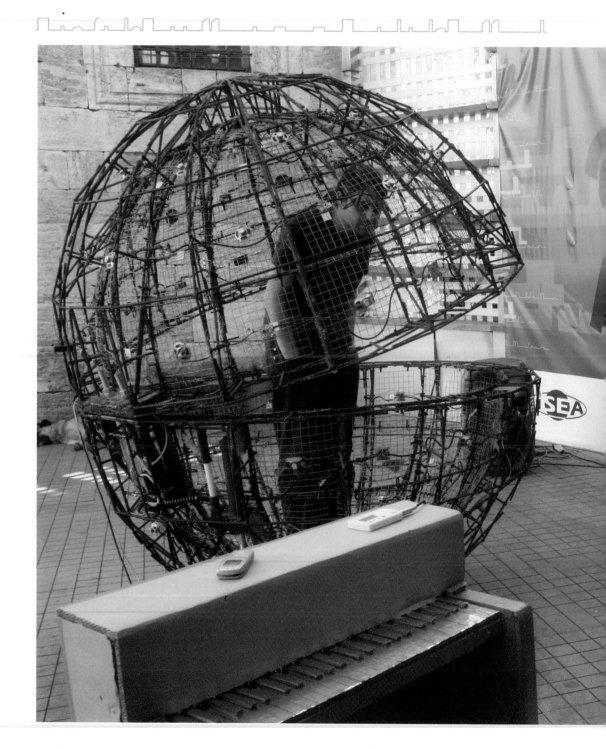

 ISSN 1071-4391 ISBN 978-1-906897-19-2

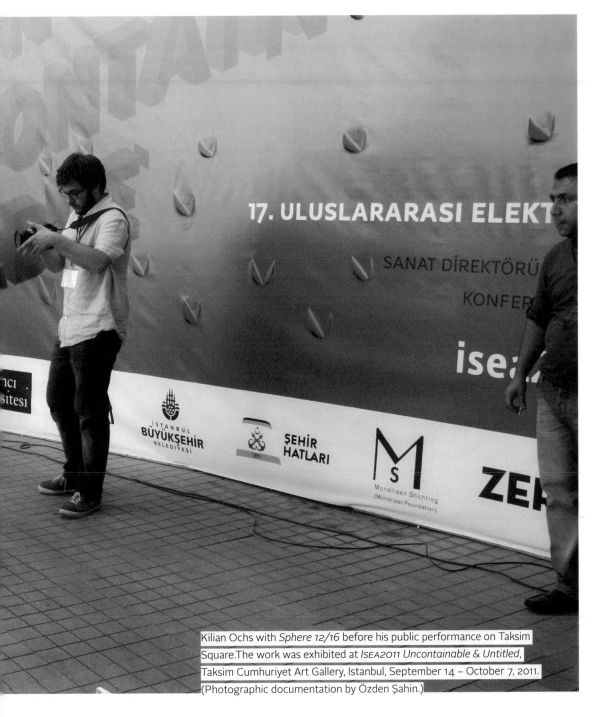

Kilian Ochs with *Sphere 12/16* before his public performance on Taksim Square. The work was exhibited at *ISEA2011 Uncontainable & Untitled*, Taksim Cumhuriyet Art Gallery, Istanbul, September 14 – October 7, 2011. (Photographic documentation by Özden Şahin.)

Uncontainable
&Untitled

 ISSN 1071-4391 ISBN 978-1-906897-19-2

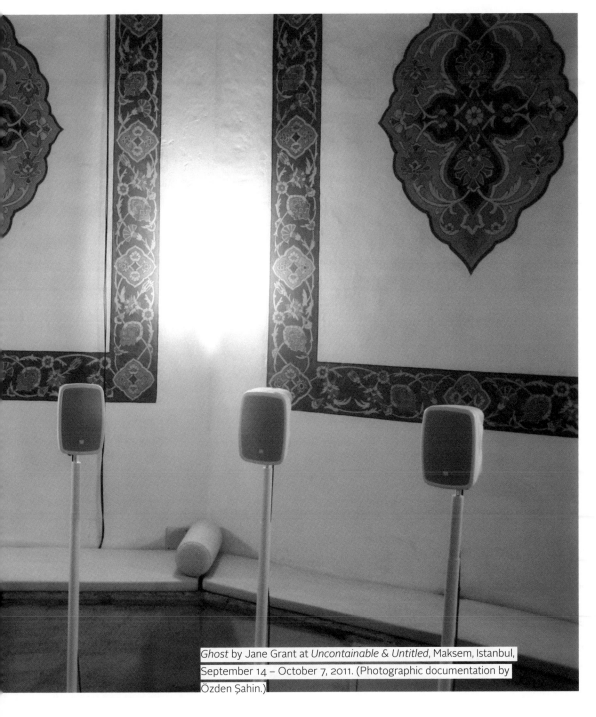

Ghost by Jane Grant at *Uncontainable & Untitled*, Maksem, Istanbul, September 14 – October 7, 2011. (Photographic documentation by Özden Şahin.)

ISSN 1071-4391 ISBN 978-1-906897-19-2

UNCONTAINABLE
&UNTITLED

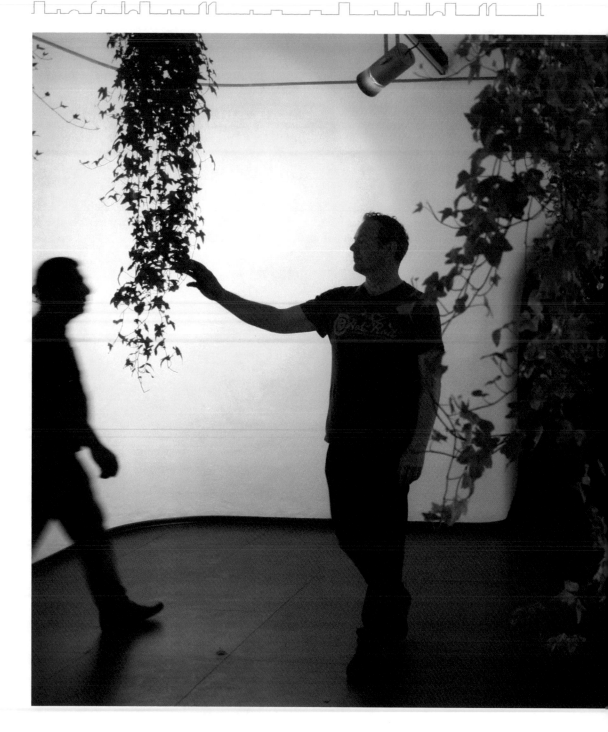

 ISSN 1071-4391 ISBN 978-1-906897-19-2

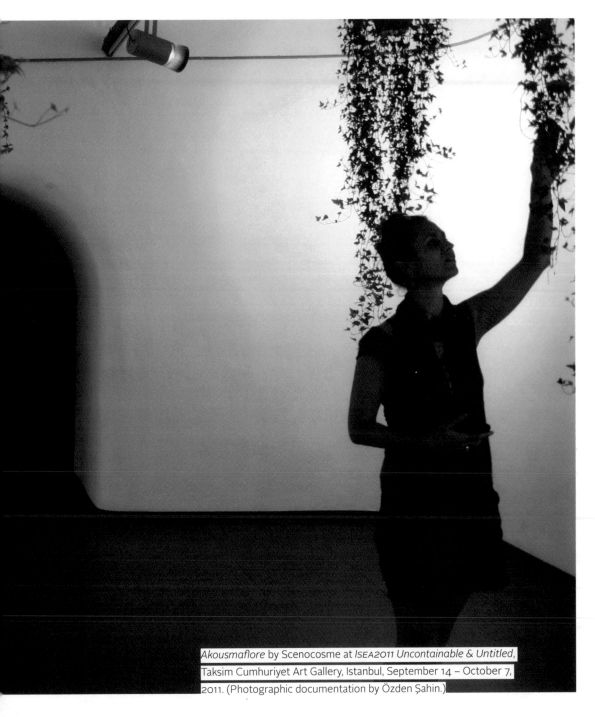

Akousmaflore by Scenocosme at *ISEA2011 Uncontainable & Untitled*, Taksim Cumhuriyet Art Gallery, Istanbul, September 14 – October 7, 2011. (Photographic documentation by Özden Şahin.)

ISSN 1071-4391 ISBN 978-1-906897-19-2

UNCONTAINABLE
&UNTITLED

Selection of artworks inspired by light, using multiple digital media based on instant and random inspiration. 1964-2011 by Teoman Madra at *ISEA2011 Uncontainable & Untitled*, Taksim Cumhuriyet Art Gallery, Istanbul, September 14 – October 7, 2011.

 ISSN 1071-4391 ISBN 978-1-906897-19-2

Tele-Present Wind by David Bowen at *ISEA2011 Uncontainable & Untitled*, Taksim Cumhuriyet Art Gallery, Istanbul, September 14 – October 7, 2011.

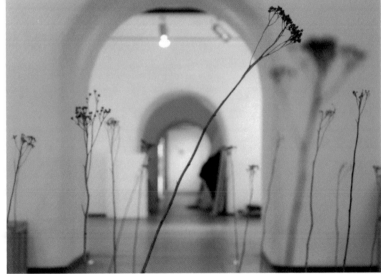

UNCONTAINABLE
&UNTITLED

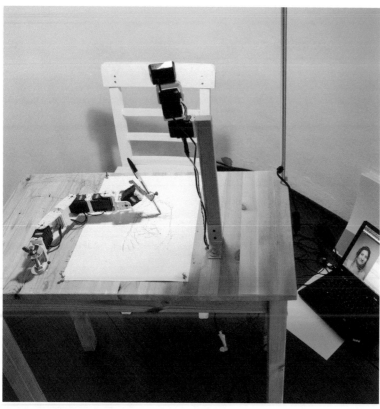

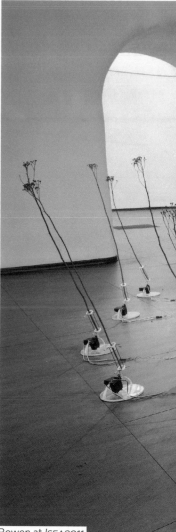

Paul by Patrick Tresset at *ISEA2011 Uncontainable & Untitled*, Taksim Cumhuriyet Art Gallery, Istanbul, September 14 – October 7, 2011.

Tele-Present Wind by David Bowen at *ISEA2011 Uncontainable & Untitled*, Taksim Cumhuriyet Art Gallery, Istanbul, September 14 – October 7, 2011. (Photographic documentation by Özden Şahin.)

ISSN 1071-4391 ISBN 978-1-906897-19-2

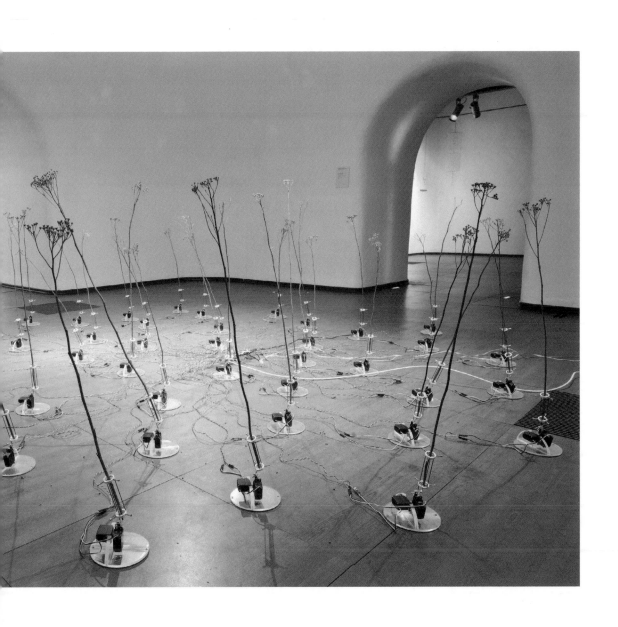

ISEA2011
UNCONTAINABLE
&UNTITLED

BAŞ KÜRATÖR/SENIOR CURATOR **LANFRANCO ACETI**
KÜRATÖR/CURATOR **ÖZDEN ŞAHİN**

SANATÇILAR/ARTISTS **THOMAS ANKERSMIT & PHILL NIBLOCK;
ART IN PROCESS (BELLO BENISCHAUER & ELISABETH M.
EITELBERGER); GAVIN BAILY, SARAH BAGSHAW & TOM CORBY;
DAVID BOWEN; AYOKA CHENZIRA; PAOLO CIRIO; DARKO FRITZ;
MURAT GERMEN; BARUCH GOTTLIEB; JANE GRANT; IAN HAIG;
JANEZ JANŠA; KUUKI (GAVIN SADE AND PRISCILLA BRACKS);
KAREN LANCEL & HERMEN MAAT; TEOMAN MADRA; YOTA
MORIMOTO; KILIAN OCHS; ESTHER POLAK & IVAR VAN BEKKUM;
DAAN ROOSEGAARDE; SCENECOSME (GRÉGORY LASSERRE
& ANAÏS MET DEN ANCXT); TAMIKO THIEL, CEM KOZAR & IŞIL
ÜNAL; PATRICK TRESSET; SANDER VEENHOF; PIETER VERHEES
& JOHANNES WESTENDORP; NILS VÖLKER.**

SANAT DİREKTÖRÜ VE KONFERANS BAŞKANI /
ARTISTIC DIRECTOR AND CONFERENCE CHAIR
LANFRANCO ACETI

KONFERANS VE PROGRAM DİREKTÖRÜ /
CONFERENCE AND PROGRAM DIRECTOR
ÖZDEN ŞAHİN

 ISSN 1071-4391 ISBN 978-1-906897-19-2

TR *Uncontainable & Untitled* ("Sığdırılamayan ve Adlandırılamayan"), *Uncontainable* adlı genel ISEA2011 İstanbul sergisinin bir parçası. *Uncontainable & Untitled* başlığı, *İsimsiz* - 12. İstanbul Bienali'ne gönderme yapıyor ve sanat, bilim ve teknolojinin kesiştiği yerlerdeki sosyo-politik meselelerin güncel önemini vurguluyor. Güncel olayların ve teknolojik gelişmelerin dağınık doğası, izleyicileri güncel sanat ve yaşamın şaşırtıcı olasılıkları ve problematik gerçeklikleriyle başbaşa bırakıyor.

EN *Uncontainable & Untitled* is an exhibition strand of the general ISEA2011 Istanbul exhibition entitled *Uncontainable*. The title *Uncontainable & Untitled* is an homage to the 12th Istanbul Biennial - *Untitled* and plays on the contemporary relevance of socio-political issues at the intersection of art, science and technology. The dispersed nature of contemporary events and technological advancements presents viewers both with the fascinating possibilities and the problematic realities of contemporary art & life.

ISSN 1071-4391 ISBN 978-1-906897-19-2

THOMAS ANKERSMIT, PHILL NIBLOCK

Two concerts : Thomas Ankersmit - A solo set with computer, modular synthesizer and acoustic alto saxophone; Phill Niblock - Music and Images (from the Movement of People Working films).

Thomas Ankersmit is a musician and installation artist based in Berlin and Amsterdam. His main instruments are a Serge analogue modular synthesizer, computer, and alto saxophone. Ankersmit regularly performs together with composer Phill Niblock and with electroacoustic artists Valerio Tricoli and Kevin Drumm. Ankersmit's music and installation work have been presented at festivals all over the world.

Phill Niblock makes thick, loud drones of music, filled with microtones of instrumental timbres which generate many other tones in the performance space. Simultaneously, he presents films/videos of the movement of people working, or of computer driven black and white abstract images floating through time. Since the mid-60's he has been making music and intermedia performances which have been shown at numerous venues around the world. Since 1985, he has been the director of the Experimental Intermedia Foundation in New York where he has been an artist/member since 1968. He is the producer of Music and Intermedia presentations at EI since 1973 and the curator of EI's XI Records label.

Thomas Ankersmit at Lampo, Chicago, February 20, 2008. (Photographic documentation by Angeline Evans.)

ISSN 1071-4391 ISBN 978-1-906897-19-2

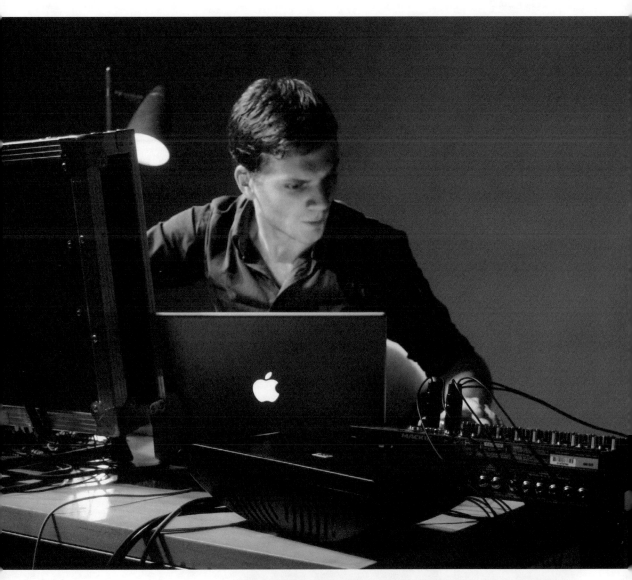

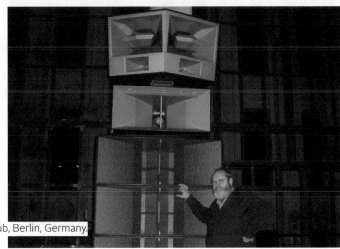

Phill Niblock at Berghain, techno club, Berlin, Germany.

ISSN 1071-4391 ISBN 978-1-906897-19-2

THOMAS ANKERSMIT, PHILL NIBLOCK

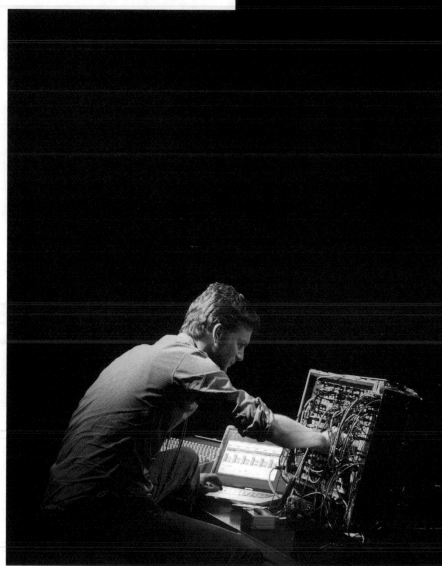

Thomas Ankersmit, Domino Festival, Brussels,
Belgium, April 6, 2011 - solo, Touch night with
Mika Vainio and Hildur Guðnadóttir. (Photographic
documentation by Mich Leemans.)

ISSN 1071-4391 ISBN 978-1-906897-19-2

ISSN 1071-4391 ISBN 978-1-906897-19-2

BELLO BENISCHAUER & ELISABETH M. EITELBERGER A.K.A. ART IN PROCESS

We critically engage with a number of issues/behaviours specific to cross-cultures and consumer culture in our work and develop projects that use new media/technology as a fusing and transmitting element.

Bello Benischauer is an independent artist (Australia/Austria) and co-founder of ART IN PROCESS, working across installation, video and performance art. Developing his practice through artistic partnerships around the world, he found his own aesthetic language, presented through numerous installations and art projects that aim for a critical social engagement on different levels with his audience. He toured a solo-exhibition in Australia from 2008 to 2011 and developed many AIR projects internationally – recently in Vienna and Sydney. He created a Commissioned Work for the LIA Lab Inter Arts, Mozarteum University Salzburg in 2010. All his digital work is distributed by CAM Contemporary Arts Media.

Elisabeth M. Eitelberger (Australia/Austria) is an independent artist and, with artist Bello Benischauer, a co-founder of ART IN PROCESS – an independent entity since 2000. Elisabeth's part involves performance acts, voice works and writing short abstract plays, as well as independent research on theoretical questions concerning ART IN PROCESS practice and context. She received her Master of Arts from the University of Vienna and is currently writing an artistic monograph about ART IN PROCESS.

INTERVENTION, 2009, Bello Benischauer, still from HD video 15'00 min.

ISSN 1071-4391 ISBN 978-1-906897-19-2

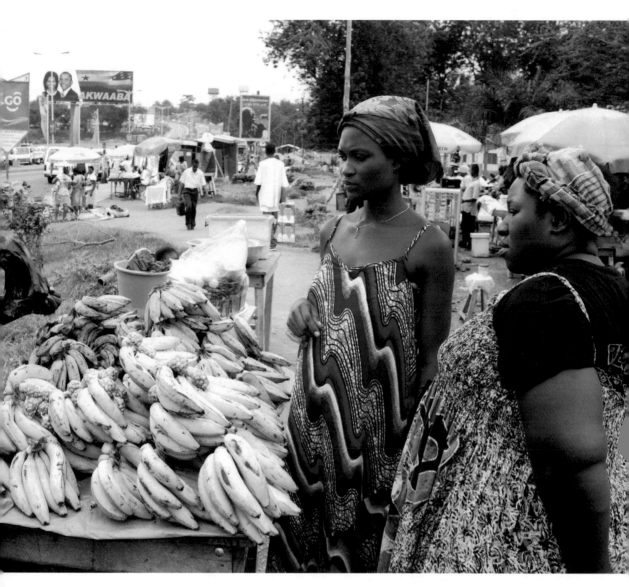

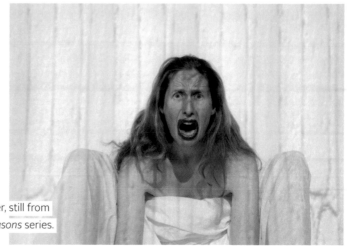

Fool's Gold, 2010, Bello Benischauer, still from
HD video 20'00 min, *Emotional Seasons* series.

ISSN 1071-4391 ISBN 978-1-906897-19-2

BELLO BENISCHAUER & ELISABETH M. EITELBERGER A.K.A. ART IN PROCESS

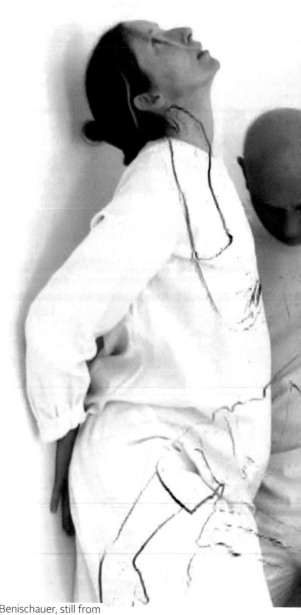

Not quite kosher, 2010, Bello Benischauer, still from HD video 12'00 min.

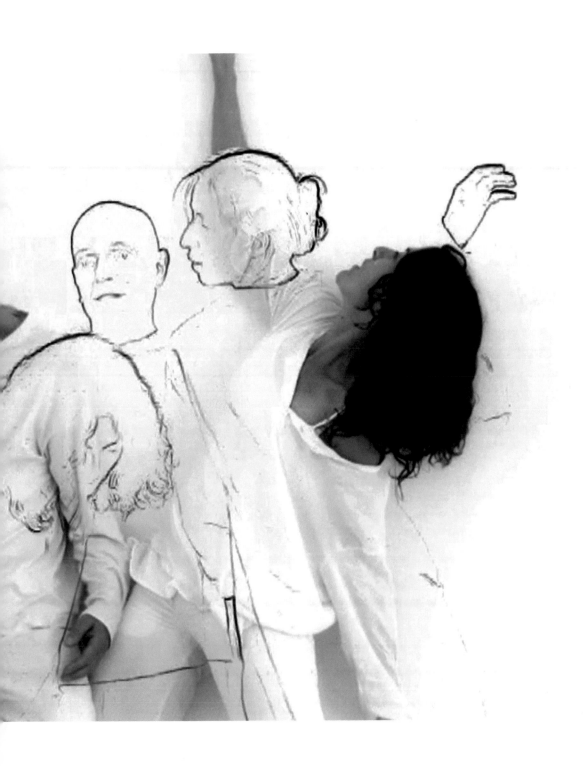

 AFGHANISTAN

GAVIN BAILY, SARAH BAGSHAW & TOM CORBY

Locus is a news archive visualisation that maps Guardian News articles to places over time – a spatial & temporal mapping of events and media attention in the last decade.

Locus is one of the most recent visualisations to come out of DataArt –a collaboration between BBC Learning and the Centre for Research in Education, Art and Media, at the University of Westminster. Tom Corby is the project Research Fellow and the deputy Director of CREAM. DataArt is funded by the UK Arts and Humanities Research Council (AHRC).

Gavin Baily is an artist and developer, and founder of TraceMedia. He has worked on arts, visualisation and research projects in various commercial and academic contexts. He studied Fine Art at Oxford University and Computer Science at UCL.

Sarah Bagshaw is the designer at TraceMedia. Sarah has extensive experience as a designer of websites, interactives, games and application GUI's. She studied Fine Art at UCL.

Tom Corby is the deputy Director of the Centre for Research in Art and Media at the University of Westminster. His research explores how artists and designers can employ digital information as an expressive medium. He studied Fine Art at Middlesex University and has a PhD from Chelsea College of Art & Design.

Locus - Afghanistan, 2011, Gavin Baily, Sarah Bagshaw & Tom Corby, Guardian News visualisation.

ISSN 1071-4391 ISBN 978-1-906897-19-2

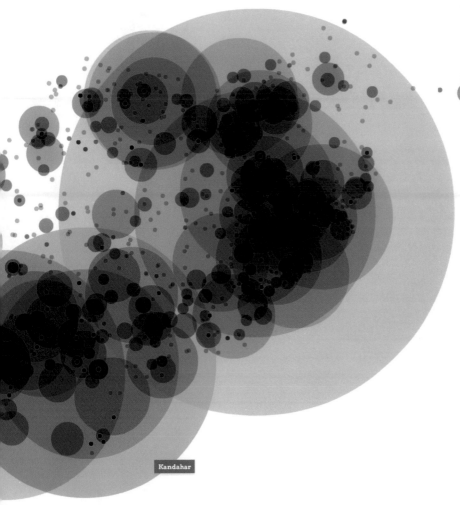

GUNMAN KILLS AT LEAST TWO SOLDIERS AT...
AFGHANISTAN SUICIDE BOMBER KILLS NINE...
TALIBAN IS DEMORALISED, SAYS BRITISH...
HAMID KARZAI CALLS ON US CONGRESS TO...
AFGHANISTAN: WHEN GENTLE...
NINE KILLED AND 81 INJURED IN KANDAHAR...
MOD PAYS £1.3M COMPENSATION TO AFGHANS...
US 'KILL TEAM': SOLDIER WHO MURDERED...
PHOTOS SHOW US SOLDIERS IN AFGHANISTAN...
US ARMY 'KILL TEAM' IN AFGHANISTAN POSED...
EARTHQUAKE RESCUE TEAMS ARRIVE FROM...
TSUNAMI, EARTHQUAKE, NUCLEAR CRISIS — ...
EARTHQUAKE AND TSUNAMI 'JAPAN'S WORST...
US TROOPS: KILLING OF HAMID KARZAI'S...
NATO TROOPS KILL AFGHAN PRESIDENT'S...
KARZAI: AFGHAN PEOPLE WILL DECIDE TERMS...
PAKISTAN ARRESTS US SECURITY...
BRITISH PHOTOGRAPHER GILES DULEY...
SEPARATING THE TALIBAN FROM AL-QAIDA...
SUICIDE BOMBER KILLS TWO IN AFGHANISTAN...
THREE AFGHAN POLICE KILLED IN NATO AIR...
AFGHAN SUICIDE BOMBER HITS BATH HOUSE...
US MILITARY INVESTIGATES 'DEATH SQUAD'...
PAKISTAN MILITANTS MOUNT ATTACKS ON...
AFGHAN TALIBAN LEADERSHIP SPLINTERED BY...
WIKILEAKS CABLES: TALIBAN TREATS HEROIN...
BARACK OBAMA: AFGHANISTAN WAR IS ON...
US EMBASSY CABLES: AMERICANS REASSURE...
US TROOPS TO START AFGHAN WITHDRAWAL...
BARACK OBAMA TO REPORT ENOUGH...
AFGHANISTAN ATTACK KILLS SIX NATO...
WIKILEAKS EMBASSY CABLES: THE KEY...
DAVID CAMERON SIGNALS AFGHAN...
CLINTON BEGINS ATTEMPT TO LIMIT DAMAGE...
WIKILEAKS CABLES, DAY 5: SUMMARY OF...
US EMBASSY CABLES: AFGHAN TRIBAL...
US SCRAMBLES TO RESTORE AFGHAN...
US EMBASSY CABLES: PRESIDENT KARZAI'S...
US EMBASSY CABLES: HAMID KARZAI'S...
US EMBASSY CABLES: AFGHAN PROVINCIAL...
US EMBASSY CABLES: NATO COMMANDER...
US EMBASSY CABLES KARZAI QUESTIONS UK...
US CONVINCED KARZAI HALF-BROTHER IS...
US EMBASSY CABLES HAMID KARZAI ON THE...
WIKILEAKS CABLES: HELICOPTERS, HEROIN...
US EMBASSY CABLES: IRAN 'BUSY' TRYING TO...
US EMBASSY CABLES: CANADIAN...
WIKILEAKS CABLES REVEAL PANIC AFTER...
WIKILEAKS CABLES PORTRAY HAMID KARZAI...
US EMBASSY CABLES: KARZAI'S ATTEMPT TO...
US EMBASSY CABLES: MILIBAND ASKS KARZAI...
US EMBASSY CABLES: KARZAI FEARED US...
US EMBASSY CABLES: US MEDIATES IN...
US EMBASSY CABLES: US AND UN DISCUSS...

Kandahar

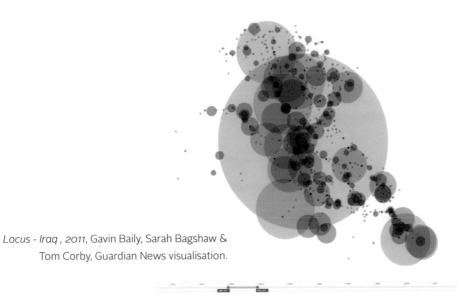

Locus - Iraq , *2011*, Gavin Baily, Sarah Bagshaw &
Tom Corby, Guardian News visualisation.

DAVID
BOWEN

> *My work is concerned with aesthetics that result from interactive, reactive and generative processes as they relate to intersections between natural and mechanical systems.*

David Bowen was born in the United States in 1975 and is a studio artist and educator. His work has been featured in numerous group and solo exhibitions including: *Brainwave* at Exit Art, New York, NY, The Japan Media Arts Festival at The National Art Center, Tokyo, *if/then* at Vox Populi, Philadelphia, PA, *Artbots* at Eyebeam, New York, NY and *Data + Art* at The NASA Jet Propulsion Laboratory, Pasadena, CA.

His work has been featured in publications such as: Art in America, Leonardo and Sculpture Magazine. He was recently awarded Grand Prize in the Art Division in The Japan Media Art Festival and 3rd Prize in the Vida 12.0 Art and Artificial Life International Awards. He received his BFA from Herron School of Art in 1999 and his MFA from the University of Minnesota, Minneapolis in 2004. He is currently an Associate Professor of Sculpture and Physical Computing at the University of Minnesota, Duluth.

Tele-Present Wind, 2010, David Bowen, plastic, aluminum, electronics, tansy, dimensions variable.

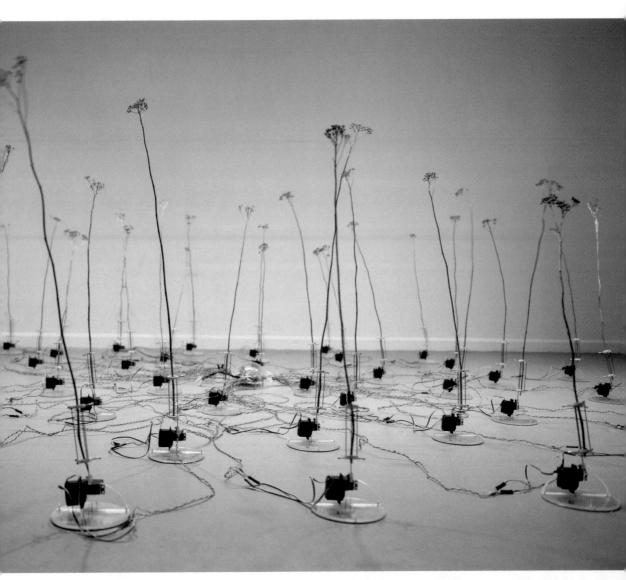

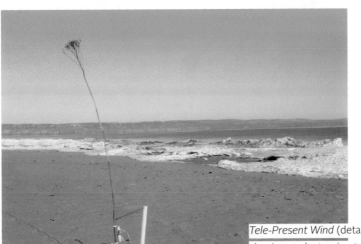

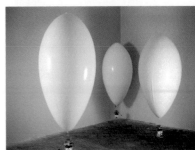

Fly Blimps, 2010, David Bowen, plastic, electronics, houseflies, helium, dimensions variable.

Tele-Present Wind (detail), 2010, David Bowen, plastic, aluminum, electronics, tansy, dimensions variable.

AYOKA CHENZIRA

> *Transmedia storytelling provides engagement opportunities around what it means to "be" in the world and the moral choices that further a goal of making the world a better place.*

Ayoka Chenzira is a filmmaker, interactive digital media artist, educator and a recognized pioneer in African-American independent cinema. She is a graduate of New York University (B.F.A. Film), Columbia University Teacher's College (M.A. in Education) and the Georgia Institute of Technology (Ph.D. Digital Media). Ayoka has created numerous award-winning films that span fiction, animation, documentary and performance. She received a Sony Innovator Award for her early work with converging film, video and computer animation, and the Apple Computer Distinguished Educator Award for her work with storytelling and digital technology. There have been many international retrospectives of her films which are also are in permanent collections including the Museum of Modern Art in New York.

Ayoka's current work is in transmedia storytelling. As an interactive filmmaker, she uses custom-built and off-the-shelf digital frameworks to combine the moving image with interactive websites, mobile phones, video, projection and sensing technologies. She is currently a professor Spelman College in Atlanta Georgia. She is the founding director of the Digital Moving Image Salon, which teaches students to produce documentary films for various digital platforms.

Ordinary On Any Given Day, 2011, Ayoka Chenzira, interactive installation with video, mobile phone and projection.

ISSN 1071-4391 ISBN 978-1-906897-19-2

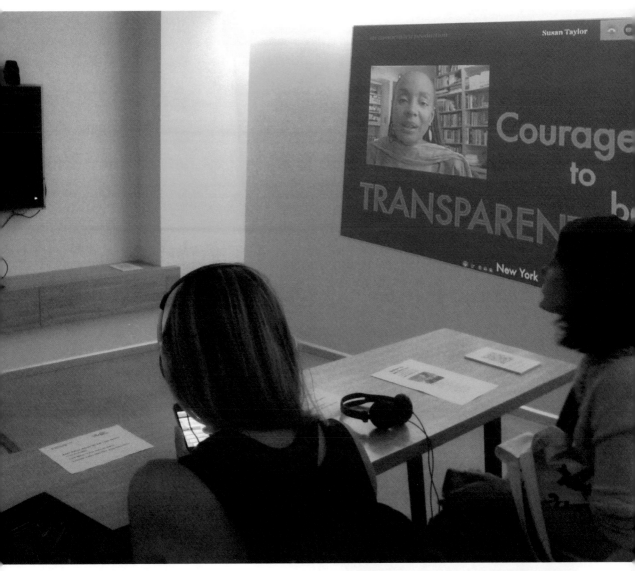

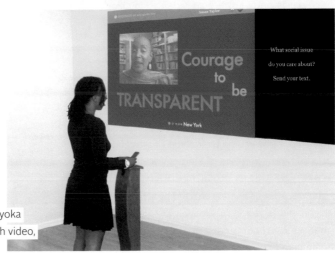

Ordinary On Any Given Day, 2011, Ayoka
Chenzira, interactive installation with video,
mobile phone and projection.

ISSN 1071-4391 ISBN 978-1-906897-19-2

PAOLO CIRIO

Recombinant Fiction *is a political and aesthetic fiction genre of new immersive and participative forms of art which defines a unique genre able to drive tactical activism and dramatic purposes.*

Paolo Cirio is an Italian artist and public speaker, who was born in Turin, Italy in 1979 and currently lives in New York. An award-winning artist, Paolo has had numerous group exhibitions worldwide and he exhibited in major exhibitions and museums such as Laboral, Gjion; s.m.a.к, Ghent; National Museum of Contemporary Art, Athens; Courtauld Institute, London; HMKV, Dortmund; PAN, Naples; MOCA, Tapei; Halle für Kunst, Lüneburg; NTT ICC, Tokyo; among others. Paolo has worked as media artist in various fields: net-art, street-art, video-art, public-art, marketing-art, software-art and experimental storytelling. He is currently fellow of Eyebeam Art + Technology for 2012/2013.

Paolo investigates how the perception and creation of cultural, political and economic realities are manipulated by new modes of control over information's power. As a tactical media artist, he hacks and orchestrates media through videos, coding, websites, social media, printed media, interventions in public spaces, characters enacted by actors, careful analyses and audience participation, creating edifying narratives and controversial provocations that tackle contemporary social issues.

Drowning NYC, 2010, Paolo Cirio. New York, U.S.

ISSN 1071-4391 ISBN 978-1-906897-19-2

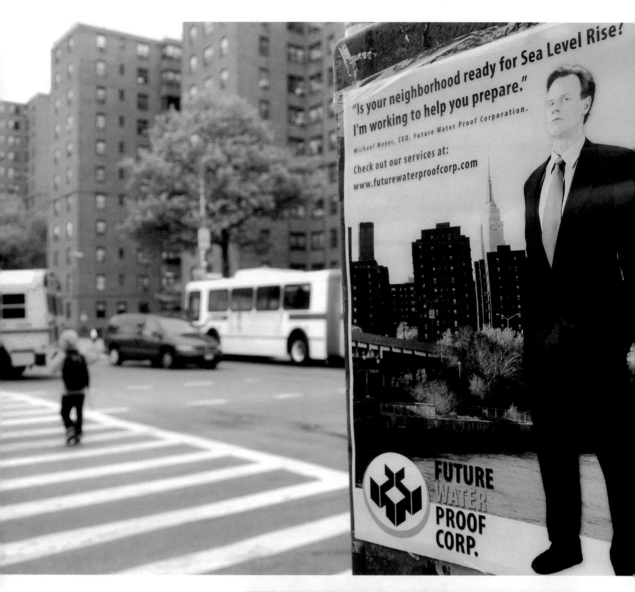

Drowning NYC, 2010, Paolo Cirio. New York, U.S.

PAOLO
CIRIO

The Big Plot, 2009, Paolo Cirio. Halle-Salle, Germany.

ISSN 1071-4391 ISBN 978-1-906897-19-2

DARKO FRITZ

I find my work filling the gap between contemporary art and media art and culture. I have an interest in the 1960s, the closing period of Modernism, and its reflection in contemporary world.

Darko Fritz is artist and independent curator and researcher. He was born in 1966, in Croatia, and currently he lives and works in Amsterdam, Zagreb and Korčula. His work fills the gap between contemporary art practices and media art culture. He has worked with video since 1988 when he also created his first computer-generated environment. He has used the Internet as artistic medium since 1994. Recently he has been developing horticultural units in public spaces, transgressing the contents from the digital domain. His research on histories of international computer-generated art resulted in several publications and exhibitions shown publicly since 2000.

As editor for media art at net portal Culturenet he edited related database and published *A Brief Overview of Media Art in Croatia* in 2002. In 2010 he started the research on the beginning of computer generated art in the Netherlands. Fritz is founder and programmer of the grey) (area – a space of contemporary and media art since 2006.

204_NO_CONTENT, 2007, Darko Fritz, horticulture unit, 3.6 × 31 m, 2220 cactusses (Echinocactus Grusonii) [each cca. 18 cm diam.], vulkanic lava, desert sand. Installation view: El Efeque, Fuerteventura, Canari Islands, Deambulatorios de una jornada, en el principio y el proyecto Tindaya. Curated by Nilo Casares, 2007 from the *Internet Error Messages* project.

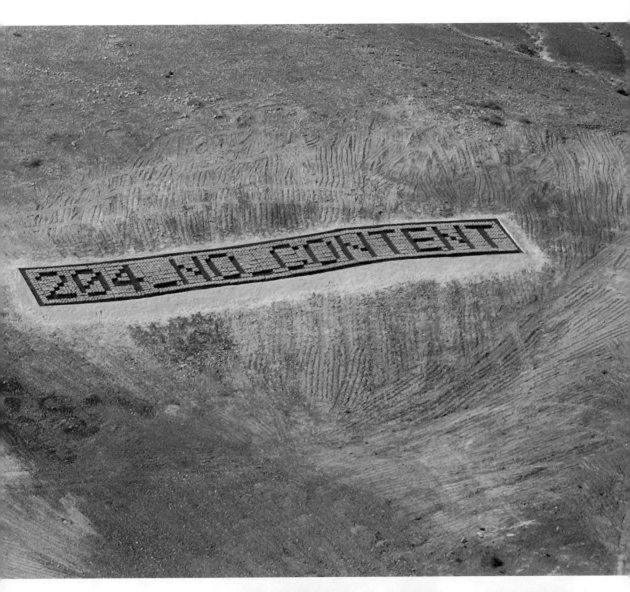

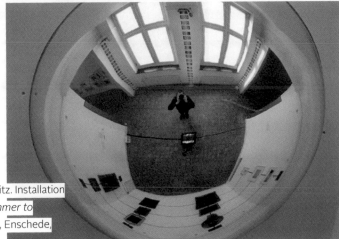

End of the Message, 1995, Darko Fritz. Installation view, *Obsessions: From Wunderkammer to Cyberspace*, Rijksmuseum Twenthe, Enschede, curated by Bas Vroege.

UNCONTAINABLE
&UNTITLED

DARKO FRITZ

Archives in Progress [Projects 1987 - 2007],
2007, Darko Fritz, 12-channel video installation, part
of the installation view, Ring Gallery, Croatian Artist
Association, Zagreb.

 ISSN 1071-4391 ISBN 978-1-906897-19-2

MURAT GERMEN

Muta-morphosis was obtained by reducing panoramic images in one axis. The lack of a single perspectival structure due to multiplicity of perspectives can be linked to Ottoman miniatures and connects the global contemporary representation to tradition.

Murat Germen is an artist who uses photography as his tool of expression. He has a MArch degree from M.I.T., where he attended as a Fulbright scholar. He received an AIA Henry Adams Gold Medal. He currently works as a professor at Sabanci University, Istanbul. His work has been exhibited at conferences such as SIGGRAPH, ISEA, Mutamorphosis, TSC, CAE, CAC2, EVA-London, ECAADE, ASCAAD and has been shown in over 50 inter/national exhibitions. He is represented by C.A.M. Gallery (Turkey), ARTITLED! (Netherlands-Belgium), Rosier Gallery (USA). His work is in over 50 private collections inter/nationally, in addition to those in the Istanbul Modern, and Proje4L Elgiz Museum of Contemporary Art collections. His work has also been auctioned at Sotheby's and Christie's.

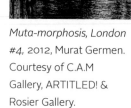

Muta-morphosis, London #4, 2012, Murat Germen. Courtesy of C.A.M Gallery, ARTITLED! & Rosier Gallery.

ISSN 1071-4391 ISBN 978-1-906897-19-2

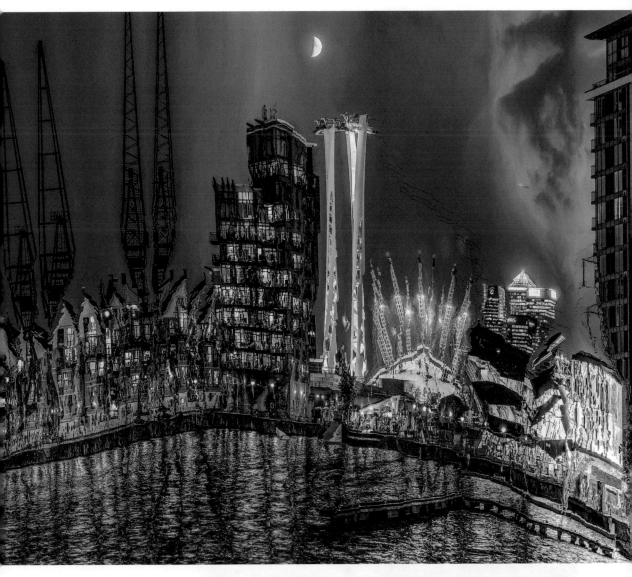

Muta-morphosis #117, Brussels, 2011, Murat Germen,
170 × 90 cm, 7 editions + 2 AP. Courtesy of C.A.M
Gallery, ARTITLED! & Rosier Gallery.

MURAT GERMEN

Muta-morphosis, #122, 2011, Murat Germen. Courtesy
of C.A.M Gallery, ARTITLED! & Rosier Gallery.

ISSN 1071-4391 ISBN 978-1-906897-19-2

BARUCH GOTTLIEB

iMine *was created to help all of us come to terms with the dark material reality brooding behind the luminous utopianism of the digital age. Through a networked game interface, users are brought into the world of mining raw materials for electronic components.*

Baruch Gottlieb, trained as a filmmaker at Concordia University, has been working in electronic image and sound with specialization in public art since 1999. He has exhibited globally including: Prince Takamatsu Gallery Tokyo (2005), ZKM Museum for Art and Media Karlsruhe (2011), Dakar Biennial (2002, 2004, 2006), transmediale, Berlin (2009, 2010, 2011, 2012), Gwangju Biennial (2004), Yeosu World Expo (2012), ISEA Istanbul (2011), LABORAL (2011) and the Canadian Embassy, Berlin (2011). From 2005-2008 he was assistant professor of Media Art at Yonsei University Graduate School for Communication and Arts. He is currently Artist-Researcher in Residence at the Institute for time-based media at the University of Arts, Berlin.

i-Mine, 2011, Baruch Gottlieb. Experimental art-app/game.

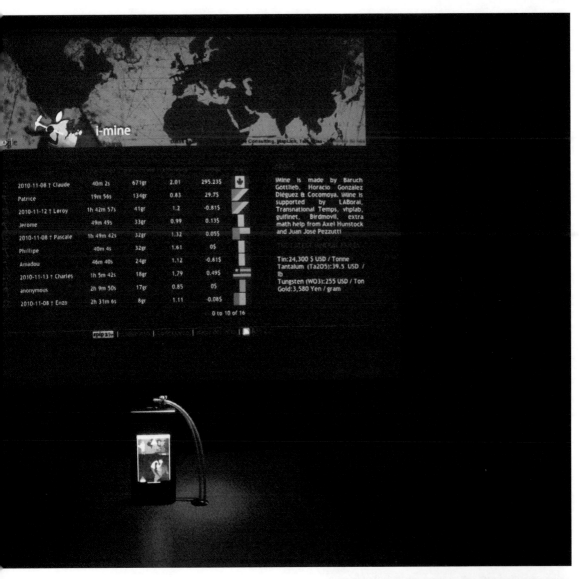

i-Mine, 2011, Baruch Gottlieb. Experimental art-app/game.

JANE GRANT

Ghost *is a neuronally embedded distributed instrument merging 'memory' or noise in the cortex and live ambient sound to form a dynamically rich and haunting sonic artwork.*

Jane Grant is an artist and academic. Her collaborative work with scientists, musicians, composers and designers has resulted in award winning projects. *The Fragmented Orchestra* created with John Matthias and Nick Ryan was the winner of the PRSF New Music Award, 2008 and received an Honorary Mention at Prix Ars Electronica 2009, Hybrid Arts Category. *The Fragmented Orchestra* was exhibited at FACT and 23 sites across the UK including the National Portrait Gallery and The Roundhouse. Grant's recent work includes *Soft Moon* and *Leaving Earth*. Both films draw upon astrophysics and science fiction with specific reference to the writing of Italo Calvino and Stanislaw Lem. She is currently working with the temporal, topological networks and pathways of the cortex, exploring them in conjunction with brain hallucinations or 'sonic ghosts' and also on a series of works regarding dark matter. The collaborative work *Plasticity*, with John Matthias, Nick Ryan and Kin, was recently exhibited at the BFI Southbank, London as part of the onedotzero_adventures in motion festival 2011. Jane is associate professor (reader) in Digital Arts at Plymouth University, UK, where she is co-director of the research group, art + sound and she is principal supervisor in the Planetary Collegium, CAiiA-Node.

Ghost, 2011, Jane Grant. Installation at Maksem during *ISEA2011 Uncontainable*, Istanbul, September 14 – October 7, 2011.

ISSN 1071-4391 ISBN 978-1-906897-19-2

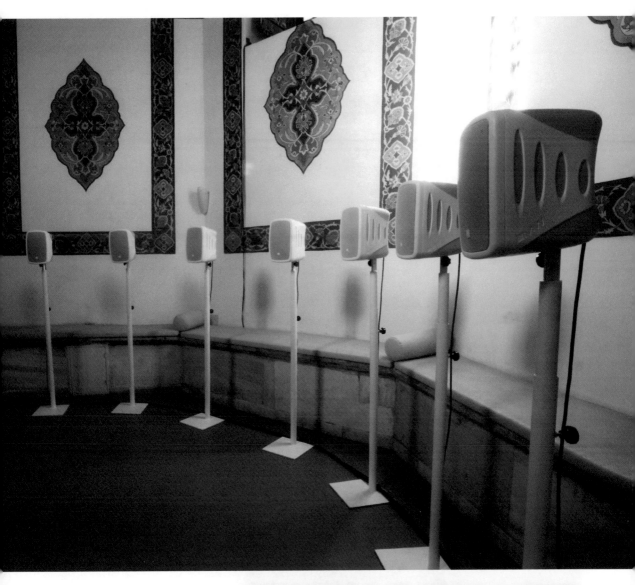

Raster Plot, Ghost 2, 2011, Jane Grant, Tim Hodsgon, screen shot.

ISSN 1071-4391 ISBN 978-1-906897-19-2

JANE GRANT

Ghost, 2011, Jane Grant. Installation at Maksem during
ISEA2011 Uncontainable, Istanbul, September 14 –
October 7, 2011.

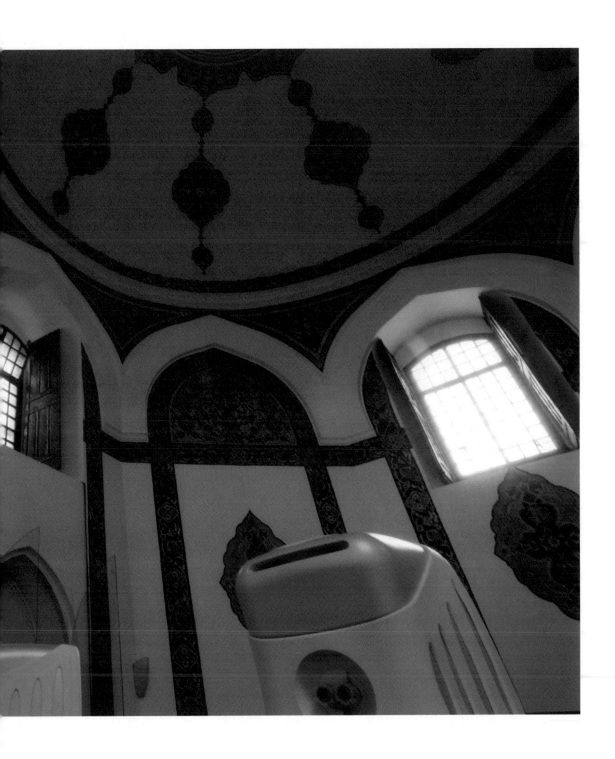

IAN HAIG

Twitch Of The Death Nerve *seeks to explore the idea of the uncanny and the unsettling feeling of seeing elements of the face cut up, recombined and reanimated through simple electrical motors.*

Ian Haig works at the intersection of visual arts and media arts. His work explores the strangeness of everyday reality and focuses on the themes of the human body, devolution, abjection, transformation and psychopathology, often seen through the lens of low cultural forms. Previous works have explored subjects ranging from the science fiction of sexuality and the degenerative and malign aspects of pervasive new technologies to the cultural forms of fanaticism and cults and the ideas of attraction and repulsion. Over the years the trajectory of Haig's vision has encompassed various media from site-specific installation projects, Super 8 movies, interactive sculpture, comics, and noise music to animations, videos, drawings, web projects, and large scale gallery installations.

Twitch Of The Death Nerve, 2011, Ian Haig, kinetic sculpture. (Photographic documentation by Korhan Karaoysal.)

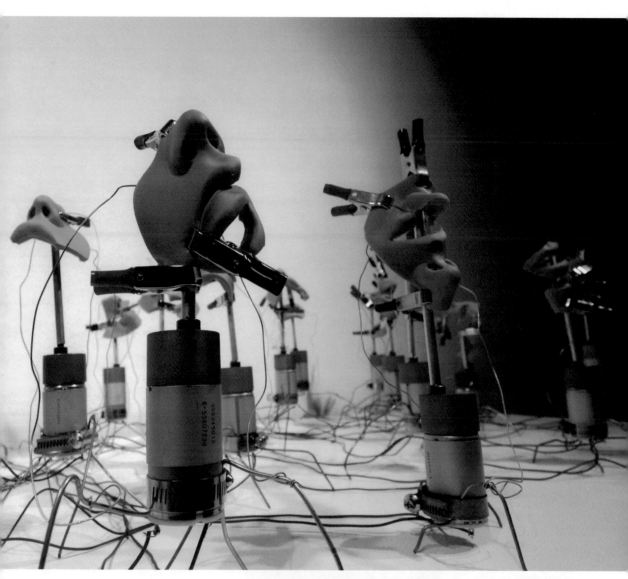

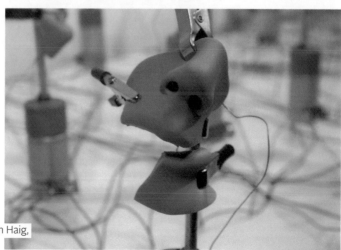

Twitch Of The Death Nerve, 2011, Ian Haig,
kinetic sculpture (detail).

ISSN 1071-4391 ISBN 978-1-906897-19-2

UNCONTAINABLE
&UNTITLED

IAN HAIG

Twitch Of The Death Nerve, 2011, Ian Haig, kinetic
sculpture. (Photographic documentation by
Korhan Karaoysal.)

 ISSN 1071-4391 ISBN 978-1-906897-19-2

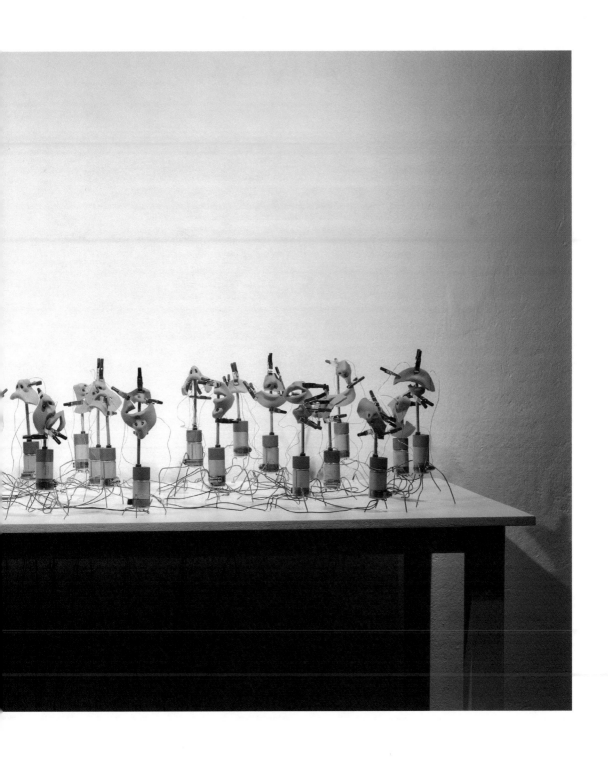

JANEZ JANŠA

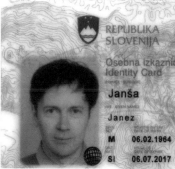

What is a personal name? What is its role in the society? Name Readymade is a project presentation dealing with a wide range of issues related to the "name changing" gesture perpetrated by three Slovenian artists.

Janez Janša (born 7 December 1970 in Bergamo, Italy, as Davide Grassi) is one of the three contemporary artists who in 2007 changed their names to the name of the Slovenian right-wing politician Janez Janša. Janez Janša is a conceptual artist, performer and producer who graduated from the Academy of Fine Arts of Milan, Italy. His work has a strong social connotation and is characterized by an inter-media approach. He is co-founder and director of Aksioma – Institute for Contemporary Art, Ljubljana.

Janez Janša (born 6 February 1964 as Emil Hrvatin) is one of the three contemporary artists who in 2007 changed their names to Janez Janša. He is an editor, theatre and film director, and contemporary performing artist.

Janez Janša (born in 1973 as Žiga Kariž in Ljubljana) is one of the three contemporary artists who in 2007 changed their names to Janez Janša. He is a visual artist. He represents the younger generation of artists who problematise the field of painting through the use of media images and a free relationship with various technological processes.

002199616 (Identity Card), 002199341 (Identity Card), 002359725 (Identity Card), 2007, Janez Janša, Janez Janša, Janez Janša. Print on plastic, 5,4 x 8,5 cm. (Courtesy: Aksioma Institute for Contemporary Art, Ljubljana.)

ISSN 1071-4391 ISBN 978-1-906897-19-2

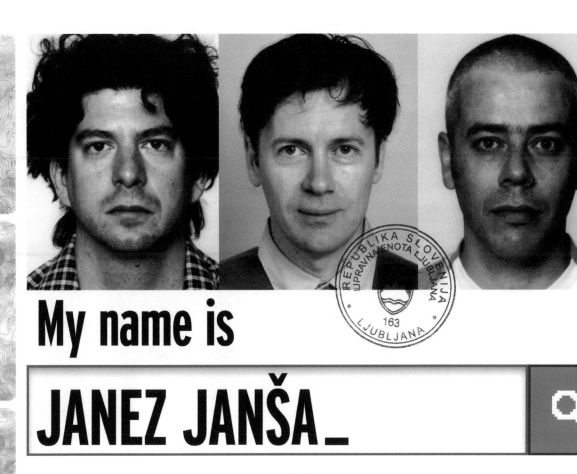

My name is
JANEZ JANŠA_

My Name Is Janez Janša, 2012, Janez Janša.
Janez Janša, Janez Janša, Janez Janša.
(Photo: Aksioma.)

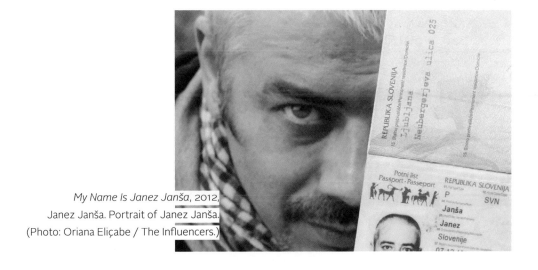

My Name Is Janez Janša, 2012,
Janez Janša. Portrait of Janez Janša.
(Photo: Oriana Eliçabe / The Influencers.)

ISSN 1071-4391 ISBN 978-1-906897-19-2

PRISCILLA BRACKS & GAVIN SADE A.K.A. KUUKI

The crickets in Suzumushi have abandoned audible communications, instead their radio frequency calls spread like memes through the swarm, appearing as text displayed on LED screen within each cricket.

Kuuki is an art, design, and media production collective directed by Gavin Sade and Priscilla Bracks. Work produced by Kuuki explores contemporary life, interpersonal relationships, and humanity's relationship with the environment and other non-human species. This work arises from 'post-environmental' politics in that it considers the cultural and anthropocentric construction of nature that inhibits our ability to develop deeper relationships with 'nature' and take meaningful steps towards protecting it.

Priscilla is a visual artist practising in photography, digital illustration, installation, and new-media. Before completing a first class honours degree in photography at the Queensland College of Art in 2002, Priscilla studied and practiced law in Australia.

Gavin is a designer in the field of interactive computational media, with a background in music and sonology. Gavin also teaches interaction design at the Queensland University of Technology.
Priscilla and Gavin have been working collaboratively since 2005. Their interactive media works have been exhibited in Australia and internationally.

Suzumushi: The Silent Swarm, 2011, Priscilla Bracks and Gavin Sade, laser-cut stainless steel, post-consumer plastic and electronics, dimensions variable.

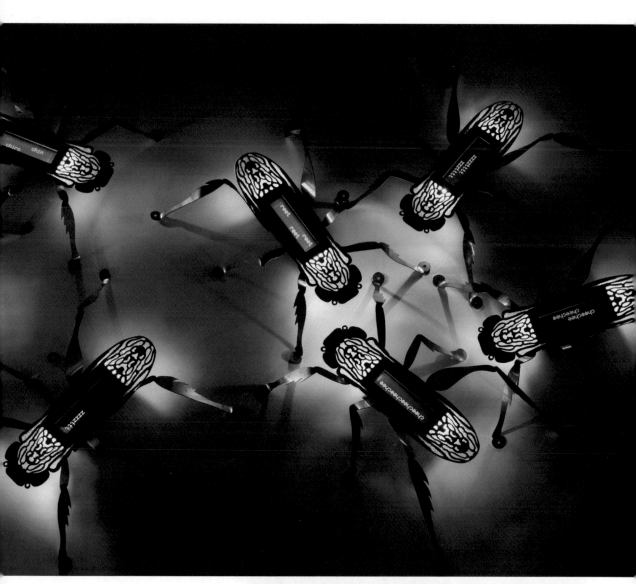

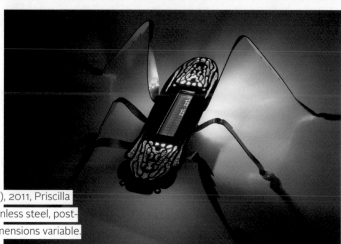

Suzumushi: The Silent Swarm (detail), 2011, Priscilla Bracks and Gavin Sade, laser-cut stainless steel, post-consumer plastic and electronics, dimensions variable.

PRISCILLA BRACKS & GAVIN SADE A.K.A. KUUKI

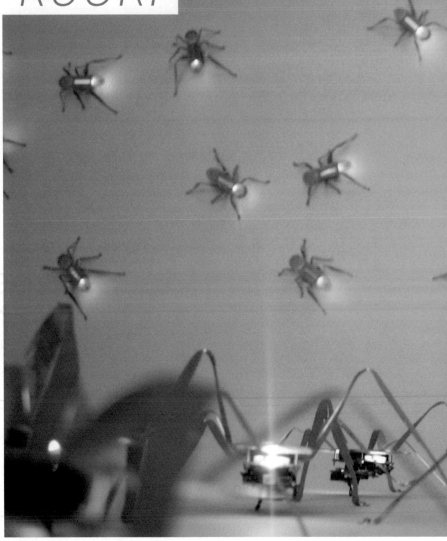

Suzumushi: The Silent Swarm, 2011, Priscilla
Bracks and Gavin Sade, laser-cut stainless steel,
post-consumer plastic and electronics,
dimensions variable. (Photographic
documentation by Özden Şahin.)

ISSN 1071-4391 ISBN 978-1-906897-19-2

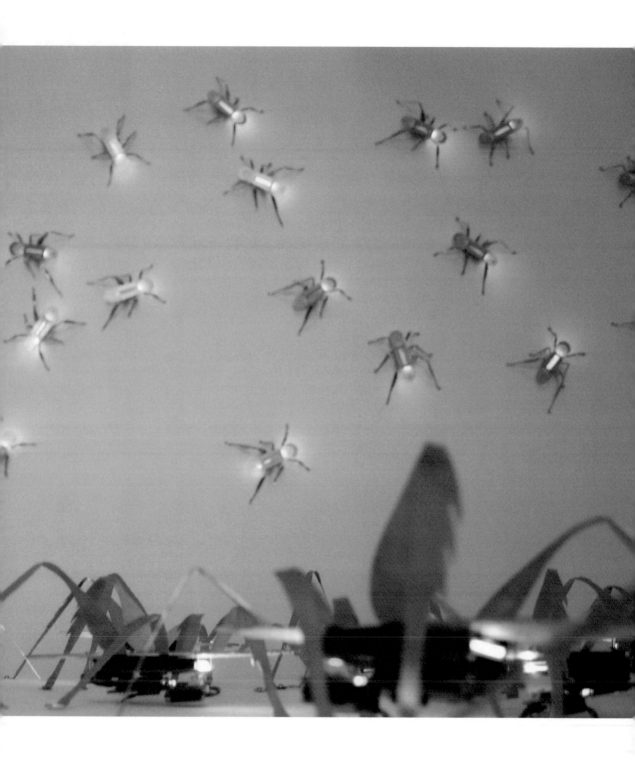

KAREN LANCEL
& HERMEN MAAT

How do we trust each other online?
Do you need to see my eyes? Or do
we need to touch? How do we trust as
networking bodies?

Karen Lancel is Ph.D. candidate at the Technical University of Delft; member of ARTI research group at Amsterdam School of the Arts; and core lecturer at MFA at Frank Mohr Institute Groningen for interactive media art.

Hermen Maat teaches media art at the Minerva Art Academy Groningen.

Artists research social systems in a mediated society. They design hybrid 'meeting places' – social sculptures in city public spaces that function as artistic 'social labs.' The audience in 'meeting place' is invited to experiment and play with social technologies, reflecting on their perception of the smart city, and their experience of body, presence, identity and community.

Tele_Trust networked performance-installation takes place in dynamic city semi-public spaces, researching new parameters for online presence, trust and privacy. Interactive and wearable *DataVeil* is a tangible body interface for scanning online trust. In an ongoing process, user generated content is continuously added to the *Tele_Trust* database. Stories from different cities weave together into an exchanging narrative.

Tele_Trust, 2009-2011, Lancel & Maat, DataVeil containing interactive wearable smart textile touch technology connected to smartphone app. (performance-installation at Waag Society for old and new media Amsterdam).

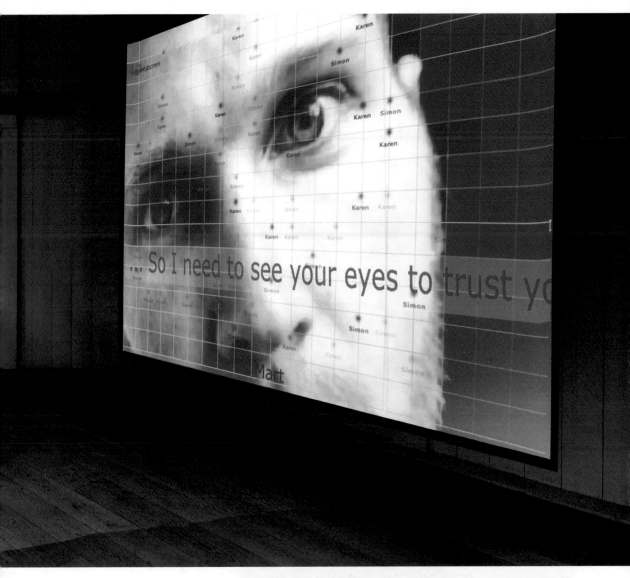

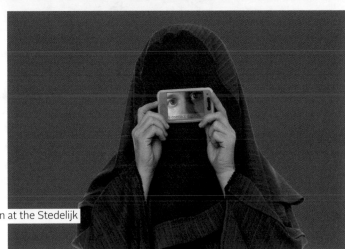

Tele_Trust (performance-installation at the Stedelijk Museum Amsterdam).

ISSN 1071-4391 ISBN 978-1-906897-19-2

KAREN LANCEL
& HERMEN MAAT

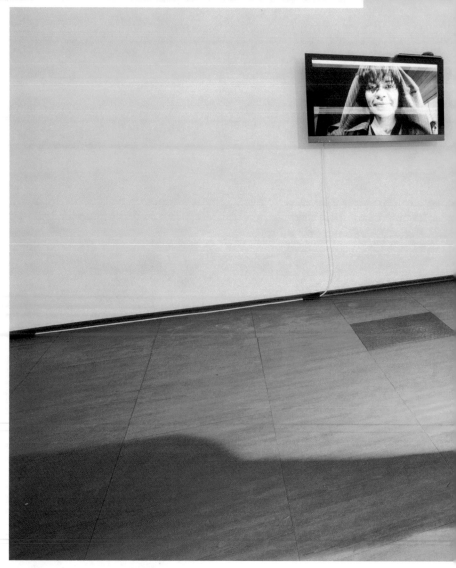

Tele_Trust , 2011, (performance-installation at
the *Uncontainable* exhibition, ISEA2011 Istanbul).
(Photographic documentation by Korhan Karaoysal.)

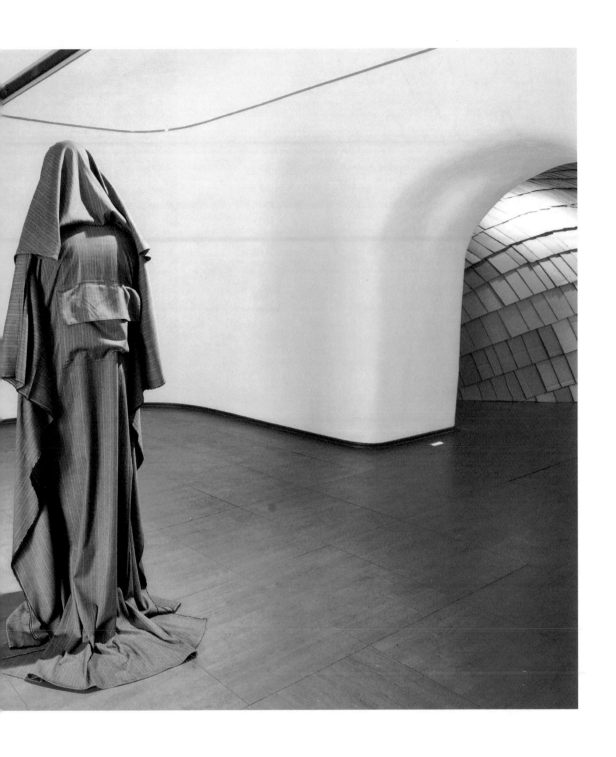

TEOMAN MADRA

Teoman Madra is a photography and multi-media artist who started his half a century production in May 1964, with his first abstract photography exhibition at the Municipal Art Gallery Beyoğlu, Istanbul. Subsequently, he continued doing new things and frequented contemporary art events yearly. His abstract photography with contemporary music shows reflected Fluxus concepts and aesthetics.

He is one of the first artists who experimented with video and computer to create multi-media environments and installations, always using the original compositions of Turkish and international musicians. He made first video art show in Istanbul Museum of Painting and Sculpture in 1979.

He did many yearly multimedia performances and installations between 1965 and 2010 and was invited to participate in the Paris Biennial of 1967 at the Musée de l'Art Moderne, as well as the 48th Venice Biennial. Throughout in 2000's, he made multimedia shows, interactions, photography video, music shows, such as *solar2002intermedia* and *Dada-Loop* show. He participated in ARTALAN II in 2005, Mediterranean Countries Festival in 2006 and AMBER Festival in 2008.

Selection of artworks inspired by light, using multiple digital media based on instant and random inspiration. 1964-2011, Teoman Madra.

ISSN 1071-4391 ISBN 978-1-906897-19-2

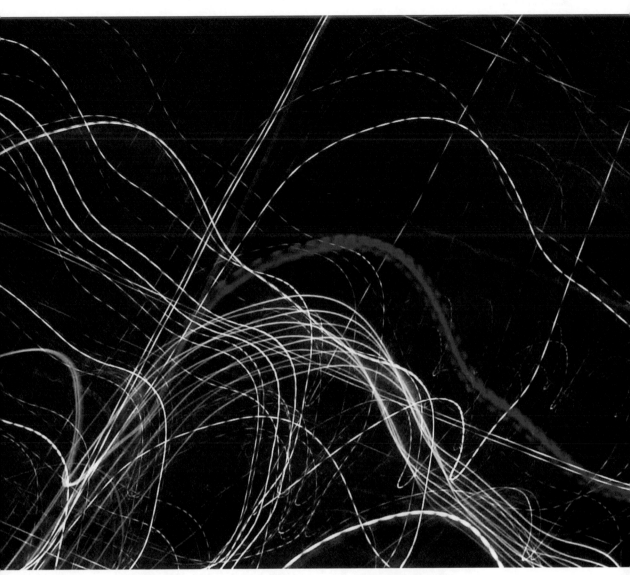

Selection of artworks inspired by light, using
multiple digital media based on instant and
random inspiration. 1964-2011, Teoman Madra.

TEOMAN
MADRA

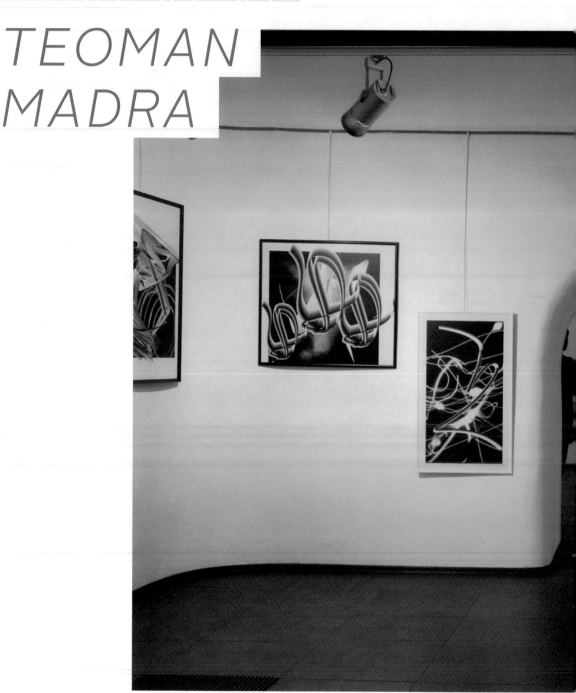

Selection of artworks inspired by light, using
multiple digital media based on instant and random
inspiration. 1964-2011, Teoman Madra. (Photographic
documentation by Eser Aygün.)

YOTA MORIMOTO

A non-conventional approach to generating and transmitting sound in audio-visual installations/performances.

Yota Morimoto is a Japanese composer born in Sao Paulo, Brazil, currently undertaking a doctorate research at the University of Birmingham, UK. His works explore unconventional approaches to generating and transmitting sound, implementing models of noise, turbulence and abstract machines.

His works have been presented in festivals and conferences such as TodaysArtFestival (Den Haag), NWEAMO (Mexico), transmediale (Berlin), ISEA (Ruhr), makeart festival (Poitier), EMUfest (Rome), ICMC (Belfast), and SMC (Porto, Barcelona).

s0 [vo.1], Yota Morimoto, audio-visual installation, 1 ch, 16:9 screen.

ISSN 1071-4391 ISBN 978-1-906897-19-2

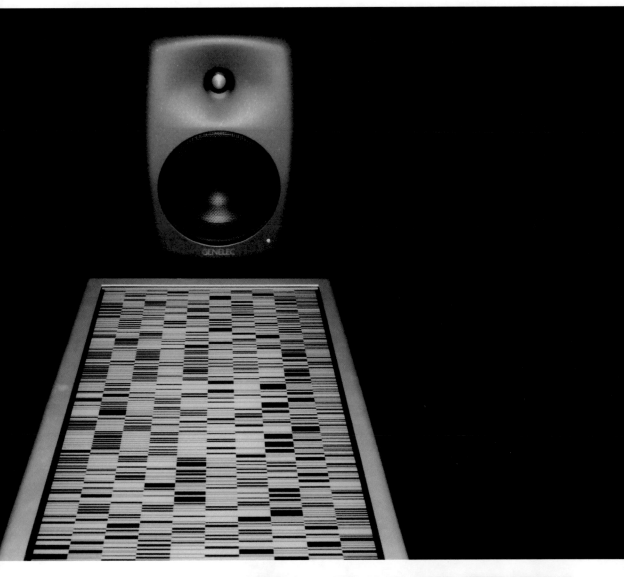

s0 (close up HD screen),

KILIAN OCHS

I believe that there is a reality of systems, which is the counterpart to the reality of usefulness in an anthropocentric sense. The systematic reality is vital and self-referential.

Kilian Ochs was born in 1980, in Pforzheim (Germany). He grew up in a family of workers and technicians. His early interest for the reality of pure logic, combined with a need for distinct expression, brought him to writing, and in 2002, at the age of 22, he was ready to start his studies in the department of philosophy at the Karlsruhe University of Arts and Design. However, feeling the urge to get closer to the obstructive challenges of materiality, he decided to change departments after one semester and to study media art. He graduated in 2010. The artist lives and works in Karlsruhe (Germany) and Tallinn (Estonia).

For several years now, he has been dealing with the development of his own theory of systems, and with the challenges that derive from shaping systematic procedures into material. With *Sphere 12/16*, one of his latest projects, he built his first object which both theoretically and aesthetically achieves the goal of melting logical thoughts and resistant material together.

Sphere 12/16 was built during a stay in Tallinn (Estonia) from 2009 to 2010. The artist wants to express his gratitude to all his friends there who supported and helped him on this project, above all to Leho Reiska and Erik Alalooga.

Sphere 12/16, 2009-2011, Kilian Ochs, steel, electronic circuits, LEDs, hydraulic system, 180 × 180 × 180 cm. The sculpture in action. (Photographic documentation by Korhan Karaoysal.)

ISSN 1071-4391 ISBN 978-1-906897-19-2

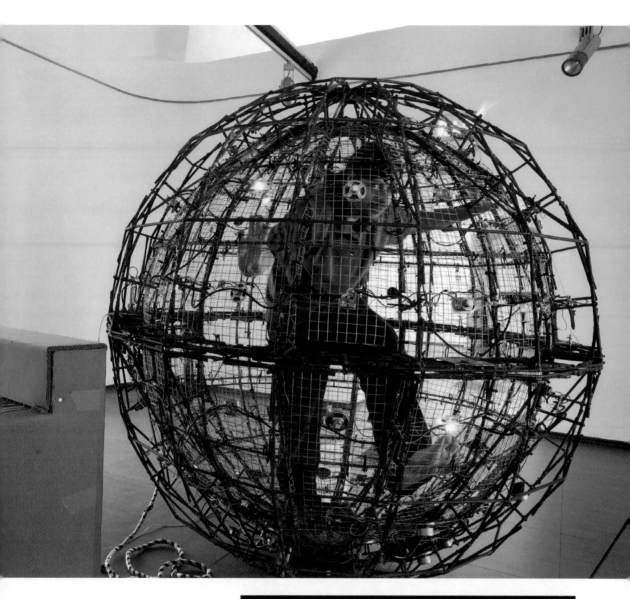

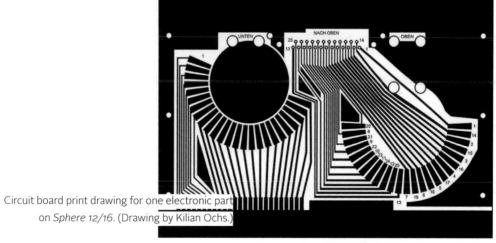

Circuit board print drawing for one electronic part on *Sphere 12/16*. (Drawing by Kilian Ochs.)

KILIAN OCHS

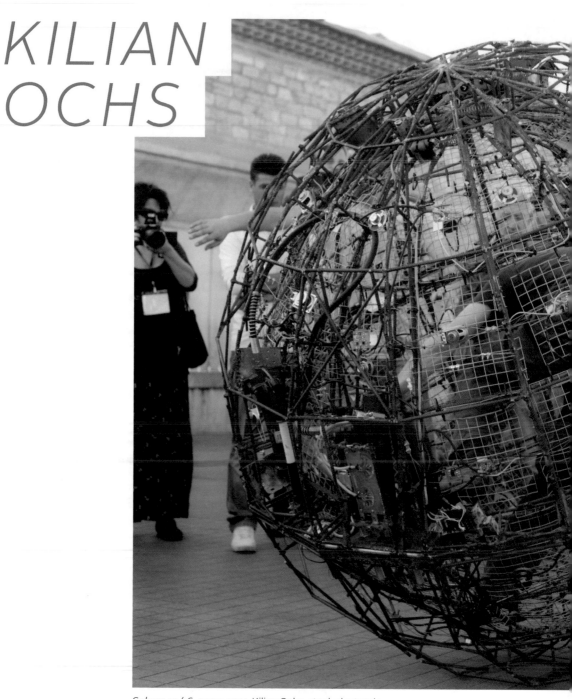

Sphere 12/16, 2009-2011, Kilian Ochs, steel, electronic circuits, LEDs, hydraulic system, 180 × 180 × 180 cm. In action on Taksim square, Istanbul. (Photographic documentation by Joscha Steffens VG Bild Kunst.)

ISSN 1071-4391 ISBN 978-1-906897-19-2

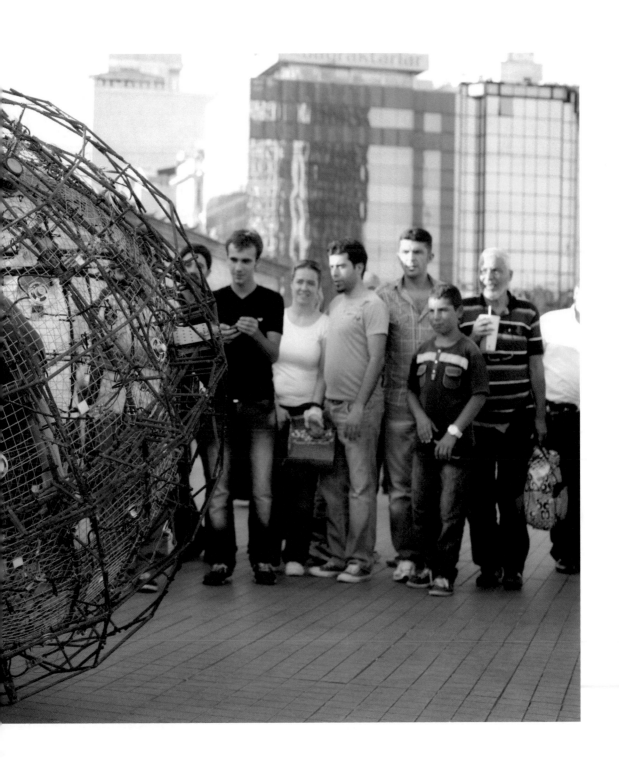

ESTHER POLAK & IVAR VAN BEKKUM

The energy of the morning is fluid. It grows stronger and warmer over time. A small machine manages to catch up and translate this orbit and its daily differences.

Esther Polak (born 1962) studied graphic art and mixed media at the Rijksacademie, The Hague.

Ivar van Bekkum (born 1965) studied journalism (Zwolle) and worked as a graphic designer.

Polak and Bekkum are interested in how technology determines (visual) perception. In their practice they focus on landscape and mobility. They use GPS and other technologies to approach and depict landscape and (the use of) space in a new way. Their visualizations are digital as well as physical.

Spiral Drawing Sunrise, 2009-2011, Esther Polak and Ivar van Bekkum, solar panel carrier, arduino, electro motor, battery, sand, bottle.

ISSN 1071-4391 ISBN 978-1-906897-19-2

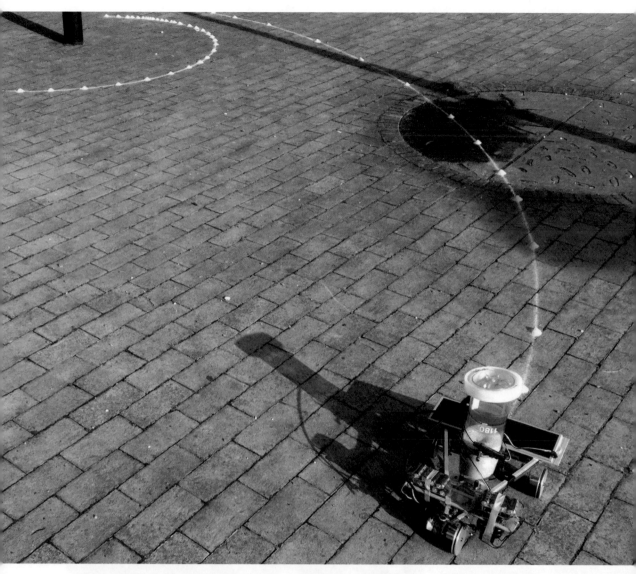

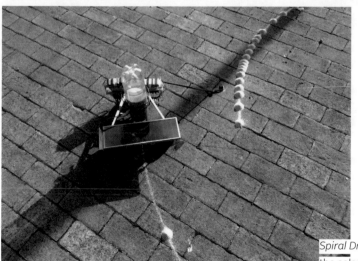

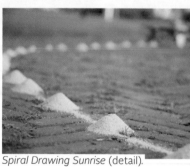

Spiral Drawing Sunrise (detail). (Close-up of sand spiral, drawn by solar powered robot.)

Spiral Drawing Sunrise (detail). (Test run, the solar cart passes its starting point.)

ESTHER POLAK &
IVAR VAN BEKKUM

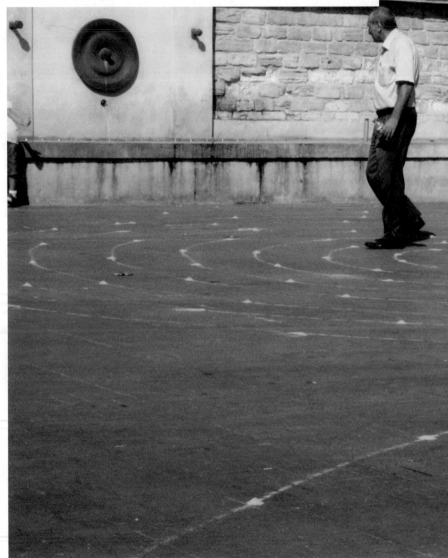

Spiral Drawing Sunrise, 2009-2011, Esther Polak and
Ivar van Bekkum, solar panel carrier, arduino, electro
motor, battery, sand, bottle. In action on Taksim
square, Istanbul. (Photographic documentation by
Özden Şahin.)

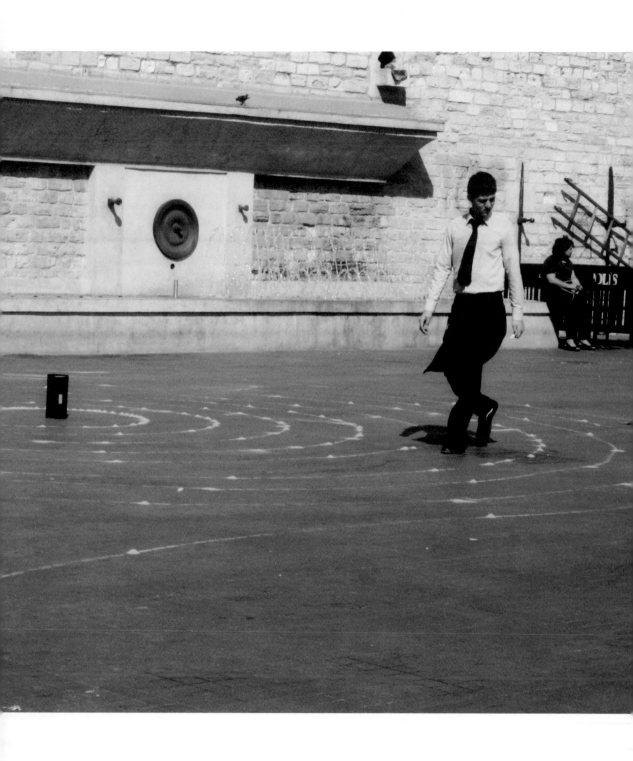

DAAN ROOSEGAARDE

The connection established between ideology and technology results in what Roosegaarde calls "techno-poetry."

Artist and architect **Daan Roosegaarde** (1979) explores the dawn of a new nature that is evolving from technological innovations by creating interactive landscapes that instinctively respond to sound and movement. Roosegaarde's remarkable works of art function as a documentation of the dynamic relation between architecture, people, and technology.

His sculptures, such as *Dune* and *Intimacy*, are tactile high-tech environments in which viewer and space become one. This connection, established between ideology and technology, results in what Roosegaarde calls "techno-poetry."

In 2009, Roosegaarde won the Dutch Design Award. He has been the focus of exhibitions at the Tate Modern, the National Museum in Tokyo, the Victoria and Albert Museum in London, and various public spaces in Rotterdam and Hong Kong.

Intimacy Black, 2010-2011, Daan Roosegaarde, in co-production with V2_Lab, Maartje Dijkstra and Anouk Wipprecht. Smart foils, wireless technologies, electronics, LEDs, copper and other media. (Photographic documentation by Özden Şahin.)

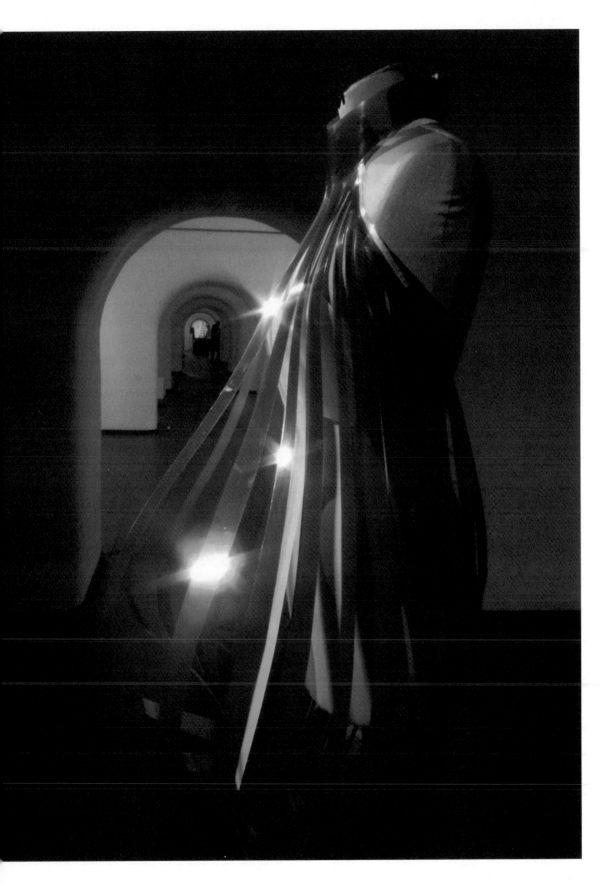

DAAN ROOSEGAARDE

LOTUS 7.0, 2010-2011, Daan
Roosegaarde, smart foils, lamps,
sensors, software and other media,
curved wall, 400 × 50 × 200 cm.

ISSN 1071-4391 ISBN 978-1-906897-19-2

GRÉGORY LASSERRE & ANAÏS MET DEN ANCXT A.K.A. SCENOCOSME

Exploring invisible relationships with environment: feeling energetic variations of living beings, and designing interactive stagings where spectators share sensory and amazing experiences.

Gregory Lasserre and Anaïs met den Ancxt are two artists who work together as a duo with the name Scenocosme. They use interactive art, music and architecture. With multiple forms of expression, they invite spectators to be in the centre of musical or choreographic collective performances. Scenocosme invents sonorous or/and visual languages: artists translate the exchanges between living beings and between the body and its environment. Materialised, sensations are augmented. Scenocosme's artworks react to the electrostatic energy of the human and uses the body itself as a continuous sensorial interface with the world. Thus, Scenocosme creates a dramaturgic space in which the different approaches of postural communication generate sonorous reactions with plants, stones, water or human body.

In 2007, Scenocosme created *Akousmaflore*, which offers original sonorous interactions by touching plants. In 2009, Scenocosme created *Lights Contacts*, an interactive installation where contacts between spectators create sounds and light according to the electrostatic energy of their bodies. In 2010, this artwork received the Visual Arts and New Technologies award at the Bains Numeriques festival.

Akousmaflore, 2007,
Grégory Lasserre &
Anaïs met den Ancxt
a.k.a. Scenocosme.
Sensitive and interactive
musical plants.

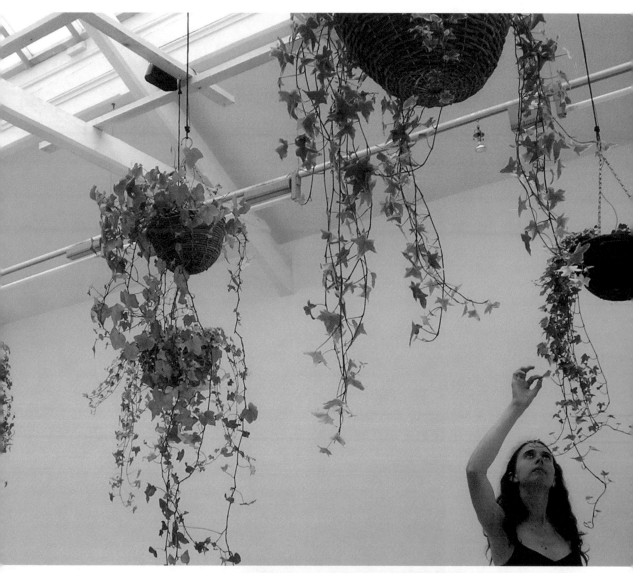

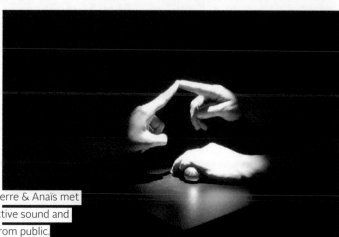

Lights Contacts, 2009, Grégory Lasserre & Anaïs met den Ancxt a.k.a. Scenocosme. Interactive sound and light installation with body and skin from public.

GRÉGORY LASSERRE & ANAÏS MET DEN ANCXT A.K.A. SCENOCOSME

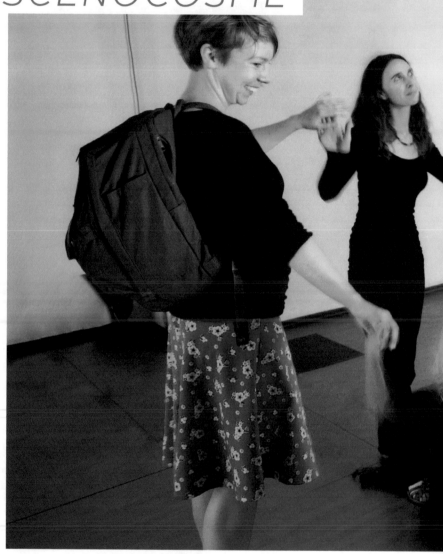

Lights Contacts, 2009, Grégory Lasserre & Anaïs met den Ancxt a.k.a. Scenocosme. Interactive sound and light installation with body and skin from public. (Photographic documentation by Korhan Karaoysal.)

TAMIKO THIEL, CEM KOZAR, IŞIL ÜNAL

'Invisible Istanbul' - *an augmented reality (AR) intervention into the Istanbul Biennial that uses GPS positioned artworks to create surrealistic and poetic juxtapositions within the physical space of Istanbul and the Biennial.*

Tamiko Thiel is American media artist who develops the dramatic and poetic capabilities of augmented reality as a medium for social and cultural issues. She has degrees in engineering from Stanford and MIT and in fine arts from the Academy of Fine Arts, Munich. Her work has been supported by WIRED Magazine, Japan Foundation, MIT, Berlin Capital City Cultural Fund and The IBM Innovation Award.

Architects **Cem Kozar** and **Işıl Ünal** founded design office PATTU (Sumerian; a field, ready to be cultivated) which focuses on creating new fields in architecture, design and urbanism through exhibitions, research projects and urban interventions. Their works have been exhibited in the Rotterdam Architecture Biennial, Istanbul Architecture festival and the Istanbul Summer exhibition. PATTU recently finished the *Ghost Buildings* research/exhibition project which was supported by the Istanbul 2010 Capital of Culture Agency. Their office is still cooperating with local and international artists on a variety of projects.

ISSN 1071-4391 ISBN 978-1-906897-19-2

Invisible Istanbul: Urban Dynamics Node 5, 2011,
PATTU (Cem Kozar/Işıl Ünal), augmented reality. Node
5: Brothels: from many brothels to one brothel to a
park and hotels.

TAMIKO THIEL, CEM KOZAR, IŞIL ÜNAL

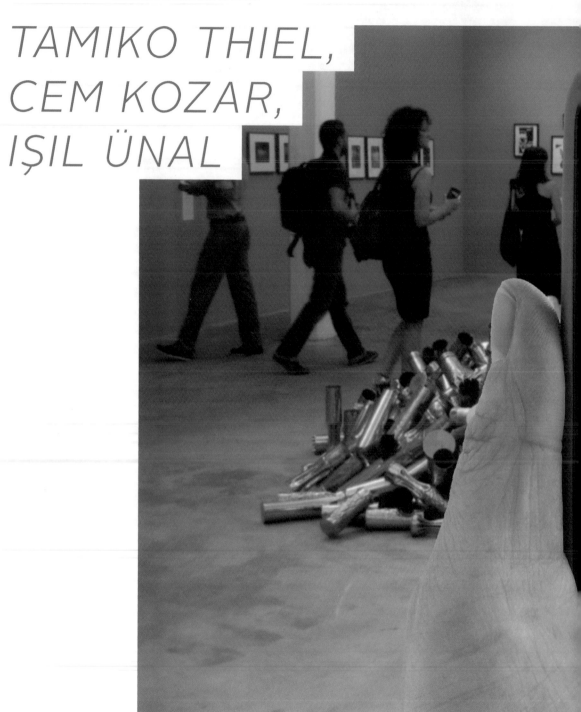

Invisible Istanbul: Captured (cannon balls), 2011, Tamiko Thiel, augmented reality. Virtual 'nazar boncuğu' glass amulets with animated eyeballs. Seen here in the Istanbul Biennial exhibition *Untitled (Death by Gun),* with Kris Martin's *Obussen II.*

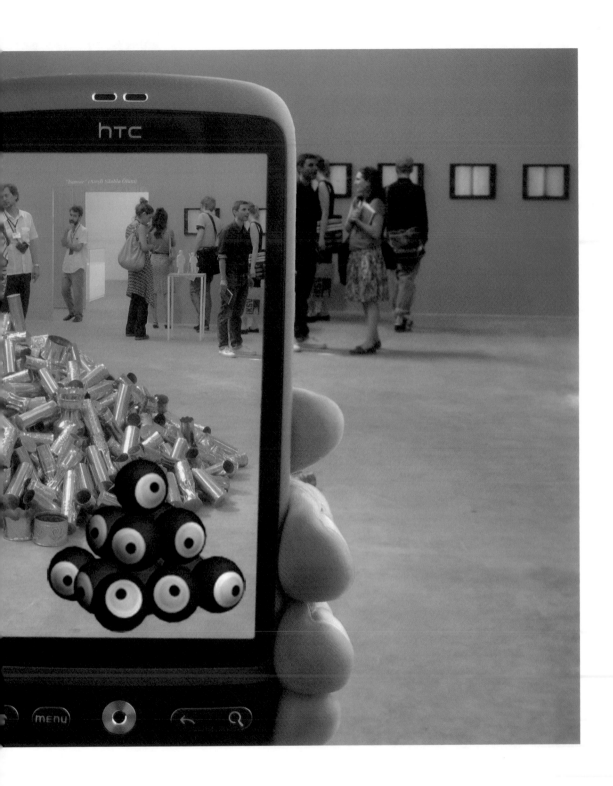

PATRICK TRESSET

Paul *is an obsessive artificial drawing entity that sketches people who pose for it. Its sketching style resembles Patrick Tresset's own.*

Patrick Tresset is a French artist/scientist currently based in London. On the artistic side Patrick uses what he calls "clumsy robotics" to create autonomous cybernetic entities that are playful projections of the artist.

On the scientific side Patrick co-directs the Aikon-II project with Prof. Frederic Fol Leymarie at Goldsmiths College, University of London. The Aikon-II project investigates the observational sketching activity through computational modeling and robotics.

Tresset's recent exhibitions in the UK include- Kinetica Art Fair, Waterman Art Center, Tenderpixel Gallery, The Victoria and Albert Museum, and the Science Museum.

Paul, 2011,
Patrick Tresset.

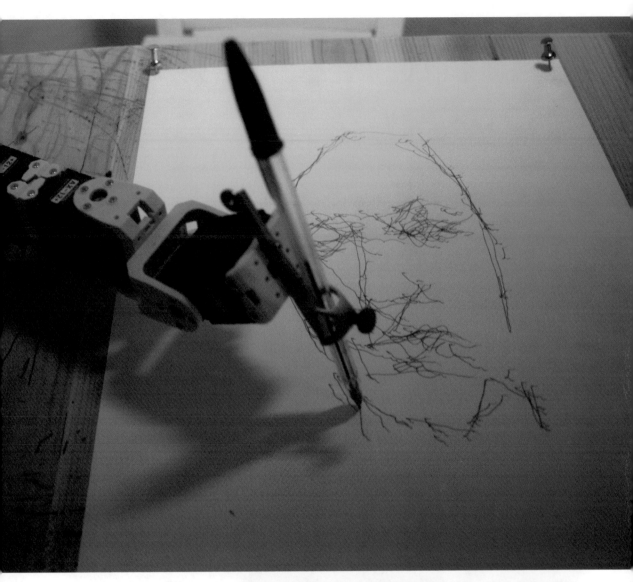

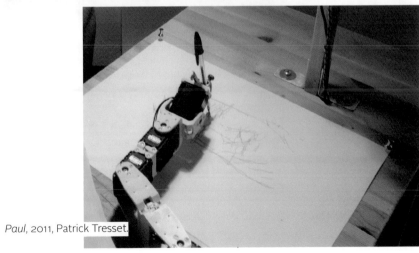

Paul, 2011, Patrick Tresset.

PATRICK TRESSET

Paul, 2011, Patrick Tresset. (Photographic
documentation by Korhan Karaoysal.)

 ISSN 1071-4391 ISBN 978-1-906897-19-2

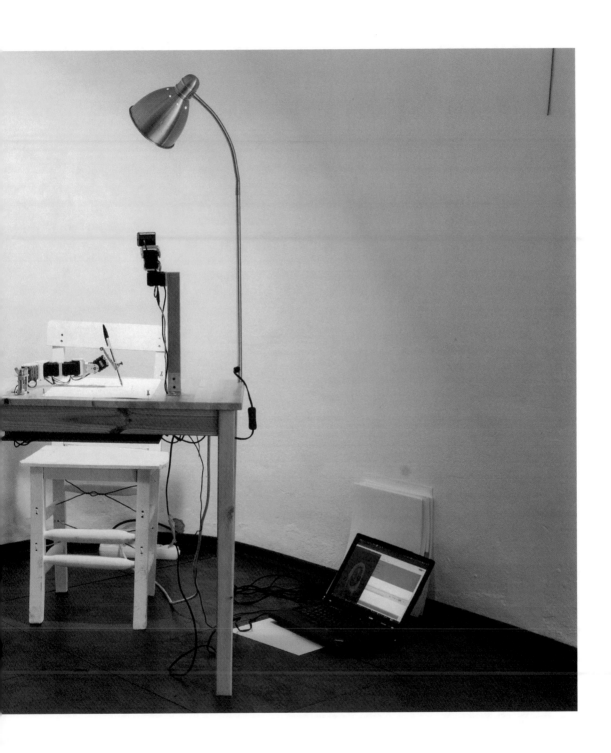

PIETER VERHEES & JOHANNES WESTENDORP

Inside Mount Lu *will drop you in a borderland between discovery and creation. You will be challenged to create a transition from functional sound towards expression and perhaps even to a musical experience.*

Pieter Verhees composes artworks, performances and installations in the real and digital domains from the disciplines of drama, sculpture and mechanics. Fascinated by the way we interpret ourselves and how we relate to our environment, his artworks can be engaged and political like the project *Theatre of War* or they can be intimate, poetic and contemplative as in *Blikkensteler*. He searches for a state of transformation, when a sensation or thought reveals something new and blocks the way back. With composer Johannes Westendorp, he developed *Inside Mount Lu*, an interactive music composition in which participants enter a sonic world and use sound as a means to navigate or as a contribution to a musical composition.

Johannes Westendorp studied guitar at the conservatories of Tilburg (Netherlands) and Gent (Belgium). In 2010 he completed his studies with a Master Artistic Research at the University of Amsterdam. He is part of the electric guitar quartet Zwerm. He designs unreliable musical instruments using them in performances such as *Tijdwerk*, *Obstructie* and *Hoquetus*.

Inside Mount Lu, 2011,
Pieter Verhees &
Johannes Westendorp.
(Acoustic performance.)

ISSN 1071-4391 ISBN 978-1-906897-19-2

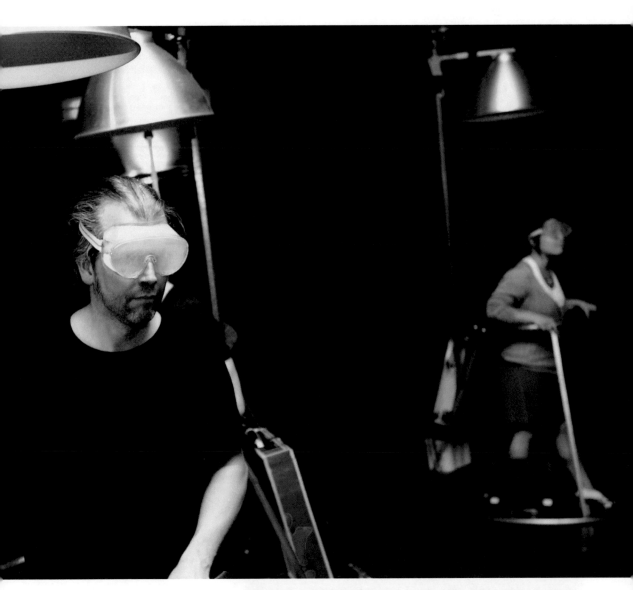

Inside Mount Lu (detail).

ISSN 1071-4391 ISBN 978-1-906897-19-2

NILS VÖLKER

One Hundred and Eight is a wall-mounted installation mainly made out of garbage bags and cooling fans. The bags are selectively inflated and deflated in controlled rhythms, creating wavelike animations across the wall.

Nils Völker is an artist and communication designer living and working in Berlin. He creates artworks with the means of physical computing somewhere at the intersection of technology and art. Often his work consists out of large amounts of everyday objects combined and rearranged in an unusual way.

One Hundred and Eight, exhibited in ISEA2011 *Uncontainable*, became the starting point for a series of installations based upon the inflating and deflating of cushions made from different materials. The largest one was made from 252 large silver bags for the exhibition *Captured – a Homage to Light and Air*. This was followed by further site specific installations such as *Thirty Six Art* for Lab Gnesta, *Forty Eight* for the Birmingham Museum & Art Gallery, *Seventy Five* for Kuandu Museum of Fine Arts in Taipei and *Eighty Eight* commissioned by the Gewerbemuseum, Winterthur, Switzerland. Nils Völker's most recent work is *64 CCFL*, a light installation that is mainly made with so-called cold cathode fluorescent lights which are normally used as backlights for computer screens. Currently he is working on his first large scale work to be placed permanently outdoors as part of a sculpture park in Hangzhou, China.

One Hundred and Eight, Summer/Autumn 2010, Nils Völker, cooling fans, plastic bags, MDF, custom electronics, 240 × 180 cm.

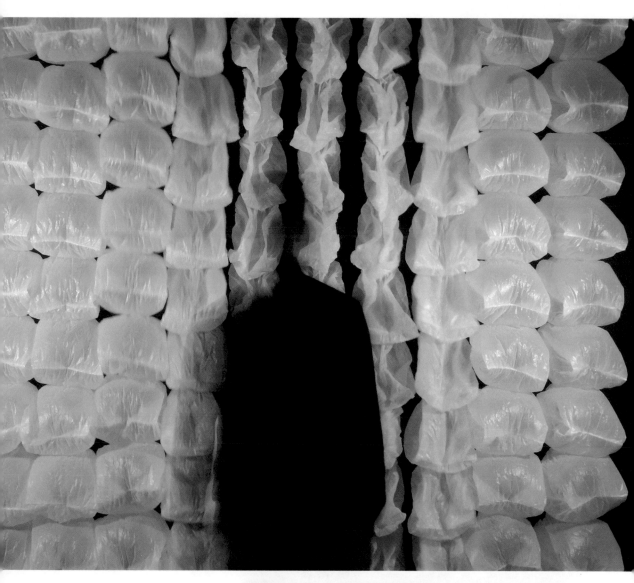

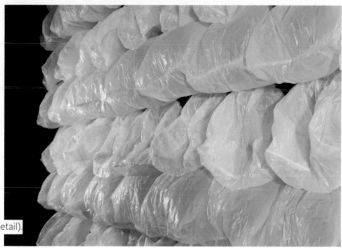

One Hundred and Eight (detail).

ISSN 1071-4391 ISBN 978-1-906897-19-2 LEA VOL 18 NO 5 **UNCONTAINABLE** 117

NILS VÖLKER

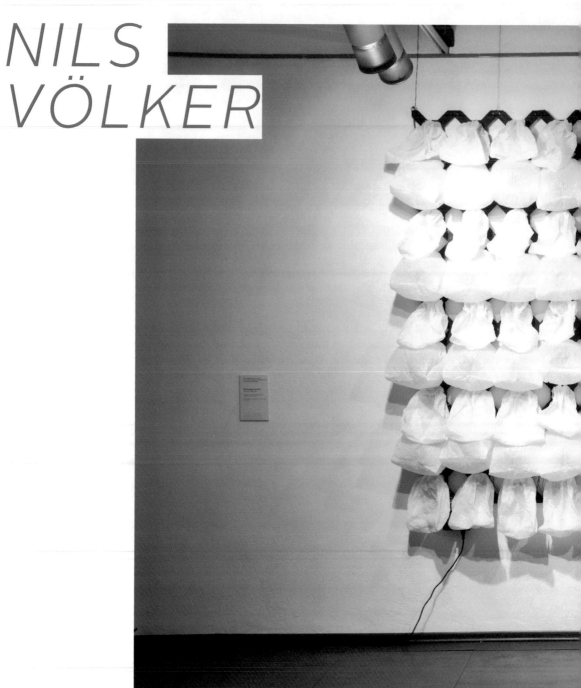

One Hundred and Eight, Summer/Autumn
2010, Nils Völker, cooling fans, plastic bags, MDF,
custom electronics, 240 × 180 cm. (Photographic
documentation by Korhan Karaoysal.)

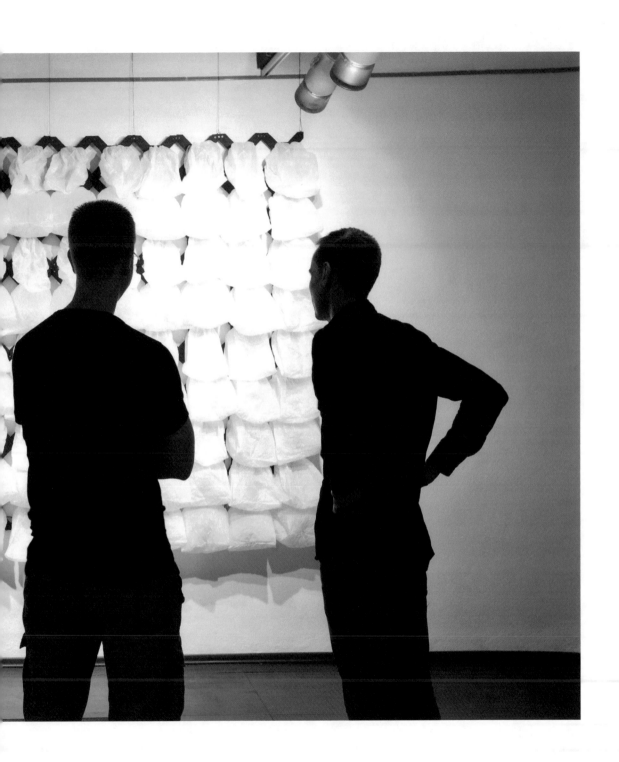

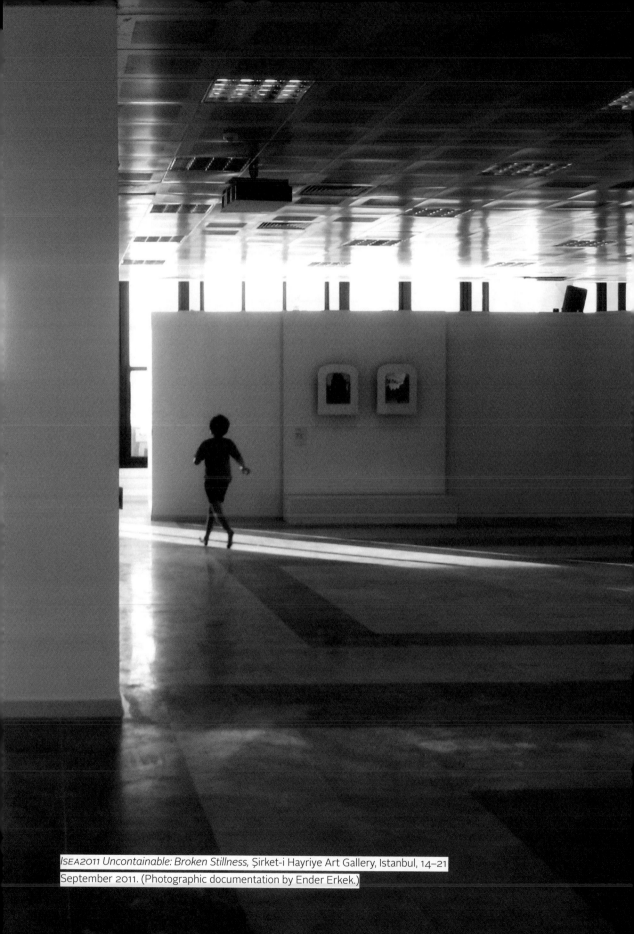

ISEA2011 Uncontainable: Broken Stillness, Şirket-i Hayriye Art Gallery, Istanbul, 14–21 September 2011. (Photographic documentation by Ender Erkek.)

ISEA2011
UNCONTAINABLE

BROKEN STILLNESS

ŞİRKET-İ HAYRİYE SANAT GALERİSİ
14–21 EYLÜL, 2011
ZİYARET SAATLERİ: 10:00–18:00

SANAT DİREKTÖRÜ/ARTISTIC DIRECTOR **LANFRANCO ACETI**
KÜRATÖR/CURATOR **HELEN SLOAN**

SANATÇILAR/ARTISTS **BOREDOMRESEARCH (VICKY ISLEY
& PAUL SMITH); SUSAN COLLINS; DAVID COTTERRELL;
SIGUNE HAMANN; PETER HARDIE; TIM HEAD; SUSAN
SLOAN.**

SANAT DİREKTÖRÜ VE KONFERANS BAŞKANI /
ARTISTIC DIRECTOR AND CONFERENCE CHAIR
LANFRANCO ACETI

KONFERANS VE PROGRAM DİREKTÖRÜ /
CONFERENCE AND PROGRAM DIRECTOR
ÖZDEN ŞAHİN

ISSN 1071-4391 ISBN 978-1-906897-19-2

UNCONTAINABLE
Broken Stillness

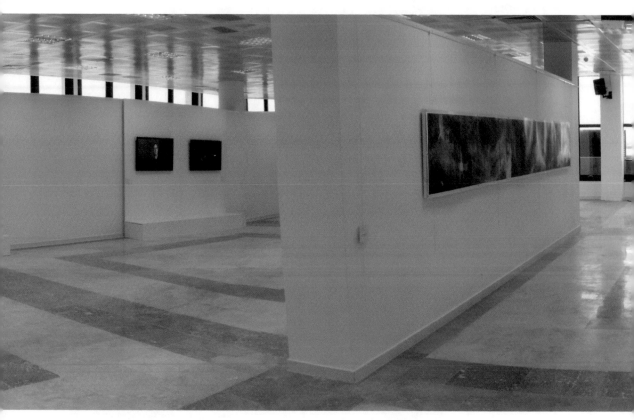

ISEA2011 Uncontainable: Broken Stillness, Şirket-i Hayriye Art Gallery, Istanbul, 14–21
September 2011. (Photographic documentation by Ender Erkek.)

 ISSN 1071-4391 ISBN 978-1-906897-19-2

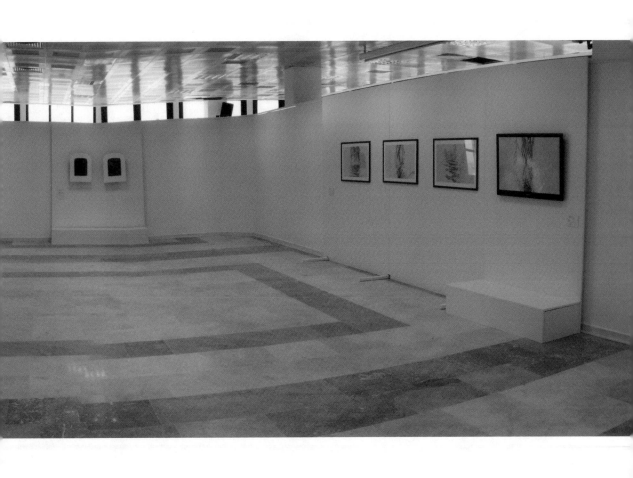

UNCONTAINABLE
Broken Stillness

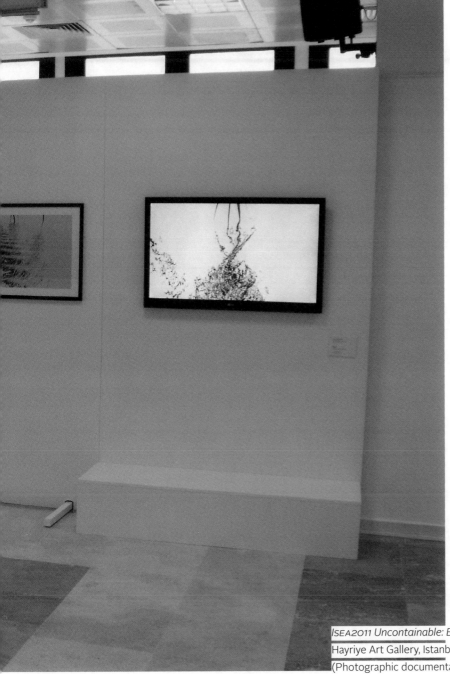

ISEA2011 Uncontainable: Broken Stillness, Şirket-i
Hayriye Art Gallery, Istanbul, 14–21 September 2011.
(Photographic documentation by Ender Erkek.)

UNCONTAINABLE
Broken Stillness

 ISSN 1071-4391 ISBN 978-1-906897-19-2

ISEA2011 Uncontainable: Broken Stillness, Şirket-i Hayriye Art Gallery, Istanbul, 14–21 September 2011. (Photographic documentation by Ender Erkek.)

ISSN 1071-4391 ISBN 978-1-906897-19-2

ISEA2011
UNCONTAINABLE
BROKEN STILLNESS

KÜRATÖR/CURATOR **HELEN SLOAN**

SANATÇILAR/ARTISTS **BOREDOMRESEARCH VICKY ISLEY & PAUL SMITH), SUSAN COLLINS, DAVID COTTERRELL, SIGUNE HAMANN, PETER HARDIE, TIM HEAD, AND SUSAN SLOAN**

SANAT DİREKTÖRÜ VE KONFERANS BAŞKANI / ARTISTIC DIRECTOR AND CONFERENCE CHAIR **LANFRANCO ACETI**

KONFERANS VE PROGRAM DİREKTÖRÜ / CONFERENCE AND PROGRAM DIRECTOR **ÖZDEN ŞAHİN**

 ISSN 1071-4391 ISBN 978-1-906897-19-2

TR Sanatçılar, özel yazılmış bilgisayar programları ve hack'lenmiş veri paketleri aracılığıyla, çağdaş görsel sanatlarda imge yaratma politikaları ve gelişimini sorgulamak için analog ve dijitalin birleşimini kullanıyor. Eserler, hareketli imge ile durağan resim ve fotoğrafçılık arasında bir yerde konumlanan görseller yaratmak üzere veriyi manipüle ediyor.

EN Through custom written software or hacked packages the artists use a fusion of the analogue and the digital to engage the politics and development of image-making in contemporary visual arts. The works manipulate data to create images that reside between the moving image and the stills of painting and photography.

VICKY ISLEY & PAUL SMITH A.K.A. BOREDOMRESEARCH

Generative artworks explore extended time frames, greatly inspired by the diversity in nature. Computational technology is used to simulate natural patterns, behaviours and intricacies that gradually change.

boredomresearch is a collaboration between Southampton UK based artists Vicky Isley and Paul Smith. The collective are internationally renowned for creating software driven art, highly aesthetic both visually and acoustically. All their art is computer generated and includes interactive public works of art, generative objects, online projects and environments. boredomresearch's artwork *Ornamental Bug Garden 001* is housed within the British Council's Collection and has been awarded honorary mentions in Transmediale.05, Berlin (2005) and the VIDA 7.0 Art & Artificial Life International Competition, Madrid (2004)

'boredomresearch's artworks have been exhibited worldwide in festivals, galleries and museums such as the KUMU Art Museum in Tallinn, Estonia (2011); [DAM]Cologne (2011); Electrohype Biennial, Ystad Art Museum in Sweden (2010); FILE Prix Luz in São Paulo (2010); Today Art Museum in Beijing (2010); LABoral Centro de Arte y Creacion Industrial in Gijón, Spain (2010); MAXXI Museo Nazionale delle Arti del XXI Secolo in Rome (2010); STRP Festival in Eindhoven, Netherlands (2009); Instituto Itaú Cultural in São Paulo (2008); SIGGRAPH08 in Los Angeles (2008); iMAL Center for Digital Cultures and Technology in Brussels, Belgium (2008) among other venues.

Lost Calls of Cloud Mountain Whirligigs (view 2, left & right), 2010, boredomresearch, software artworks in lacquered frames, 60 × 49 × 2 cm. Courtesy of [DAM]Berlin.

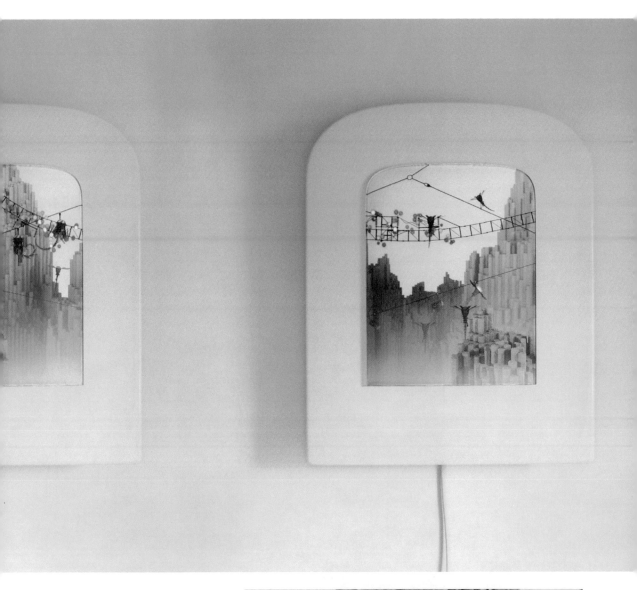

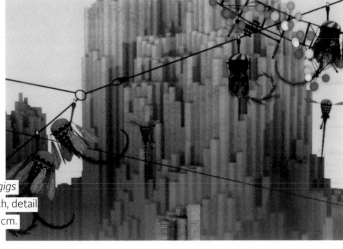

Lost Calls of Cloud Mountain Whirligigs
(view 2, left), 2010, boredomresearch, detail
from software artwork, 60 × 49 × 2 cm.
Courtesy of [DAM]Berlin.

VICKY ISLEY & PAUL SMITH A.K.A. BOREDOMRESEARCH

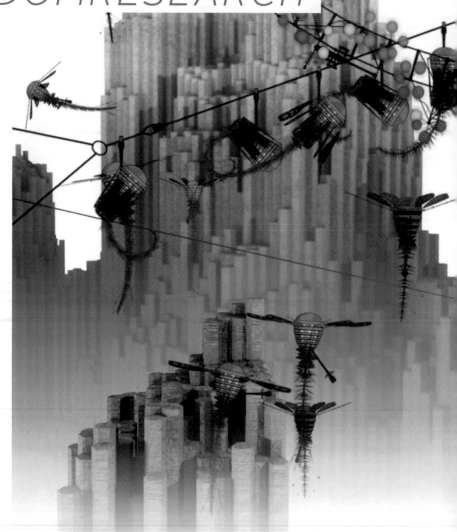

Lost Calls of Cloud Mountain Whirligigs (view 2, left & right), 2010, boredomresearch, detail from software artwork, 60 × 49 × 2 cm. Courtesy of [DAM]Berlin.

ISSN 1071-4391 ISBN 978-1-906897-19-2

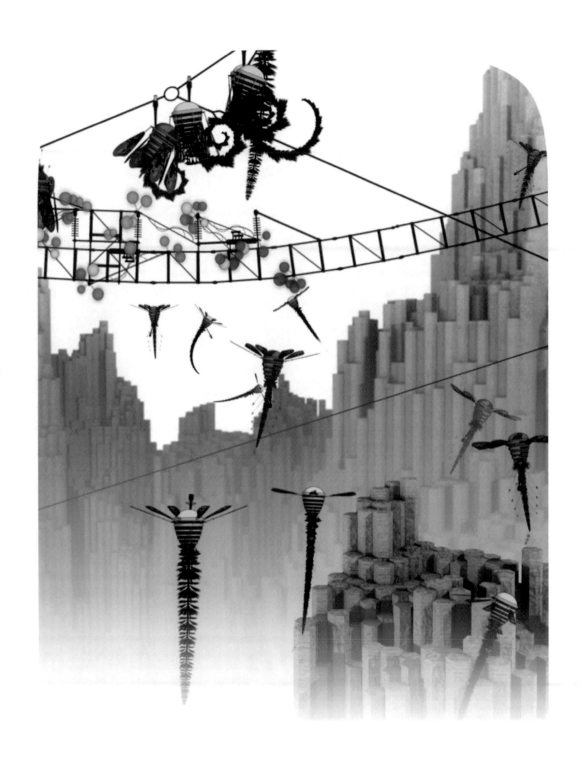

SUSAN COLLINS

Recorded for a time period of 2 years, through a networked camera overlooking Loch Faskally, Scotland, programmed to record images at one pixel a second, Glenlandia addresses the relationship between the natural and the man-made, and our perception of landscape and technology over time.

Susan Collins works across public, gallery and online spaces with recent works employing transmission, networking and time as primary materials. She has exhibited extensively internationally including the works, *In Conversation*; Tate in Space (a BAFTA nominated Tate netart commission); *Transporting Skies* which transported sky (and other phenomena) live between Newlyn Art Gallery, Penzance in Cornwall and Site Gallery Sheffield in Yorkshire; *Fenlandia* and *Glenlandia*, pixel by pixel internet transmissions from remote landscapes; *The Spectrascope*, an ongoing live transmission from a haunted house in England, and *Seascape* commissioned by Film and Video Umbrella and the De La Warr Pavilion. Public commissions include a wildlife surveillance system for Sarah Wigglesworth Architect's RIBA award winning Classroom of the Future, and *Underglow*, a network of illuminated drains for the Corporation of London. Susan Collins is a Professor of Fine Art and the Director of the Slade School of Fine Art, University College London where she established the Slade Centre for Electronic Media in Fine Art (SCEMFA) in 1995.

Glenlandia, 2005-06,
Susan Collins, 19 August
2005 at 09:53 a.m.

ISSN 1071-4391 ISBN 978-1-906897-19-2

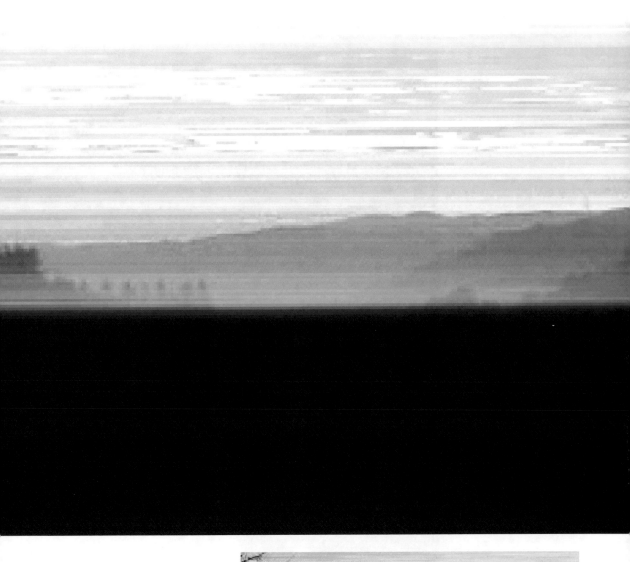

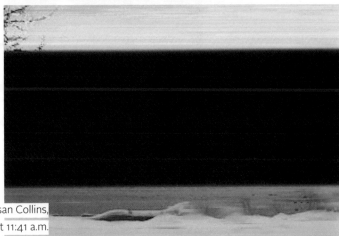

Glenlandia, 2005-06, Susan Collins,
11 March 2006 at 11:41 a.m.

UNCONTAINABLE
Broken Stillness

SUSAN COLLINS

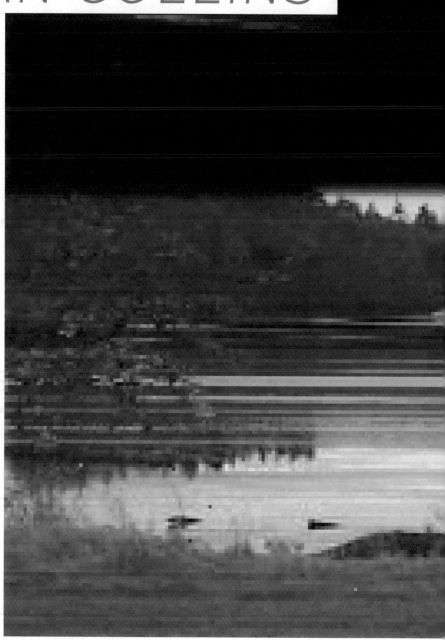

Glenlandia, 2005-06, Susan Collins, 1 September
2005 at 15:03 p.m.

ISSN 1071-4391 ISBN 978-1-906897-19-2

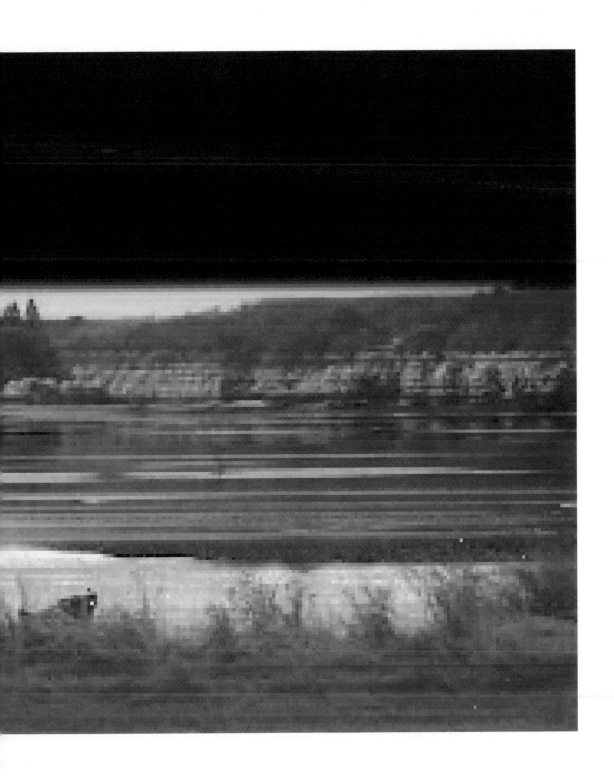

SIGUNE HAMANN

In film-strips I capture the energy of urban environments using a photographic camera in the manner of a movie camera. The film-strip at ISEA2011 depicts a section of a 90 second handheld pan of the UK student protest march against budget cuts in Whitehall 9.12.2010.

Sigune Hamann is an artist who deals with still and moving images. In photographs, videos, installations and online environments she explores the effects time and perception have on the construction of mental images. Hamann's projects include film-strips (ISEA, Istanbul Biennial 2011, Kunsthalle Mainz 2008, Gallery of Photography, Dublin 2008, Harris Museum, and Preston 2005); *wave* (Wellcome Collections 2012), *the walking up and down bit* (BFI, 2009) and *Dinnerfor1* (British Council, transmediale, Berlin, 2005) and NothingButTheTruth.org.uk 2002.

Born in Frankfurt am Main, Hamann graduated from the UdK Berlin and RCA London (with distinction). She is a Senior Lecturer at Camberwell College of Arts. Hamann curated the symposium *Stillness and Movement* at Tate Modern in 2010.

Undercurrent, 2008,
Sigune Hamann.
Photograph on blueback
paper, wall-mounted,
1,80 × 12m
Kunsthalle Mainz,
Germany.

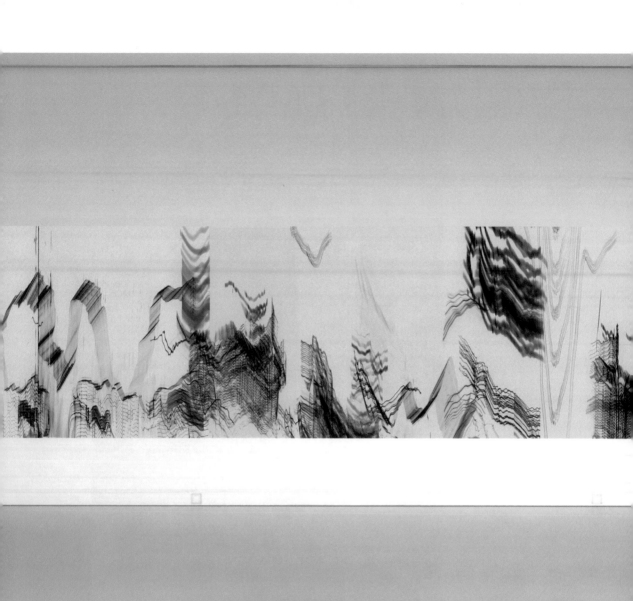

I'll walk alone - you'll never walk alone,
2005, Sigune Hamann. Photographic film-
strip, size variable, proportion 1 × 50.

SIGUNE HAMANN

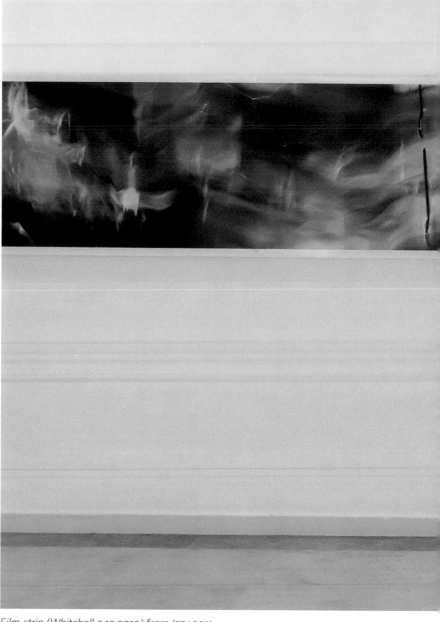

Film-strip (Whitehall 9.12.2010) from *ISEA2011*
Uncontainable: Broken Stillness, Sigune Hamann.
C-type-print, 568 × 65cm.

ISSN 1071-4391 ISBN 978-1-906897-19-2

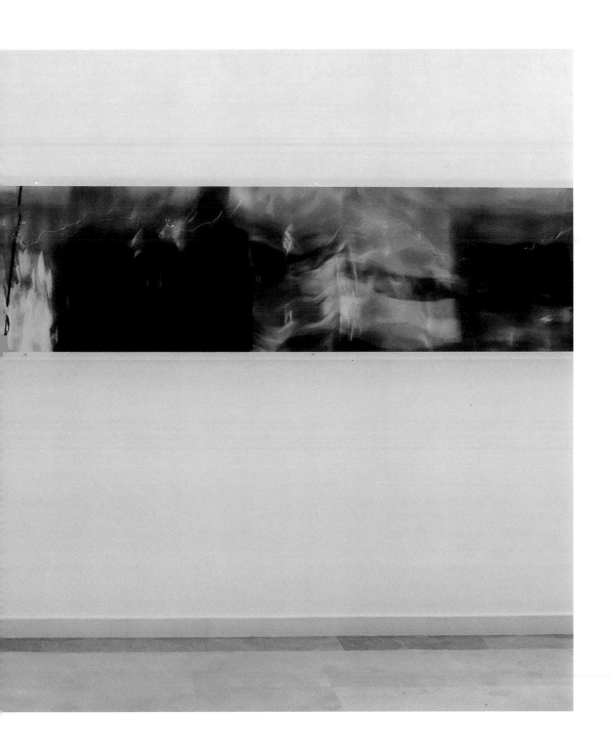

PETER HARDIE

> My work is driven by the observation and reaction to moments in time and place of landscape. In the current work, the landscape is willow trees reflecting onto a rippling river.

Peter Hardie is full time artist focusing on the creation of still and moving artworks though the innovative use of the tools and techniques available in three dimensional computer animation systems. His work is based on the study of natural phenomena and landscape exploring the area between realism and abstraction, looking at aspects of colour, light, form and movement to deliver specific, sensation based experiences. The current artworks started in 2004 and are ongoing. The works have been exhibited widely within the UK and also at festivals and conferences in Europe and the United States.

Before 2007, Hardie was instrumental in developing computer animation courses for art-based students in UK universities, in particular the undergraduate and master's programs in computer animation at Bournemouth University. He has also been program leader for the Masters in Arts in 3D Computer Animation from its inception to 2004. He was the founding member and leader of the Visual Research from its inception to 2004. Parallel to these activities, he has been engaged in exhibitions, publications, and creating computer animated sequences for television and computer generated simulation ride films.

Reflection_one, 2011, Peter Hardie, print generated using a computer animation system, 60 × 48 cm.

ISSN 1071-4391 ISBN 978-1-906897-19-2

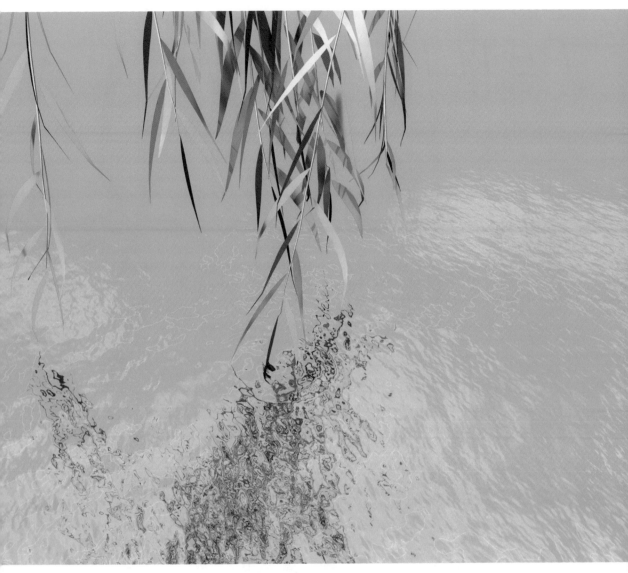

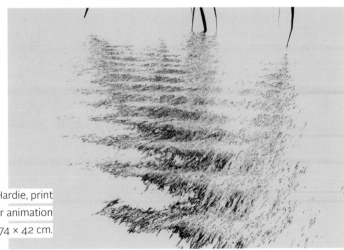

Ripple_grey_one, 2011, Peter Hardie, print generated using a computer animation system, 74 × 42 cm.

ISSN 1071-4391 ISBN 978-1-906897-19-2

PETER HARDIE

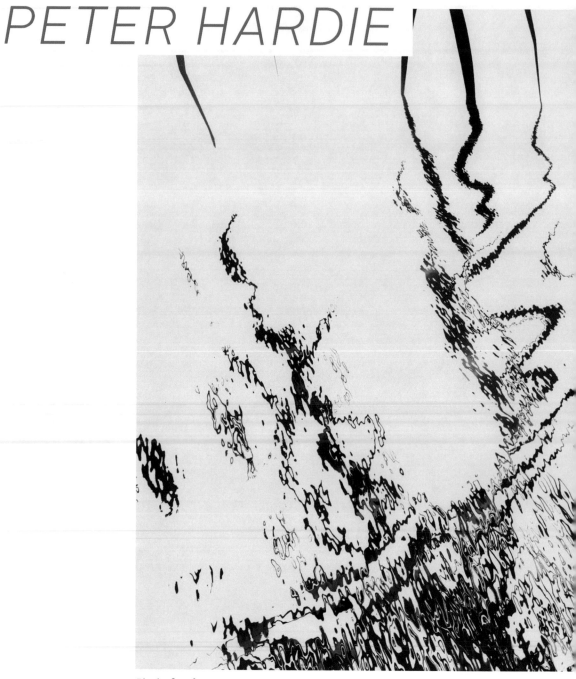

Ripple_flat_four, 2011, Peter Hardie, print generated
using a computer animation system, 74 × 42 cm.

ISSN 1071-4391 ISBN 978-1-906897-19-2

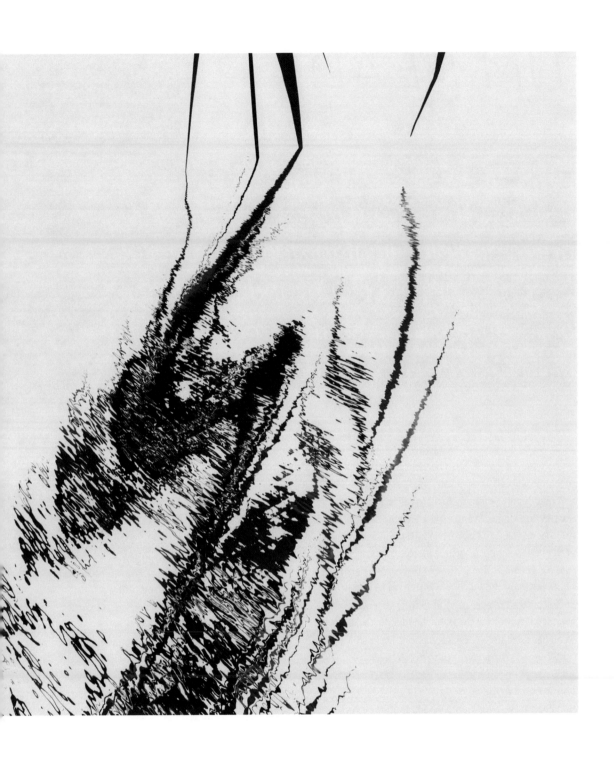

ISSN 1071-4391 ISBN 978-1-906897-19-2 LEA VOL 18 NO 5 **UNCONTAINABLE** 145

TIM HEAD

Here the basic elements are the luminous fabric of the screen pixels with the red, green and blue light mixing to produce over 16.5 million colours and the hidden procedures of the computer operating at ultra fast speeds that drive them.

Tim Head was born in 1946 in London. He studied at the University of Newcastle-upon-Tyne from 1965 to 1969, where his teachers included Richard Hamilton and Ian Stephenson. In 1968 he went to New York where he worked as an assistant to Claes Oldenburg, and met Robert Smithson, Richard Serra, Eva Hesse, Sol LeWitt, John Cale and others. He studied on the Advanced Sculpture Course run by Barry Flanagan at St Martin's School of Art, London, in 1969. In 1971 he worked as an assistant to Robert Morris on his Tate Gallery show. From 1971 to 1979 he taught at Goldsmiths College, London. In 1987 Head was awarded First Prize in the 15th John Moores Exhibition. Head has exhibited widely internationally. His solo shows include MOMA, Oxford (1972); Whitechapel Art Gallery, London (1974 and 1992); British Pavilion, Venice Biennial (1980); ICA, London (1985); and Kunstverein Freiburg, Germany, and touring (1995).

Nowhere, 2010, Tim Head. Still from dataprojection from realtime computer programme.

ISSN 1071-4391 ISBN 978-1-906897-19-2

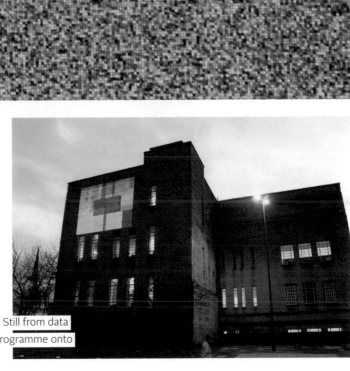

Sunday Morning, 2009, Tim Head. Still from data projection of realtime computer programme onto building exterior.

ISSN 1071-4391 ISBN 978-1-906897-19-2

TIM HEAD

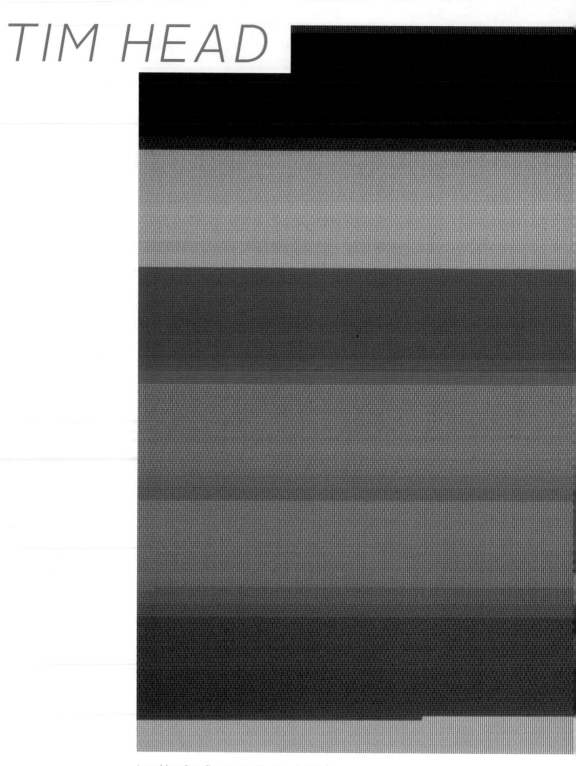

Laughing Cavalier, 2002, Tim Head. Still from LED
display from realtime computer programme.

ISSN 1071-4391 ISBN 978-1-906897-19-2

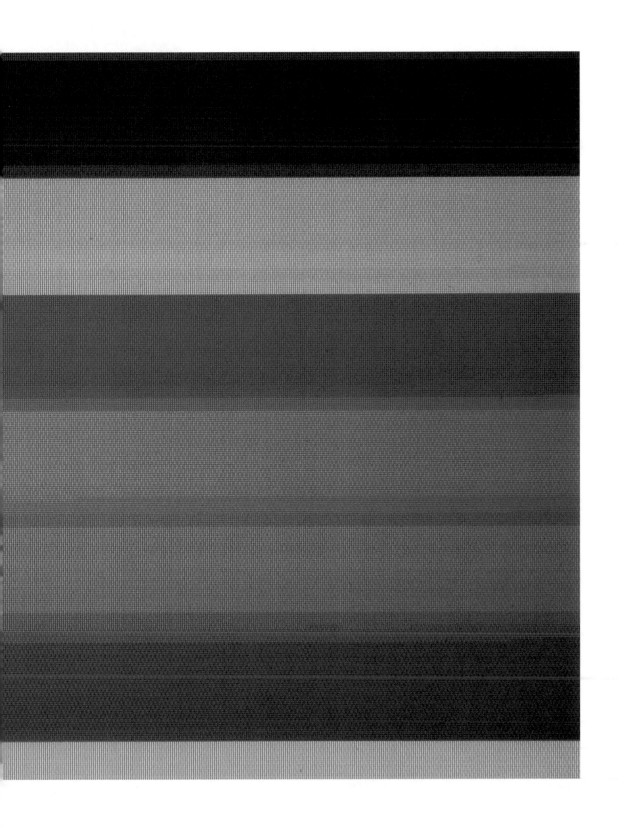

SUSAN SLOAN

> *These portraits lie between painting, animation, video and sculpture. They draw from all of these practices and whilst entirely constructed in 3D software the motion of the subject is recorded from real life.*

Susan Sloan is a Lecturer/ Research Fellow at the National Centre for Computer Animation, Bournemouth University. She works both collaboratively and alone using animation to create artworks and public projects. Her work has been shown nationally and internationally at exhibitions including the SIGGRAPH Gallery, San Diego; 404 Festival, Argentina; IV03 London; IV06, London, Sydney; Kunstihoone Gallery, Tallinn, Estonia; Yokohama Art Museum, Japan; An Tuireann, Isle of Skye, Glasgow International Festival; NPAR, Annecy Animation Festival, France. She has undertaken a number of residencies including District of Columbia Schools, Washington DC; Royal Scottish Academy, Florence and The National Centre for Computer Animation, Bournemouth University.

Mary, 2011, Susan Sloan. Motion capture animated portrait (still from moving image sequence).

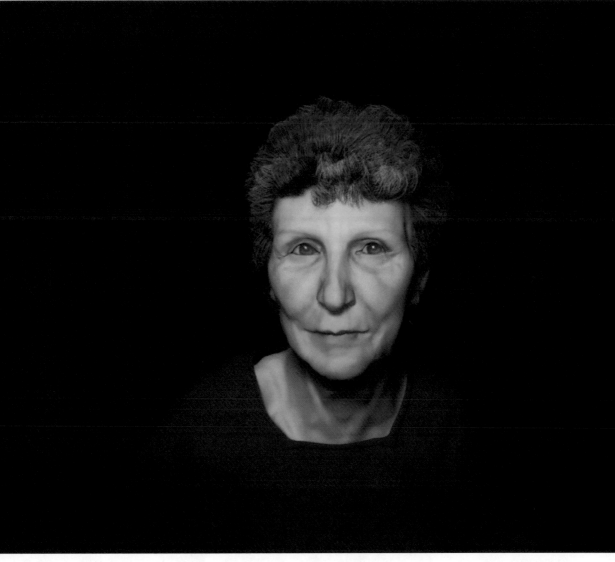

Annie and Mary, 2011, Susan Sloan. Installation view
of motion capture animated portraits, *ISEA2011*
Uncontainable: Broken Stillness, Şirket-i Hayriye Art
Gallery, 14-21 September 2011.

SUSAN SLOAN

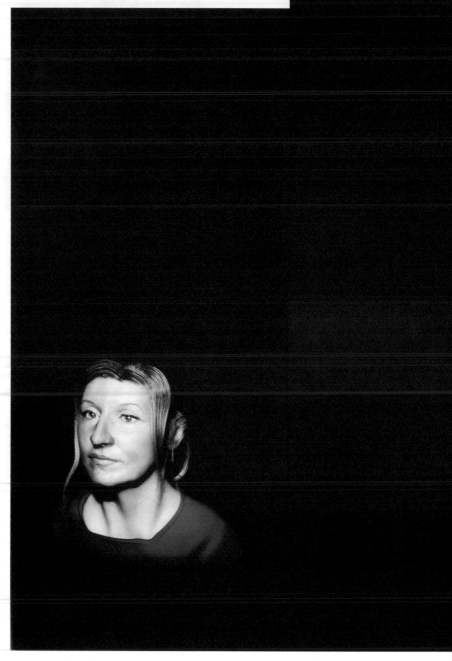

Susan and Annie, 2011, Susan Sloan. Installation view of motion capture animated portraits.

ISSN 1071-4391 ISBN 978-1-906897-19-2

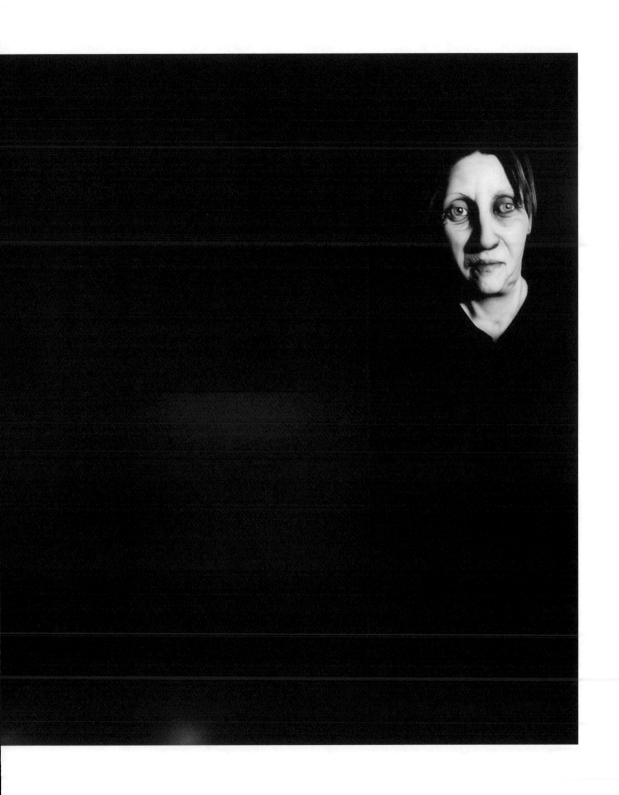

Uncontainable: Broken Stillness
A change of speed, a change of style

BY

Helen Sloan

Director, SCAN

The relationship between technology and speed has been closely associated with the development of progressive technology in the 20th century and now in this century, with the ubiquity of personal computers, mobile devices and networks, with rapidly increasing capability. It has been an expectation that machines will work faster and more seamlessly in the service of making society more flexible and agile. Unless procedures go wrong in the mainstream, data transfer, manipulation and creation is rarely questioned. Notably Paul Virilio commented on these developments observing that speed is so much a part of our engagement with society that we are dependent on it, while apprehensive or even fearful that the technology of speed may break, stop or cause accident and disaster. This subject has of course been the subject of much science fiction over the last 120 years from HG Wells to James Cameron. Current debate, such as that present in ISEA2011, focuses on our relationship with digital data and the complexities that have arisen in terms of creative practice, data storage, the environmental impact of working with digital data, and new forms of socio-economic grouping that are being created by social media and data mining.

The work in *Uncontainable: Broken Stillness* asks the viewer to address the issue of the relationship between new creative practices and older analogue pursuits, such as painting and pre-digital photography – the exhibition suggests that the temptation to discard art history in the digital era may be misguided.

ISSN 1071-4391 ISBN 978-1-906897-19-2

Uncontainable: Broken Stillness is a shameless celebration of an artist's signature work and style in an age celebrating collective authoring, sharing and the 'hive mind'. The exhibition does not suggest an alternative for shared working but suggests that there is space for individual practice to make a contribution. The works have been selected for their use of digital techniques embedded in the development of a visual language begun in earlier forms of image-making. Much of the work is implicitly political and subverts the mainstream use of technology - particularly in relation to speed, mostly by slowing the process down at least for the viewer. The artists use the unique value of technology to increase the spectrum of mark-making, landscape, media and gesture.

Tim Head, a forerunner of the contemporary trend towards fusion of art and science and the producer of politically driven imagery and installation, strips data back to the material of the os and the screen with a program written in C that randomly generates lines of colour on screen in conceptual works such as *Laughing Cavalier* - shown in the exhibition. (In some of his works randomly generated colours are produced pixel by pixel.)

Peter Hardie, a pioneer in computer animation, has dedicated years to studying the properties of water and the representation of its movement in animation. His *Ripple* series shown in the exhibition combines his interest in impressionist painting with animation. This work strives to find marks and techniques that can only be produced through computer programming. His study of water and light has combined mathematics, the study of molecular movement and light with the observational techniques of the impressionists. It is this combination that has enabled the artist to extend the range of techniques possible for describing movement of water and the reflection of light on it.

Susan Collins has worked since the 1980s in computer and electronic arts and is recognised as a leading UK artist in this area of practice. *Glenlandia*, a contemporary investigation into landscape art, is an archive of images gathered from pointing a webcam at Loch Faskally. The work shows images on screen generated by changing pixel by pixel over approximately 21 hours in a day. This piece provides a timeframe as well as an in-depth study of a single landscape. Presented on the screen in landscape format the artist introduces the representation of time, showing simultaneously day and night views of the same scene studied and recorded over two years. Collins has produced a series of archives in the UK and internationally that explore the subtleties of the landscape tradition.

boredomresearch continues the landscape theme using Processing to develop artificial life for their playful diptych *Lost Calls of Mountain Whirligigs*. The work generates fictional beings (Whirligigs) set in an environment combining landscape with mechanical technology. Each viewer experiences the piece differ-

ently as the Whirligigs exhibit individually generated behaviors and lifespan. Through the use of genetic algorithms, boredomresearch rely on the generation of unique images and behaviors so that no two people will see exactly the same image. boredomresearch is interested in the way that viewers engage with landscape and the ability of digital media to develop fictional, fantastic, landscapes with which the viewer can engage. This multiple creation of images is reflected in Tim Head and Susan Collins' pieces, although all are dealing with very different approaches to image-making and concept.

Sigune Hamann, photographer and video-maker, uses analogue 35mm stills photography to add movement to the image by shooting a still film in one take. The resultant film-strip (*Whitehall* 9.12.10) made at the student protests in December 2010 stunningly combines moving image, panoramic photography and painterly gesture. This work develops her interest in the role of the camera and subject in standard narrative in film and photography and the application of digital techniques to old media to question and subvert these narratives. For example, the student protests were a mix of dreary, dynamic and subversive atmospheres and yet here the film-strip shows a beautiful painterly scene that seems removed from the reality of the subject.

David Cotterrell's work also subverts context by challenging our understanding of war through media images. His recent body of work assembled from footage taken during his residency in Helmand Province, Afghanistan, deliberately looks at the images of war that represent the waiting for action rather than the much publicized activity of war. *Green Room* is a video loop showing the anticipation of the arrival of casualties to the medical room in Helmand. Treated in post production and heavily mediated, *Green Room*

creates a sumptuous image that enhances anticipation of action – a very different tableau from media and cinematic representations of casualties of war.

Susan Sloan has researched extensively the use of motion capture in animation. This technique, most associated with gaming and cinema special effects, tends to focus on the production of stylized and standardized movements of characters. These are achieved through a post production 'cleaning' process erasing glitches in movement. Through the inclusion of individual signature gestures and character in her subjects, *Mary and Annie*, Susan Sloan is able to develop the language of portraiture and likeness through image and movement. Her short loop of each character provides an image that occupies a place somewhere between a painting and an animation.

Whilst all the images in *Uncontainable: Broken Stillness* suggest movement or are animated, these movements are subtle, falling in between the tradition of moving and still image. It is the power of the subtle suggestion of movement and the place the work occupies in art historical, cinematic or media representation, that is the focus of the exhibition. The pieces in this exhibition seek to develop significantly the role of image-making using these new techniques. ∎

NOTES

1. Paul Virilio, *The Aesthetics of Disappearance*, trans. Philip Beitchman (New York, NY: Semiotext(e), 1991).

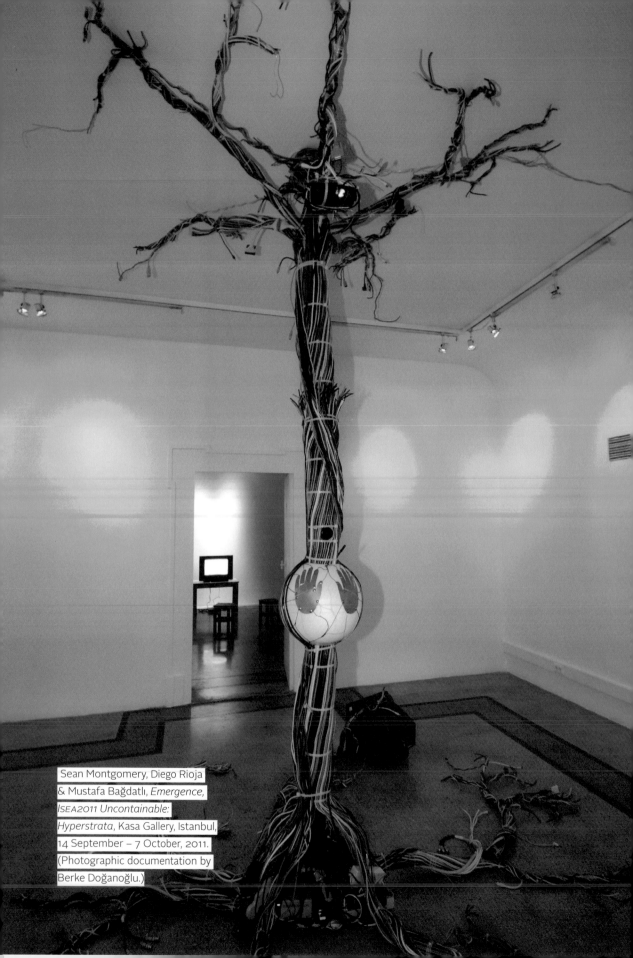

Sean Montgomery, Diego Rioja
& Mustafa Bağdatlı, *Emergence,
ISEA2011 Uncontainable:
Hyperstrata*, Kasa Gallery, Istanbul,
14 September – 7 October, 2011.
(Photographic documentation by
Berke Doğanoğlu.)

ISEA2011
UNCONTAINABLE

HYPER-
STRATA

KASA GALERİ
14 EYLÜL–7 EKİM, 2011
ZİYARET SAATLERİ: 10:00–18:00

BAŞ KÜRATÖR/SENIOR CURATOR **LANFRANCO ACETI**

SANATÇILAR/ARTISTS **MARK AMERIKA; ROY ASCOTT,
ELIF AYITER, MAX MOSWITZER & SELAVY OH; SEAN
MONTGOMERY, DIEGO RIOJA & MUSTAFA BAĞDATLI.**

SANAT DİREKTÖRÜ VE KONFERANS BAŞKANI /
ARTISTIC DIRECTOR AND CONFERENCE CHAIR
LANFRANCO ACETI

KONFERANS VE PROGRAM DİREKTÖRÜ /
CONFERENCE AND PROGRAM DIRECTOR
ÖZDEN ŞAHİN

SENSORSTAR

ISSN 1071-4391 ISBN 978-1-906897-19-2

Uncontainable
Hyperstrata

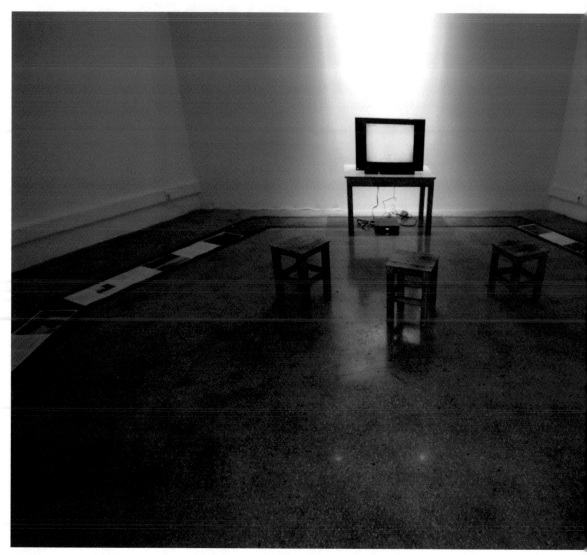

Mark Amerika, *Immobilité Remixes, ISEA2011 Uncontainable: Hyperstrata*, Kasa
Gallery, Istanbul 14 September – 7 October, 2011.

 ISSN 1071-4391 ISBN 978-1-906897-19-2

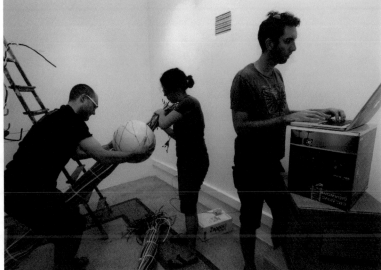

Sean Montgomery, Erica St. Lawrence and Diego
Rioja (from left to right) setting up *Emergence*.
ISEA2011 Uncontainable: Hyperstrata, Kasa
Gallery, Istanbul, 14 September – 7 October, 2011.
(Photographic documentation by Berke Doğanoğlu.)

UNCONTAINABLE
Hyperstrata

 ISSN 1071-4391 ISBN 978-1-906897-19-2

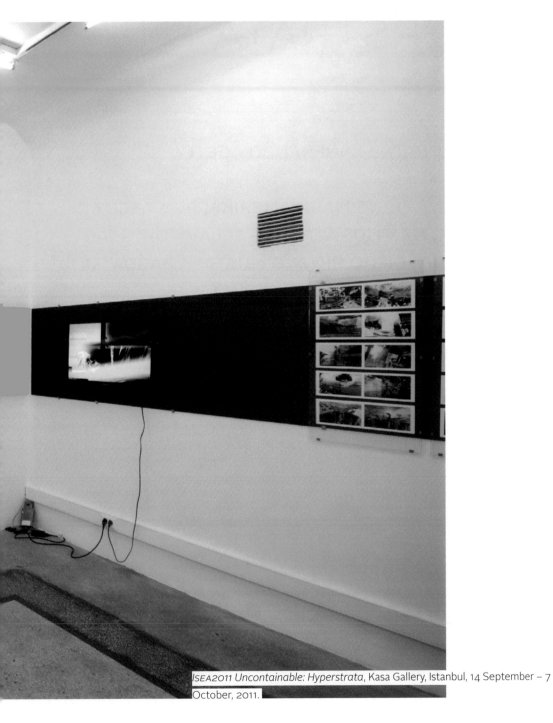

ISEA2011 Uncontainable: Hyperstrata, Kasa Gallery, Istanbul, 14 September – 7 October, 2011.

ISSN 1071-4391 ISBN 978-1-906897-19-2

ISEA2011
UNCONTAINABLE
HYPERSTRATA

KÜRATÖR/CURATOR **LANFRANCO ACETI**

SANATÇILAR/ARTISTS **MARK AMERIKA; ROY ASCOTT, ELIF AYITER, MAX MOSWITZER & SELAVY OH; SEAN MONTGOMERY, DIEGO RIOJA & MUSTAFA BAĞDATLI.**

SANAT DİREKTÖRÜ VE KONFERANS BAŞKANI / ARTISTIC DIRECTOR AND CONFERENCE CHAIR
LANFRANCO ACETI

KONFERANS VE PROGRAM DİREKTÖRÜ / CONFERENCE AND PROGRAM DIRECTOR
ÖZDEN ŞAHİN

ISSN 1071-4391 ISBN 978-1-906897-19-2

TR *Hyperstrata*, güncel estetiğin katmanlaşma, çökelme, melezleşme ve ortam değiştirme süreçleriyle ilgileniyor. Seçilen eserler bu kriterlerden en az birini yansıtıyor ve güncel tekno-toplumların kışkırttığı ve tanıklık ettiği tarihsel dönüşümlere örnek teşkil ediyor. Piksel, zaman zaman imgeleri 21. yüzyıl estetiğine büründürmenin aracı oluyor; bu katman, eski/yeni d-evrimsel gelişmeleri yansıtıyor.

EN *Hyperstrata* looks at the process of layering, sedimentation, hybridization and transmediation of contemporary aesthetics. The artworks chosen reflect one or more of these criteria and are a current example of the historical transformations that contemporary technosocieties are provoking and witnessing. The pixel becomes from time to time a contemporary media tool to overlay images with 21st century's aesthetics. The pixel is a layer that reflects previous and new r-evolutionary developments.

MARK AMERIKA

Remix your life or else someone else will remix it for you.

Mark Amerika is internationally renowned as a "remix artist" who not only reconfigures existing cultural content into new forms of art, but also mashes up the mainstream media forms and genres in which most commercial artists work . His body of remix artworks includes published cult novels, pioneering works of internet art, museum installations, large scale video projections in public spaces, live VJ performance, and a series of feature-length "films" shot with different image capturing devices in various locations.

Amerika's work has been exhibited internationally at venues such as the Whitney Biennial, the Denver Art Museum, the Institute of Contemporary Arts, London, the Walker Art Center, the American Museum of the Moving Image and ACA Media Arts Plaza in Tokyo. In 2009–2010, the National Museum of Contemporary Art in Athens, hosted Amerika's retrospective exhibition UNREALTIME. He is the author of many books including his collection of artist writings entitled META/ DATA: A Digital Poetics (MIT Press, 2007) and his new hybrid publication project, remixthebook (University of Minnesota Press, 2011). Amerika is a Professor of Art and Art History at the University of Colorado, Boulder and Principal Research Fellow at La Trobe University.

Immobilité, 2007, Mark Amerika., film stills from feature-length mobile phone film.

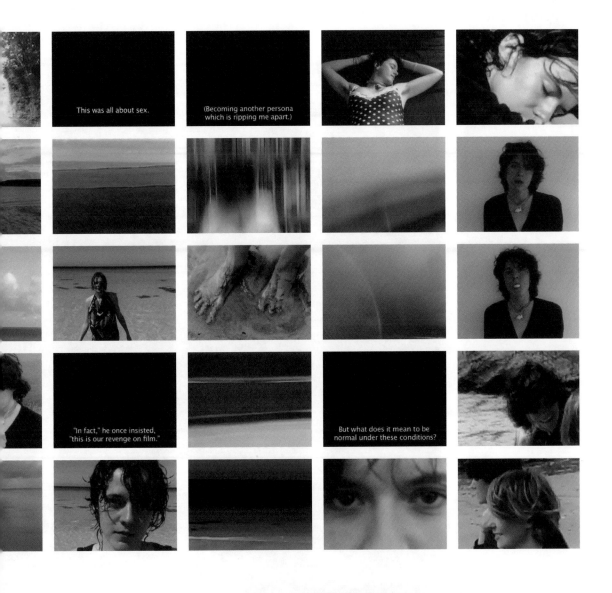

This was all about sex.

(Becoming another persona which is ripping me apart.)

"In fact," he once insisted, "this is our revenge on film."

But what does it mean to be normal under these conditions?

Immobilité, 2007, Mark Amerika, film still from feature-length mobile phone film.

MARK AMERIKA

The Immobilité Remixes, 2007, Mark Amerika,
film stills from feature-length mobile phone film,
installation at Kasa Gallery.

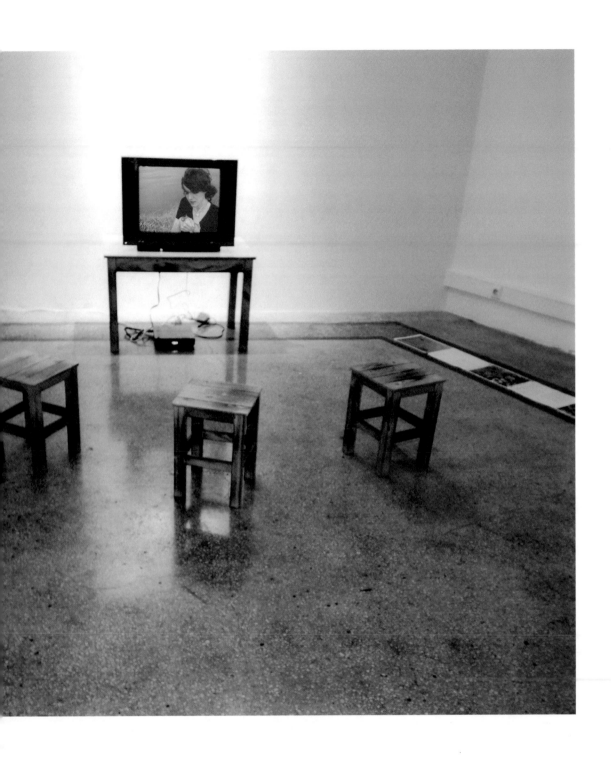

ROY ASCOTT, ELİF AYİTER, MAX MOSWITZER, SELAVY OH

LPDT2 alludes Roland Barthes's book Le Plaisir du Texte, a famous discourse on authorship, semantic layering, and the creative role of the reader as the writer of the text.

Roy Ascott is an artist and theorist whose research is invested in cybernetics, technoetics, telematics, and syncretism. He is the founder and director of the Planetary Collegium, and DeTao Master of Technoetic Arts at DTMA Shanghai. His exhibitions range from the Venice Biennial, Ars Electronica to the Shanghai Biennial. His theoretical work is widely published, translated and referenced.

Elif Ayiter is the chief editor of the academic journal *Metaverse Creativity* with Intellect publishers and is active as a virtual builder and fashion designer both in Second Life and the OpenSim.

Max Moswitzer is a multiple Ars Electronica award recipient, who in recent years has collaborated extensively with Chris Marker for whom he also built *Ouvroir*, a virtual three dimensional museum in Second Life and the New Genres Grid.

Selavy Oh has been created as an avatar in the virtual world of Second Life in February 2007. Since then, she showed her work in various exhibitions both inside the virtual world and in mixed-reality shows.

LPDT2, 2011, Roy Ascott, Elif Ayiter, Max Moswitzer, Selavy Oh. "The Lettercube" and the LPDT2 avatars.

LPDT2 is the Second Life incarnation of Roy Ascott's new media art work *La Plissure du Texte* ('The Pleating of the Text'), created in 1983. LPDT2 does not attain its textual input from discrete individuals but from generative text which is being harvested from the online Gutenberg Project. Thus the project brings together the voices of many authors and epochs, pleated into a poetic waterfall of distributed authorship that is mapped both onto a three dimensional metaverse architecture as well as its (robotic avatar) inhabitants.

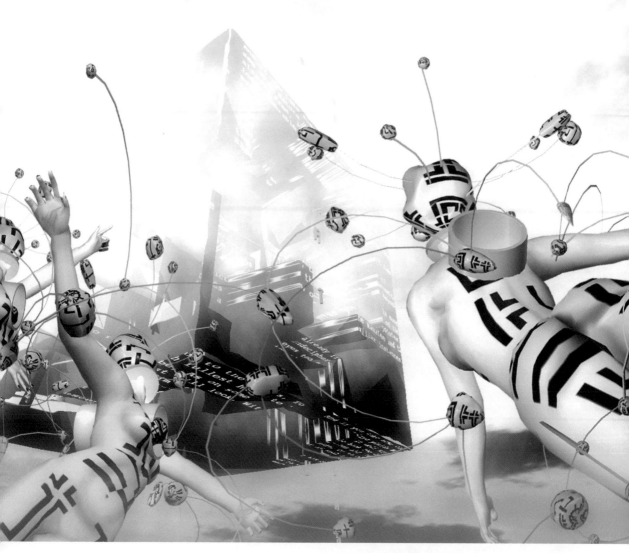

LPDT2, 2011, Roy Ascott, Elif Ayiter, Max Moswitzer, Selavy Oh. "The whisper plateau".

UNCONTAINABLE
Hyperstrata

ROY ASCOTT, ELİF AYİTER, MAX MOSWITZER, SELAVY OH

LPDT2, 2011, Roy Ascott, Elif Ayiter, Max Moswitzer, Selavy Oh. Installation photo from Kasa Gallery exhibition. (Photographic documentation by Elif Ayiter.)

 · ISSN 1071-4391 ISBN 978-1-906897-19-2

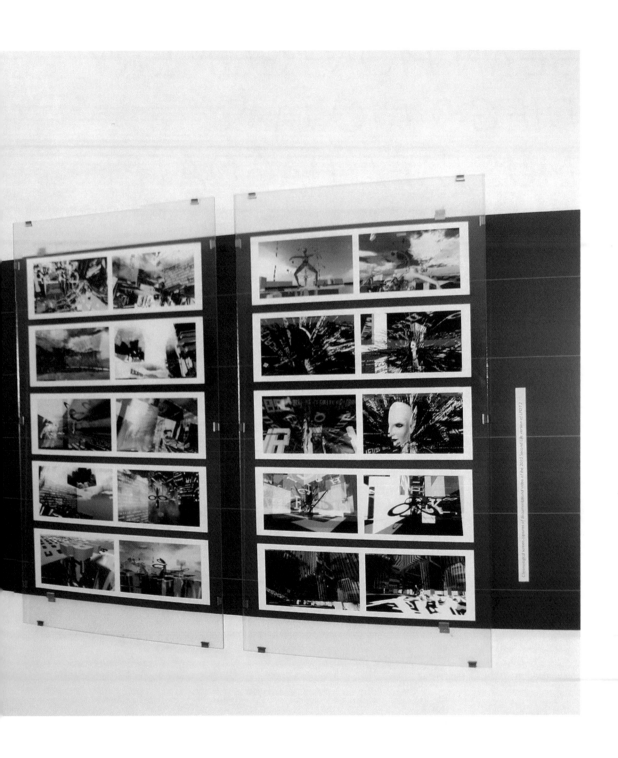

SEAN MONTGOMERY, DIEGO RIOJA & MUSTAFA BAĞDATLI

Emergence invites the viewer to think about what differentiates the electrical impulses of the internet from those impulses constantly traveling throughout the human body.

Sean Montgomery is a New York based artist, inventor and technology consultant. After completing his Ph.D. in neuroscience, he has been particularly interested in the emerging possibilities at the interface of technology and biology to create new forms of personal expression and interpersonal communication and looks forward to creating portals of opportunity at the intersection of art, science and technology.

Diego Rioja was born in Chile and moved to New York City where he obtained a master's degree at New York University's Interactive Telecommunications Program. He now works as an artist and interaction designer in New York City.

Mustafa Bağdatlı is a New York based interaction designer. Upon completing an undergraduate degree in industrial engineering, Mustafa went on to pursue a master's degree in interaction design at New York University's Interactive Telecommunications Program. His current areas of interest are physical interaction, exhibition/experience design, computer vision, multi-touch technologies, and data visualization.

Emergence, 2010,
Sean Montgomery,
Diego Rioja, Mustafa
Bağdatlı, wires cables
circuits connectors,
315 × 400 × 400cm.

ISSN 1071-4391 ISBN 978-1-906897-19-2

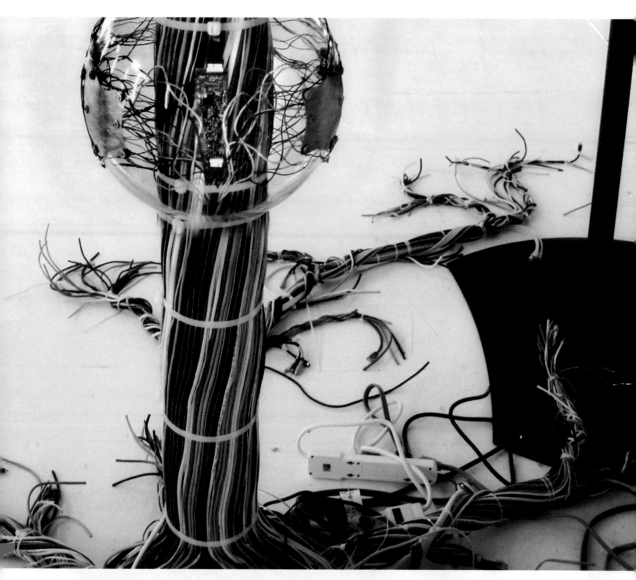

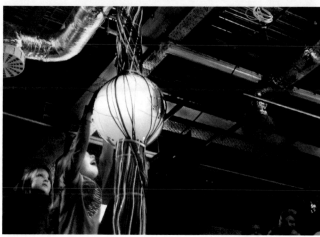

Emergence (detail).

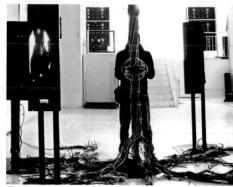

Emergence, 2010, Sean
Montgomery, Diego
Rioja, Mustafa Bağdatlı.

SEAN MONTGOMERY, DIEGO RIOJA & MUSTAFA BAĞDATLI

Emergence, 2010, Sean Montgomery, Diego Rioja, Mustafa Bağdatlı, wires cables circuits connectors, 315 × 400 × 400cm. (Photographic documentation by Berke Doğanoğlu.)

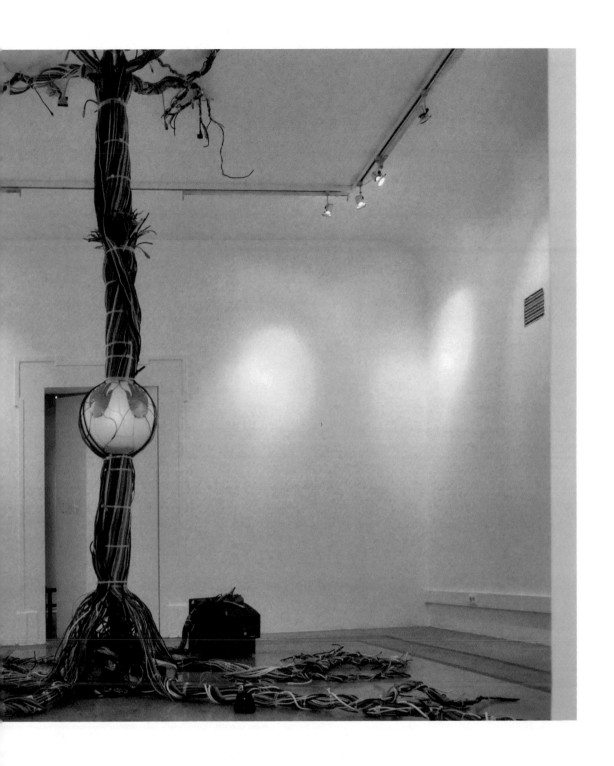

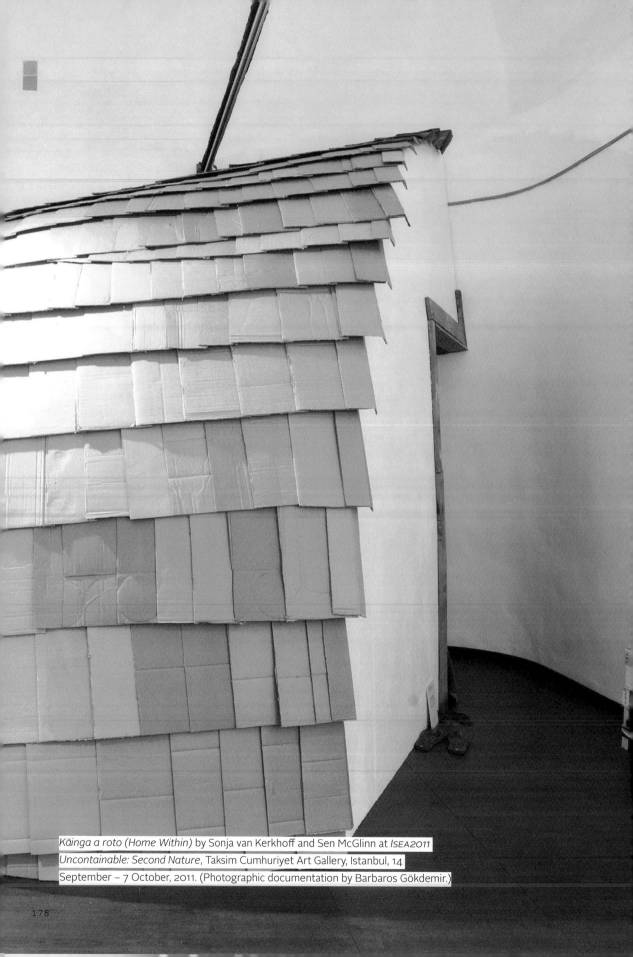

Kāinga a roto (Home Within) by Sonja van Kerkhoff and Sen McGlinn at *ISEA2011*
Uncontainable: Second Nature, Taksim Cumhuriyet Art Gallery, Istanbul, 14
September – 7 October, 2011. (Photographic documentation by Barbaros Gökdemir.)

ISEA2011
UNCONTAINABLE

SECOND NATURE
TE KORE RONGO HUNGAORA

TAKSİM CUMHURİYET SANAT GALERİSİ
14 EYLÜL–7 EKİM, 2011
ZİYARET SAATLERİ: 10:00–18:00

SANAT DİREKTÖRÜ/ARTISTIC DIRECTOR **LANFRANCO ACETI**
KÜRATÖR/CURATOR **IAN CLOTHIER**

SANATÇILAR/ARTISTS **SOPHIE JERRAM & DUGAL MCKINNON; SONJA VAN KERKHOFF & SEN MCGLINN; PAUL MOSS; JULIAN OLIVER; MICHAEL PAULIN; JULIAN PRIEST; RACHEL RAKENA; LISA REIHANA & JAMES PINKER; JO TITO; TE HUIRANGI WAIKEREPURU.**

SANAT DİREKTÖRÜ VE KONFERANS BAŞKANI /
ARTISTIC DIRECTOR AND CONFERENCE CHAIR
LANFRANCO ACETI

KONFERANS VE PROGRAM DİREKTÖRÜ /
CONFERENCE AND PROGRAM DIRECTOR
ÖZDEN ŞAHİN

UNCONTAINABLE
Second Nature

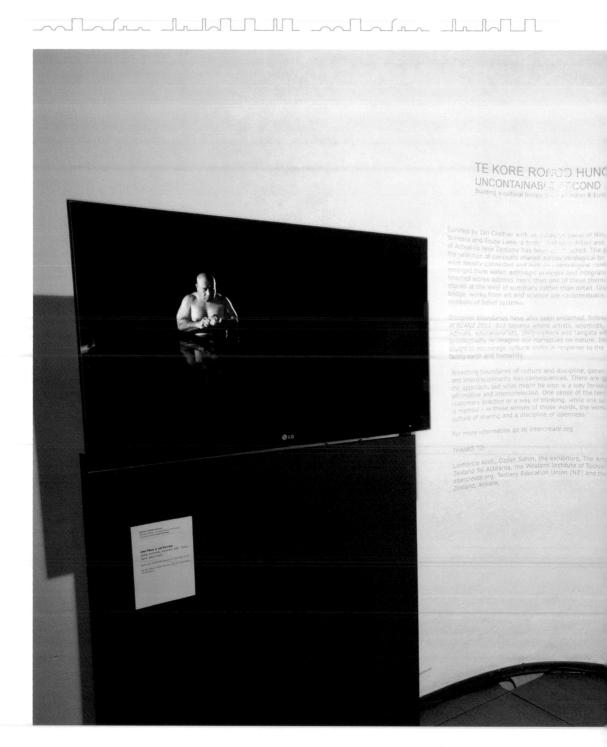

 ISSN 1071-4391 ISBN 978-1-906897-19-2

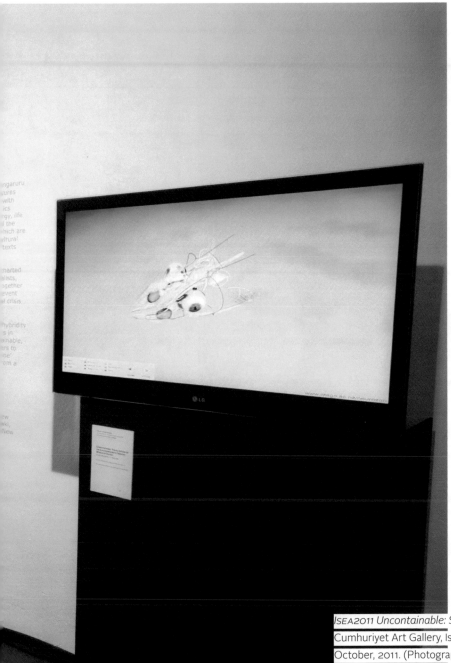

ISEA2011 Uncontainable: Second Nature, Taksim Cumhuriyet Art Gallery, Istanbul, 14 September – 7 October, 2011. (Photographic documentation by Barbaros Gökdemir.)

UNCONTAINABLE
Second Nature

Sen McGlinn setting up *Kāinga a roto (Home Within)*.
ISEA2011 Uncontainable: Second Nature, Taksim
Cumhuriyet Art Gallery, Istanbul, 14 September – 7
October, 2011. (Photographic documentation by
Barbaros Gökdemir.)

ISSN 1071-4391 ISBN 978-1-906897-19-2

ISEA2011 Uncontainable: Second Nature, Taksim Cumhuriyet Art Gallery, Istanbul, 14 September – 7 October, 2011. (Photographic documentation by Barbaros Gökdemir.)

ISEA2011
UNCONTAINABLE
SECOND NATURE
TE KORE RONGO HUNGAORA

KÜRATÖR/CURATOR **IAN CLOTHIER**

SANATÇILAR/ARTISTS **SOPHIE JERRAM & DUGAL MCKINNON; SONJA VAN KERKHOFF & SEN MCGLINN; PAUL MOSS; JULIAN OLIVER; MICHAEL PAULIN; JULIAN PRIEST; RACHEL RAKENA; LISA REIHANA & JAMES PINKER; JO TITO; TE HUIRANGI WAIKEREPURU.**

SANAT DİREKTÖRÜ VE KONFERANS BAŞKANI /
ARTISTIC DIRECTOR AND CONFERENCE CHAIR
LANFRANCO ACETI

KONFERANS VE PROGRAM DİREKTÖRÜ /
CONFERENCE AND PROGRAM DIRECTOR
ÖZDEN ŞAHİN

 ISSN 1071-4391 ISBN 978-1-906897-19-2

TR Ian Clothier'ın küratörlüğünü, Nina Czegledy, Trudy Lane ve Tengaruru Wineera'nın danışmanlığını yaptığı sergide kültürel ve disipliner sınırlar ihlal ediliyor. Māori ve Avrupa akıllarına dayalı bir çerçeve dahilinde kültürel bir köprü kuruluyor. Avrupa ve Māori dünya görüşlerinden beş tema mevcut: *kozmolojik bağlam, her şey enerjidir, hayat sudan çıkmıştır, antropik (insancı) ilke ve entegre sistemler.* Sergideki tüm eserler bu temalardan birkaçına ait.

EN Curated by Ian Clothier with an advisory panel of Nina Czegledy, Trudy Lane and Tengaruru Wineera, the exhibition crosses cultural and discipline boundaries. A cultural bridge has been constructed, based on a framework of both Māori and European knowledge. Five themes from within European and Māori world views were located: *cosmological context, all is energy, life emerged from water, anthropic principle and integrated systems.* All the selected works address more than one of these thematic regions.

SOPHIE JERRAM, DUGAL MCKINNON

We work from the Maori concept of Te Kore, the void of potential, as the moment before the universe began. The breath bridges the sacred and the everyday.

Sophie Jerram works in video, audio and through intervention, finds meaning in negotiating between the phatic and the prized. Jerram also works as a curator and is the co-director of the New Zealand programme *Letting Space*, which concerns the artistic occupation of commercial and commons sites and based in Wellington, NZ.

Dugal McKinnon is a composer of electronic, instrumental and multimedia work and a sound artist and a writer on contemporary music. He is the director of the Lilburn Electroacoustic Music Studios at the New Zealand School of Music (Wellington, NZ). Together Dugal and Sophie direct Now Future, an organisation founded in 2009 to foster interdisciplinary research and production at the intersection of art and ecology.

Te Kore, (Street of Breaths), 2011, Sophie Jerram and Dugal McKinnon, distributed audio (three locations).

ISSN 1071-4391 ISBN 978-1-906897-19-2

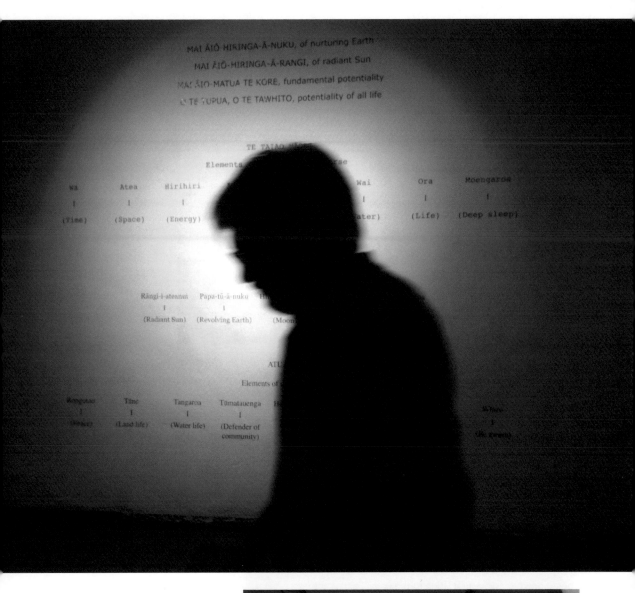

MAI ÄIÖ HIRINGA-Ä-NUKU, of nurturing Earth

MAI ÄIÖ-HIRINGA-Ä-RANGI, of radiant Sun

MAI ÄIÖ-MATUA TE KORE, fundamental potentiality

Ö TE UPUA, O TE TAWHITO, potentiality of all life

TE TAIAO

Elementa rse

Wa	Atea	Hirihiri			Wai	Ora	Moengaroa
I	I	I			I	I	I
(Time)	(Space)	(Energy)			ater)	(Life)	(Deep sleep)

Rāngi-i-ateanui	Papa-tū-ā-nuku	H
I	I	I
(Radiant Sun)	(Revolving Earth)	(Moon

ATU

Elements of

Rongotau	Tāne	Tangaroa	Tūmatauenga	H			Wha
I	I	I	I				I
(Peace)	(Land life)	(Water life)	(Defender of community)				(He green)

Te Kore, (Street of Breaths), 2011, Sophie Jerram and Dugal McKinnon. Installation at *ISEA2011 Uncontainable: Second Nature*, Taksim Cumhuriyet Art Gallery, Istanbul, 14 September - 7 October, 2011.

ISSN 1071-4391 ISBN 978-1-906897-19-2

SONJA VAN KERKHOFF, SEN MCGLINN

Kāinga a roto (Home Within) *consists of videos, soundscapes, music, spoken text, and a physical space. Each video is a system of allusions and symbols, relating the personal to the environmental, cultural and cosmic systems.*

Sonja van Kerkhoff (born 1960, Taranaki, Aotearoa/ New Zealand) and **Sen McGlinn** (born 1956, Christchurch, Aotearoa/New Zealand) have been based in the Netherlands since 1989. Their art projects are listed on www.sonjavank.com/sensonja . Sonja has a blog on art and media at www.sonjavank. wordpress.com and a listing of essays, reviews and papers at www.sonjavank.com/text. Sen's blog on postmodern theology in relation to the Bahai Faith is at senmcglinn.wordpress.com .

Kāinga a roto (Home Within), 2011, Sonja van Kerkhoff, Sen McGlinn. Cardboard and wood collected from the streets around Taksim Square and the Dolapdere gypsy area, 50 carpet mats, 5 stereo channel videos. The form reflected the curves of the Cumhuriyet gallery walls and ceilings. (Interior view.)

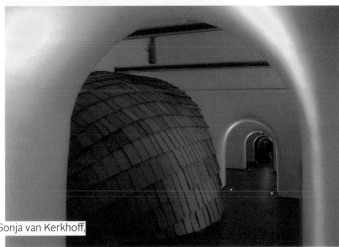

Kāinga a roto (Home Within), 2011, Sonja van Kerkhoff,
Sen McGlinn. (Exterior view.)

ISSN 1071-4391 ISBN 978-1-906897-19-2

SONJA VAN KERKHOFF, SEN MCGLINN

Kāinga a roto (Home Within), 2011, Sonja van Kerkhoff, Sen McGlinn. Interior view. The following video link http://youtu.be/XRSLvY-6qwE gives an overview of the process of collecting the materials from the street and the construction of the installation.

ISSN 1071-4391 ISBN 978-1-906897-19-2

ISSN 1071-4391 ISBN 978-1-906897-19-2

PAUL MOSS

> The beginning of time back to the cradle of civilisation, with humility and desire to inspire thinking about our relationships with nature, to create a framework to re-invent our views and behaviours with nature.

Paul Moss is a new media artist, specialising in astro-photography and astro-video for entertainment and illustrative purposes, for art gallery installations, for publication in newspaper and magazine articles, CD covers, posters, calendars/almanacs, and including publication in the NZ award winning book, *Astronomy Aotearoa*. Paul organises events with telescopes, live music, camera crews for documentaries and live video screens at festivals. Paul performs as VJ, DJ and dubmaster Moza. Paul was awarded a global gold medal by UNESCO and IAU for 'Most Outstanding Individual' - for record breaking astronomy events IYA2009.

The Milky Way – Te Māngōroa, 2008, Paul Moss.

Stonehenge, 2008, Paul Moss. Aotearoa,
New Zealand.

ISSN 1071-4391 ISBN 978-1-906897-19-2

PAUL MOSS

Clusters M6 Butterfly Cluster – NGC 6383 M7 Open
Cluster – NGC 6475, 2010, Paul Moss.

ISSN 1071-4391 ISBN 978-1-906897-19-2

ISSN 1071-4391 ISBN 978-1-906897-19-2

JULIAN OLIVER

> *The most transformative language today –shaping the way we move, make, communicate and think– is engineering. As a critical engineer, I study, expose and exploit this influence.*

Julian Oliver is a New Zealander and critical engineer based in Berlin. His projects and papers have been presented at many museums, international electronic art events and conferences, including the Tate Modern, transmediale, Ars Electronica and the Japan Media Arts Festival. His work has received several awards, the most notable being a Golden Nica at Ars Electronica 2011 for *Newstweek*, developed in collaboration with Danja Vasiliev.

Julian has given numerous workshops and master classes around the world in software art, augmented reality, creative hacking, data forensics and object-oriented programming for artists, virtual architects, artistic game developers and on information visualization, UNIX/Linux and open source development practices.

psworld – The Inward, 2011, Julian Oliver, Mini-ITX x86 computer, tripod, 400x microscope, custom software, GNU/Linux OS 160 × 90 × 90 cm.

psworld – The Inward, 2011, Julian Oliver, Mini-ITX x86 computer, tripod, 400x microscope, custom software, GNU/Linux OS 160 × 90 × 90 cm.

ISSN 1071-4391 ISBN 978-1-906897-19-2

psworld –The Inward (detail).

MIKE PAULIN

How the shark's electrosensory system evolved, from simple(r) to sophisticated creatures? Seems to me there's a story there, about art and science and storytelling as ways of seeing and navigating.

Mike Paulin is Associate Professor of Zoology at the University of Otago in New Zealand. He studies fundamental questions about brain function using computer models of early nervous system evolution, and models of nervous system function in animals as diverse as spiders, sharks and humans. **He takes a synthetic, rather than an analytic, approach to understanding brains and minds, by embedding brain models in virtual animals and robots, in simulated and real environments.

Computational Visualization of the Electromagnetic Sensory World of Sharks, 2008, Michael G. Paulin, computational physics simulation with 3D visualization. (Photographic documentation by Eser Aygün.)

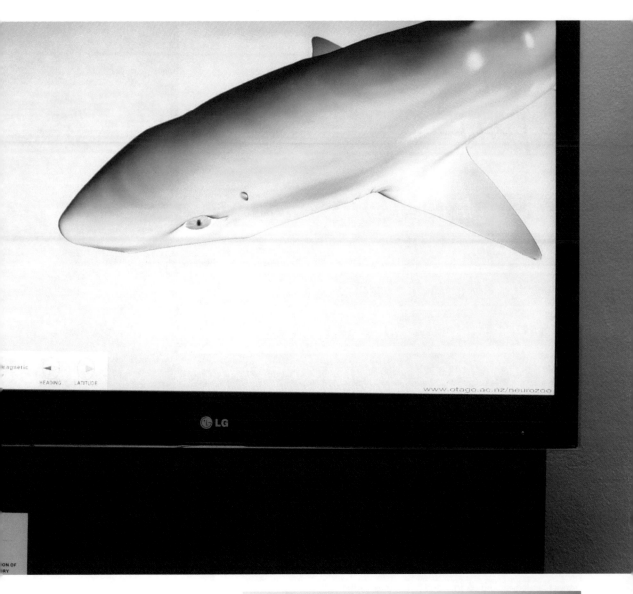

*Computational Visualization of the
Electromagnetic Sensory World of Sharks*,
2008, Michael G. Paulin, computational physics
simulation with 3D visualization.

ISSN 1071-4391 ISBN 978-1-906897-19-2

JULIAN PRIEST

> The Sun is the Earth's information service provider. The Earth is an open system that creates forests of life, culture and technology and exports entropy into the galactic gloaming.

Julian Priest is an artist and researcher. He was an early community wireless networker and became an activist and advocate for the freenetworking movement, exploring wireless networking as a theme in fields of arts, development, and policy.
He was co-founder of the consume project and one of the instigators of WSFII, the world summits on free information infrastructures, an international series of events to promote grass roots information infrastructures. He has commented on radio spectrum policy and co-founded policy intervention OpenSpectrum UK to advocate an open spectrum in the public interest, in Europe and the UK.

Since 2005 he has developed an artistic practice around participatory and collaborative forms. His current interests are themes around the physical and cultural boundaries between technology and the environment, and the connection between energy and information. He is based in Whanganui, New Zealand where he has a project room 'The Green Bench.' He is on the board of Aotearoa Digital Arts Trust and lectures in creative technologies with the Interdisciplinary unit at A.U.T. University in Auckland.

Information Comes From The Sun, 2011, Julian Priest, solar powered monitor, video animation, media player, photovoltaic cells. (Light sensitive animation and collection of Whanganui river objects and stories. 100% light.)

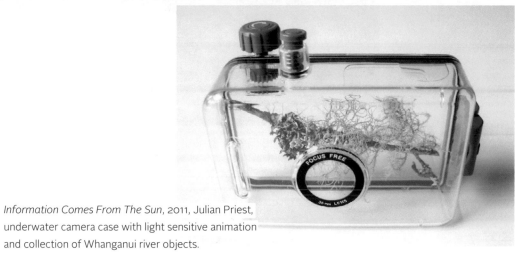

Information Comes From The Sun, 2011, Julian Priest,
underwater camera case with light sensitive animation
and collection of Whanganui river objects.
Kiri Rakau - The Skin.

JULIAN PRIEST

Information Comes From The Sun, 2011, Julian Priest,
underwater camera case with light sensitive animation
and collection of Whanganui river objects.
Kiri Rakau - The Skin. (Photographic documentation
by Eser Aygün.)

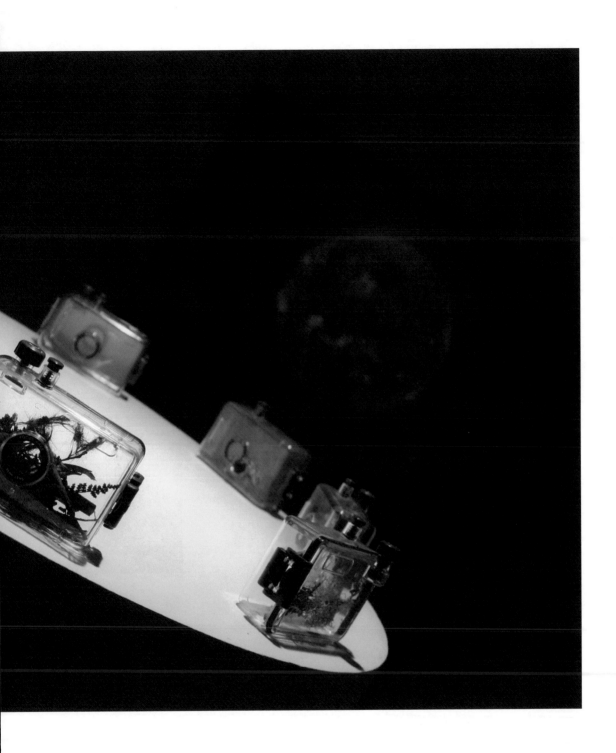

RACHAEL RAKENA

A solitary and self-contained male figure eats at the table of Tangaroa (the god of the sea) in a dark water world, which is at once sensuous and forbidding - evoking narratives of Narcissus, Maui and Hine nui Te Po.

Rachael Rakena was born in 1969 in Wellington, New Zealand, of Maori and European/Pakeha descent (Ngai Tahu, Nga Puhi). She has a Master of Fine Arts (Distinction) and is a lecturer at Massey University, School of Maori Visual Arts. In work that is both ethereal and political, she employs a new language and new tools derived from digital media and video to invoke a contemporary Maori identity that is timeless and fluid. She is a highly innovative artist who explores the application of contemporary technology to articulate timeless notions of Maori culture and identity that flow from the past, through the present and into the future. Rakena has been exhibiting widely for more than 10 years throughout New Zealand, Australia and Europe, and in the UK and USA. Rakena is a video artist who frequently collaborates. In 2007, *Aniwaniwa* a collaborative project with Brett Graham was included in the collateral events section of the 2007 Venice Biennial. Other major international exhibitions of recent years have included the Busan Biennial, 2008 and Sydney Biennial, 2006.

One Man is an Island, 2009, Rachael Rakena (Iwi - Ngai Tahu, Nga Puhi). High definition video, courtesy of Bartley and Company Art, Wellington.

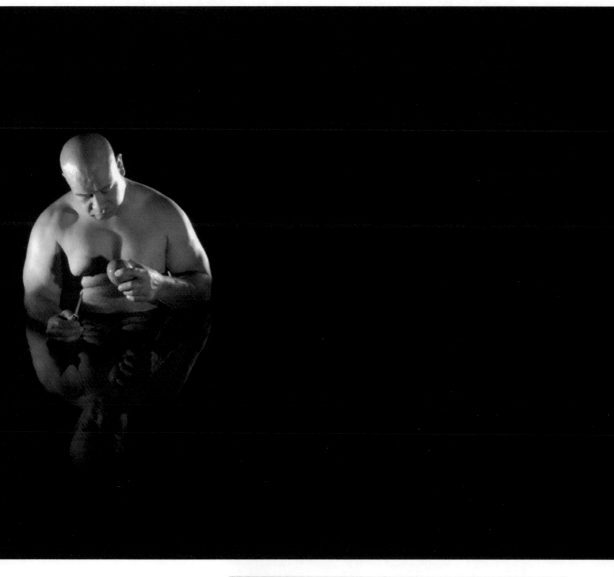

One Man is an Island, 2009, Rachael Rakena
(Iwi - Ngai Tahu, Nga Puhi).

LISA REIHANA, JAMES PINKER

Whanaunga [family] features the Maori demi-god Maui, he is the Trickster and Shapeshifter figure in Maori cosmology. Maui was believed to be still-born, and is cast into the ocean in his mother Taranga's topknot of hair.

Lisa Reihana is a Maori artist who has played a leading role in the development of film and multimedia art in Aotearoa New Zealand. Her works communicate complex ideas about indigenous identity and bi-cultural living, and are drawn from eclectic sources, including Maori mythology and contemporary culture. Reihana reinterprets important oral histories and customary lore, making them available to a collective Aotearoa New Zealand consciousness through their contemporary presentation.

James Pinker has worked for many years within the visual art world primarily as a sound artist but also as a photographer and videographer. Pinker is the Visual Arts Manager of Mangere Arts Centre Ngā Tohu o Uenuku which presents the work of Maori and Pacific artists. He is a member of Holiwater, a collaboration with Indian musical maestros Vikash and Prabash Maharaj from Varanasi, India, and Tom Bailey, UK.

MAUI Charles Koroneho
CAMERA James Pinker
MONTAGE Lisa Reihana
SOUNDTRACK James Pinker & Lisa Reihana

Whanaunga, 2011, Lisa Reihana (artist) and James Pinker (sound), digital video.

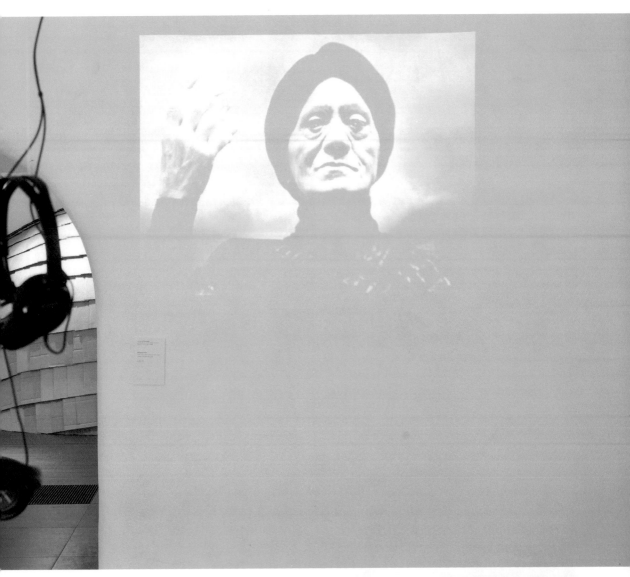

Whanaunga, 2011, Lisa Reihana (artist) and James Pinker (sound), digital video still.

ISSN 1071-4391 ISBN 978-1-906897-19-2

UNCONTAINABLE
Second Nature

JO TITO

A rock is shaped by water that flows from the mountain across the land and out to sea. It has many stories and carries the energy of the land from which it comes...

Jo Tito is a 37 year old creative entrepreneur and artist who is passionate about art and bringing about change in the world. An innate connection to the land and environment inspires her creativity and the stories she tells through her work. She has been a photographer for the past 16 years and is also a multimedia artist working in painting, sculpture and digital storytelling. She also has a background in health and education and has worked at the grass roots level of community using art as a tool for change. Connections and relationships are important to her and are at the heart of everything she does. Over the past 10 years, she has had the privilege of working with some of the most talented artists from around the world through overseas travel, exhibitions, festivals and gatherings.

Kohatu, 2011, Jo Tito, painted rock.

 ISSN 1071-4391 ISBN 978-1-906897-19-2

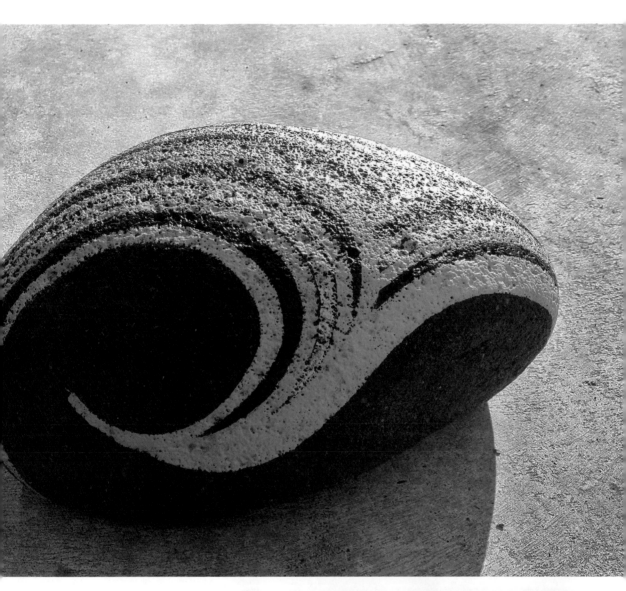

Kohatu (detail).

ISSN 1071-4391 ISBN 978-1-906897-19-2

JO TITO

Kohatu, 2011, Jo Tito, painted rock.

ISSN 1071-4391 ISBN 978-1-906897-19-2

TE HUIRANGI WAIKEREPURU

Te Taiao Maori *is a representation of Maori whakapapa (genealogy) and cosmology.*

Te Huirangi Waikerepuru a Taranaki kaumatua with a nationally significant record of contributions to the cultural life of Aotearoa including early work in developing Māori Television and ensuring a path for legislation of the Māori language to be held as a national taonga. He is Te Kāhui Kaumātua for the Tertiary Education Union Council, serves as a Guardian of Taranaki, fulfils the role of Cultural Advisor to WITT and is a prize winning author of childrens books in Te Reo Māori. He holds an Honorary Doctorate for his contribution to Māori submissions on the radio spectrum.

Te Taiao Maori (detail), 2011, Te Huirangi Waikerepuru. Vinyl text, 2500mm × 2000mm. (Photographic documentation by Eser Aygün.)

ISSN 1071-4391 ISBN 978-1-906897-19-2

MAI AIO-HIRINGA-Ā-RANGI, of radiant Sun
MAI ĀIO-MATUA TE KORE, fundamental potentiality
O TE TUPUA, O TE TAWHITO, potentiality of all life

TE TAIAO MĀORI

Elements of the Māori Universe

Wā	Atea	Hirihiri	Āwheko	Taketahi	Wai	Ora	Moeh
I	I	I	I	I	I	I	
Time)	(Space)	(Energy)	(Matter)	(Interaction)	(Water)	(Life)	(Deep

WHAKAPAPA

Genealogy

Rāngi-i-ateanui	Papa-tū-ā-nuku	Hina te marama	Whetū	Upokoroa
I	I	I	I	I
(Radiant Sun)	(Revolving Earth)	(Moon)	(Myriad Stars)	(Meteorites)

ATUA

Elements of natural law

TE KORE (POTENTIALITY)

MAI ĀIŌ-HIRINGA-Ā-NUKU, of nurturing Earth

MAI ĀIŌ- HIRINGA -Ā-RANGI, of radiant Sun

MAI ĀIŌ-MATUA TE KORE, fundamental potentiality

O TE TUPUA, O TE TAWHITO, potentiality of all life

Te Taiao Maori (detail).

TE HUIRANGI WAIKEREPURU

Te Taiao Maori, 2011, Te Huirangi Waikerepuru.
(Photographic documentation by Korhan Karaoysal.)

ISSN 1071-4391 ISBN 978-1-906897-19-2

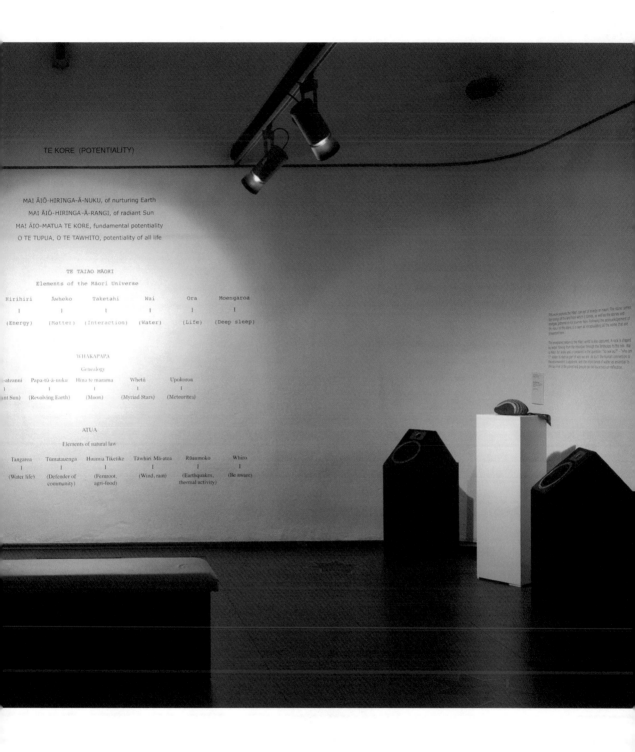

TE KORE (POTENTIALITY)

MAI ĀIŌ-HIRINGA-Ā-NUKU, of nurturing Earth
MAI ĀIŌ-HIRINGA-Ā-RANGI, of radiant Sun
MAI ĀIO-MATUA TE KORE, fundamental potentiality
O TE TUPUA, O TE TAWHITO, potentiality of all life

TE TAIAO MĀORI
Elements of the Māori Universe

Hirihiri	Āwheko	Taketahi	Wai	Ora	Moengaroa
(Energy)	(Matter)	(Interaction)	(Water)	(Life)	(Deep sleep)

WHAKAPAPA
Genealogy

-ateanui	Papa-tū-ā-nuku	Hina te marama	Whetū	Upokoroa
ant Sun)	(Revolving Earth)	(Moon)	(Myriad Stars)	(Meteorites)

ATUA
Elements of natural law

Tangaroa	Tūmatauenga	Haumia Tiketike	Tāwhiri Mā-atea	Rūaumoko	Whiro
(Water life)	(Defender of community)	(Fernroot, agri-food)	(Wind, rain)	(Earthquakes, thermal activity)	(Be aware)

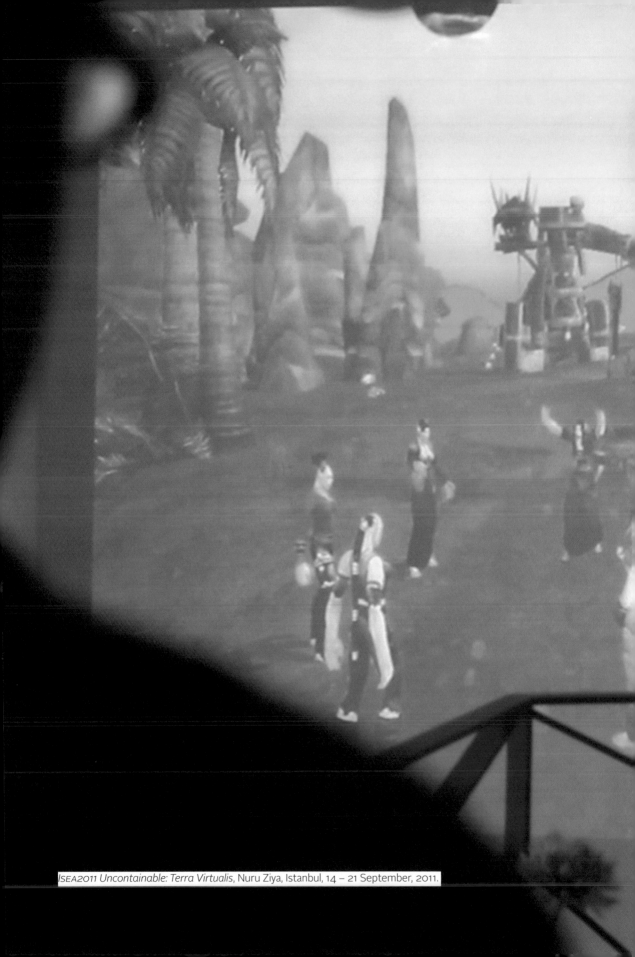

ISEA2011 Uncontainable: Terra Virtualis, Nuru Ziya, Istanbul, 14 – 21 September, 2011.

ISEA2011
UNCONTAINABLE

TERRA VIRTUALIS

NURU ZİYA
14–21 EYLÜL, 2011

SANAT DİREKTÖRÜ/ARTISTIC DIRECTOR **LANFRANCO ACETI**
KÜRATÖR/CURATOR **THE AUSTRALIAN CENTRE OF
VIRTUAL ART**

SANATÇILAR/ARTISTS **WARREN ARMSTRONG & ANDREW
BURRELL; CHAMPAGNE VALENTINE (ANITA FONTAINE &
GEOFFREY LILLEMON); AROHA GROVES; TROY INNOCENT
& INNAE HWANG.**

SANAT DİREKTÖRÜ VE KONFERANS BAŞKANI /
ARTISTIC DIRECTOR AND CONFERENCE CHAIR
LANFRANCO ACETI

KONFERANS VE PROGRAM DİREKTÖRÜ /
CONFERENCE AND PROGRAM DIRECTOR
ÖZDEN ŞAHİN

ACVA

ISSN 1071-4391 ISBN 978-1-906897-19-2

UNCONTAINABLE
Terra Virtualis

 ISSN 1071-4391 ISBN 978-1-906897-19-2

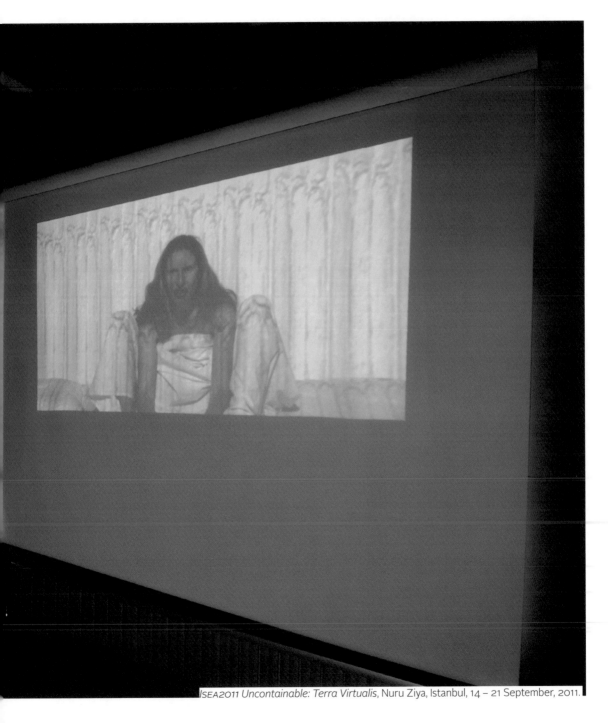

ISEA2011 Uncontainable: Terra Virtualis, Nuru Ziya, Istanbul, 14 – 21 September, 2011.

ISSN 1071-4391 ISBN 978-1-906897-19-2

UNCONTAINABLE
Terra Virtualis

ISEA2011 Uncontainable: Terra Virtualis, Nuru Ziya, Istanbul, 14 – 21 September, 2011.

 ISSN 1071-4391 ISBN 978-1-906897-19-2

ISEA2011 Uncontainable: Terra Virtualis, Nuru Ziya,
Istanbul, 14 – 21 September, 2011.

ISSN 1071-4391 ISBN 978-1-906897-19-2

ISEA2011
UNCONTAINABLE
TERRA VIRTUALIS

KÜRATÖR/CURATOR **THE AUSTRALIAN CENTRE OF VIRTUAL ART**

SANATÇILAR/ARTISTS **WARREN ARMSTRONG & ANDREW BURRELL; CHAMPAGNE VALENTINE (ANITA FONTAINE & GEOFFREY LILLEMON); AROHA GROVES; TROY INNOCENT & INNAE HWANG.**

SANAT DİREKTÖRÜ VE KONFERANS BAŞKANI / ARTISTIC DIRECTOR AND CONFERENCE CHAIR **LANFRANCO ACETI**

KONFERANS VE PROGRAM DİREKTÖRÜ / CONFERENCE AND PROGRAM DIRECTOR **ÖZDEN ŞAHİN**

ISSN 1071-4391 ISBN 978-1-906897-19-2

TR *Terra Virtualis*, anıştırdığı "Terra Australis" kelimelerinin yanısıra, Avustralya'nın dünyanın geri kalanı ile ilişkisi üzerinden kendi geçmiş ve geleceğine de dair imalarda bulunuyor. Sanal sanat, gerçekliğe yeni potansiyeller sunup gerçekliği yeniden konumlandırarak yeni açılımların kapısını zorluyor. Günümüzün zamanı sanal zaman; ve sadece sanal sanat sanal zamanların getirdiklerine meydan okuyabilir.

EN *Terra Virtualis* brings together several allusions: both the past and future of Australia in relation to the rest of the world, and the notion of exploration that the linguistic pun "Terra Australis" implies. Virtual art locates and presents new points of potential, and forces new openings into actuality. The time of the contemporary is virtual time, and only virtual art can meet the challenges of our virtual times.

WARREN ARMSTRONG & ANDREW BURRELL

'The Institute For Advanced Augmentiform Development and Release' *consists of virtual and augmented realities that are dynamically linked through live interactions and data exchange.*

Warren Armstrong is a new media artist whose practice explores web-based art, sonification and augmented reality. His most recent works include the *Information Virus* (2010), a 3D augmented reality work that was exhibited as part of the Bushwick Augmented Reality Intervention 2010 in Brooklyn New York; and the *Twitterphonicon/Twitter Hymn Book* (2010), an installation that converts Twitter updates into music. This latter work was exhibited as part of the New Interfaces in Musical Expression conference in Sydney, and was a finalist in the 2010 Blake Prize for Religious Art.

Andrew Burrell is a Sydney-based artist working in real time 3D and interactive audio installation. His areas of interest include the construction of self with regard to the interrelationship of personal identity with memory and imagination, and the way in which networked virtual spaces influence these interactions.

 ISSN 1071-4391 ISBN 978-1-906897-19-2

*The Institute For Advanced Augmentiform
Development and Release*, 2011, Warren Armstrong
and Andrew Burrell, Multi User Virtual Environment
and Augmented Reality Application.

ANITA FONTAINE & GEOFFREY LILLEMON A.K.A. CHAMPAGNE VALENTINE

A picture of a future in subdued chaos and explosive color; weaving 3D and videogame graphics, photography, film, sound, sculpture – abusing contemporary culture's literacy of highly hybridised media communication.

Anita Fontaine and Geoffrey Lillemon a.k.a. Champagne Valentine have changed the art and advertising cosmos with their provocative and decadent creations. A fantastical entity, they shapeshift between commercial, fashion and luxurious realms while remaining attuned to ethical and contemporary art trends. **Visionaries Geoffrey Lillemon and Anita Fontaine lead an agency of roguish superstars whose MO is to embed engaging layers of beauty inside reality.** At the forefront of emerging interactive technologies their aesthetically timeless work can also be seen in commercials, print, animation, and in museums and royal gardens. They have also been known participants of some out-of-control champagne dinner parties. Delicious. Their adored clientele includes the likes of Diesel, Tate Modern, Edun, Bernhard Willhelm, (RED), Tim Burton and Vh1. Champagne Valentine's headquarters are situated in the enchanting village of Amsterdam.

Rainbow × Apocalypse, (2011) Anita Fontaine and Geoffrey Lillemon a.k.a. Champagne Valentine. Still from short animated film.

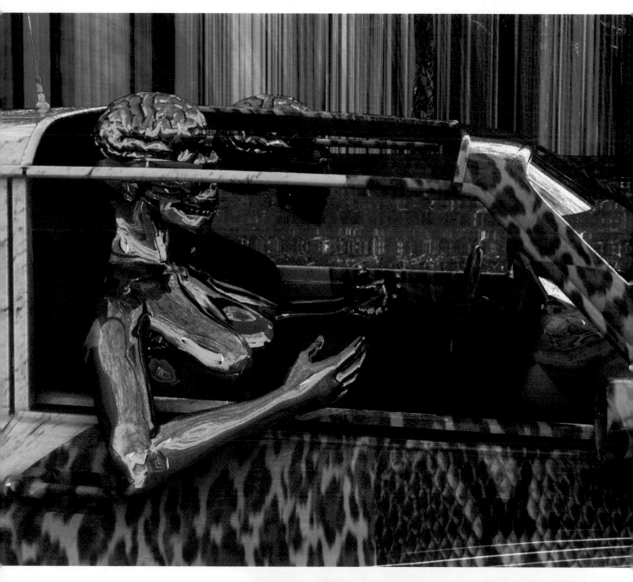

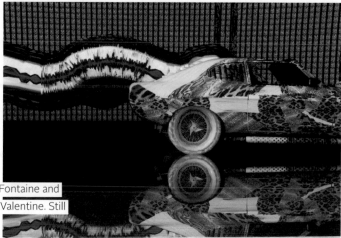

Rainbow × Apocalypse, (2011) Anita Fontaine and
Geoffrey Lillemon a.k.a. Champagne Valentine. Still
from short animated film.

ISSN 1071-4391 ISBN 978-1-906897-19-2

ANITA FONTAINE & GEOFFREY LILLEMON A.K.A. CHAMPAGNE VALENTINE

Rainbow × Apocalypse, (2011) Anita Fontaine and
Geoffrey Lillemon a.k.a. Champagne Valentine.

ISSN 1071-4391 ISBN 978-1-906897-19-2

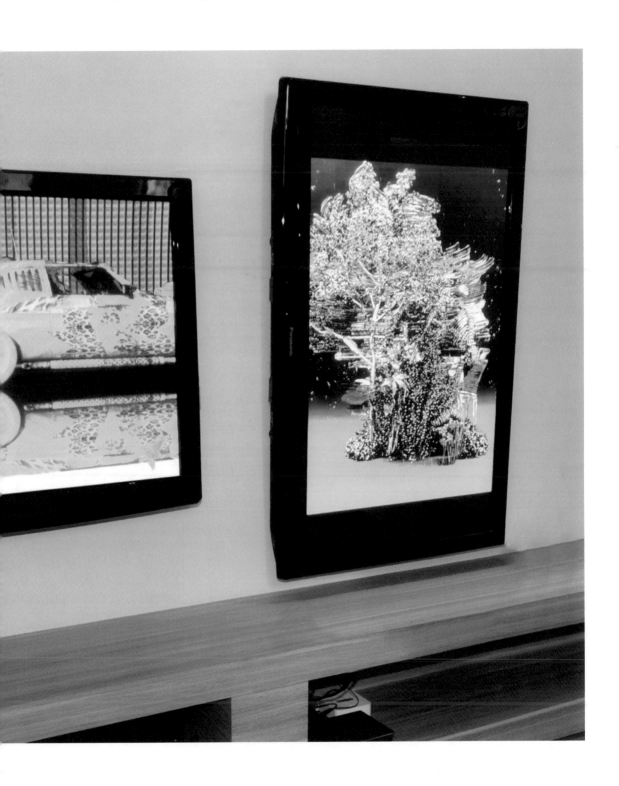

AROHA GROVES

"Meandering" intends to 'meander' through varying ideas, emotions, environs, levels and forms of consciousness, and styles, to take the viewer on a journey of the soul.

Aroha Groves is Aboriginal Australian (Weilwan & Gomeroi, Weridjerong & Gamillaraay language groups) self taught virtual artist branching into other digital art practices. Aroha's work is produced using multi-user virtual environments, such as Second Life. Her virtual, or post-convergent arts involve exciting media such as gaming engines, allowing for a more intense sensory experience for the user. She is currently living on the south coast of New South Wales.

Budding, 2011, Aroha Groves. An image from the Second Life work as shown at the Australian Centre of Virtual Art's sim.

Budding, 2011, Aroha Groves. Showing the seeds from the Second Life work as shown at the Australian Centre of Virtual Art's sim.

ISSN 1071-4391 ISBN 978-1-906897-19-2

AROHA GROVES

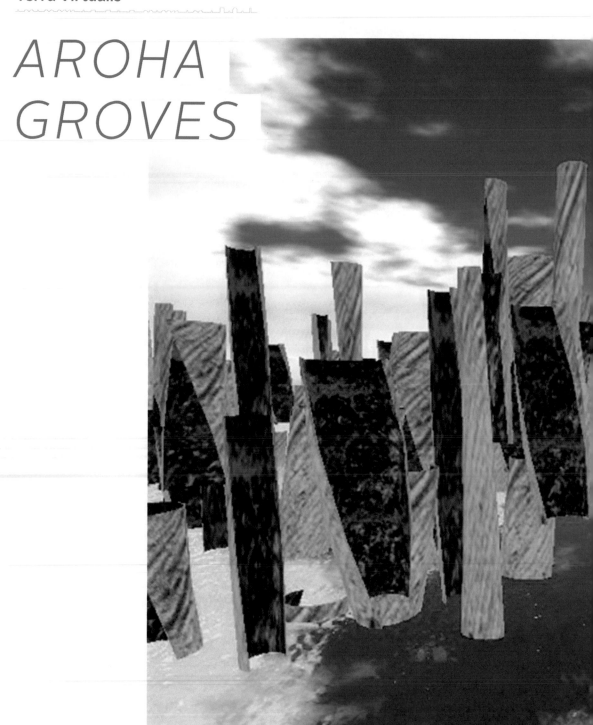

Meandering – Canoe Tree, 2011, Aroha Groves. An image from the Second Life work as shown at the Australian Centre of Virtual Art's sim.

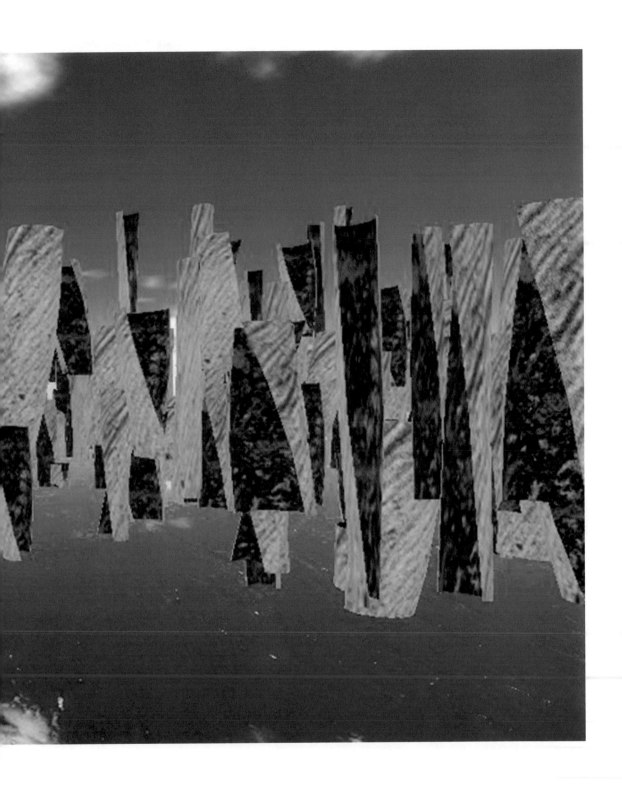

ISSN 1071-4391 ISBN 978-1-906897-19-2

TROY INNOCENT
& INDAE HWANG

noemaflux describes an act of shifting perception. This work it is centered on augmented reality that enables different ways of seeing the city. The experience is constructed via a network of relationships.

Dr Troy Innocent is a world builder, iconographer and reality newbie. His artificial worlds – *Iconica* (SIGGRAPH 98, USA), and *Semiomorph* (ISEA02, Japan) – explore the dynamics between the iconic ideal and the personal specific, the real and the simulated, and the way in which our identity is shaped by language and communication.

Troy Innocent has received numerous awards, including Honorary Mention, LIFE 2.0: Artificial Life, Spain (1999); Foreign Title Award, MMCA Multimedia Grand Prix, Japan (1998); First Prize, National Digital Art Awards, Australia (1995); and Honorary Mention, Prix Ars Electronica (1992). *lifeSigns: an eco-system of signs & symbols* (2004), was commissioned by the Australian Centre for the Moving Image and Film Victoria. His most recent work is an urban art environment entitled *Colony within Digital Harbour at the Docklands*, Melbourne. Innocent is currently Senior Lecturer in Games and Interactivity, Faculty of Life and Social Sciences, Swinburne University, Melbourne. Innocent is represented by Tolarno Galleries and Hugo Michell Gallery.

noemafllux, 2010, Troy Innocent & Indae Hwang, urban art environment, dimensions variable.

noemaflux, 2010, Troy Innocent & Indae Hwang, urban
art environment, dimensions variable.

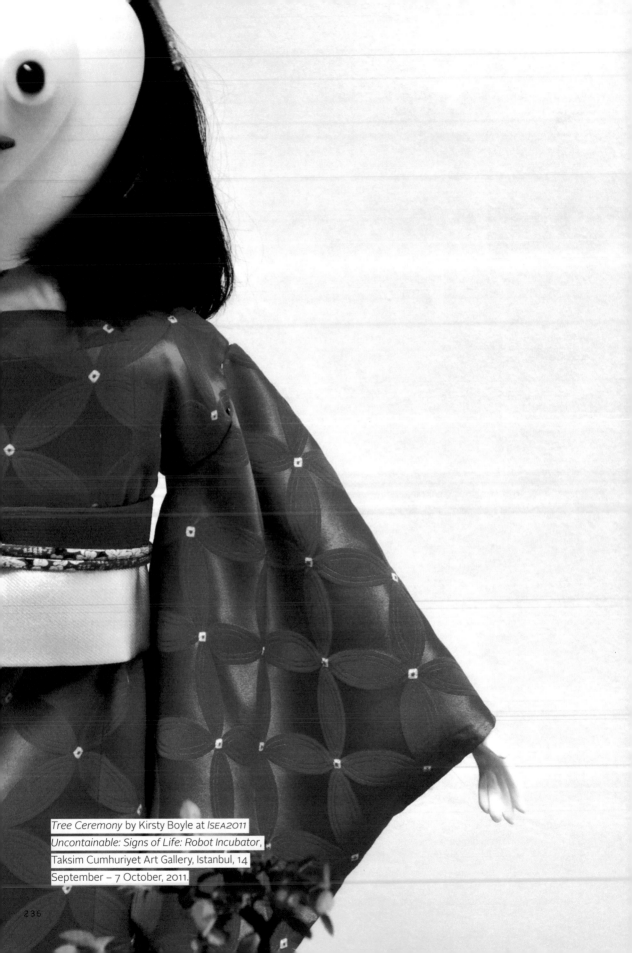

Tree Ceremony by Kirsty Boyle at *ISEA2011*
Uncontainable: Signs of Life: Robot Incubator,
Taksim Cumhuriyet Art Gallery, Istanbul, 14
September – 7 October, 2011.

ISEA2011
UNCONTAINABLE

SIGNS OF LIFE: ROBOT INCUBATOR

TAKSİM CUMHURİYET SANAT GALERİSİ
14 EYLÜL–7 EKİM, 2011
ZİYARET SAATLERİ: 10:00–18:00

SANAT DİREKTÖRÜ/ARTISTIC DIRECTOR **LANFRANCO ACETI**
KÜRATÖR/CURATOR **KATHY CLELAND**

SANATÇILAR/ARTISTS **KIRSTY BOYLE; JOHN TONKIN; MARI VELONAKI.**

SANAT DİREKTÖRÜ VE KONFERANS BAŞKANI /
ARTISTIC DIRECTOR AND CONFERENCE CHAIR
LANFRANCO ACETI

KONFERANS VE PROGRAM DİREKTÖRÜ /
CONFERENCE AND PROGRAM DIRECTOR
ÖZDEN ŞAHİN

ISSN 1071-4391 ISBN 978-1-906897-19-2

UNCONTAINABLE
Signs of Life: Robot Incubator

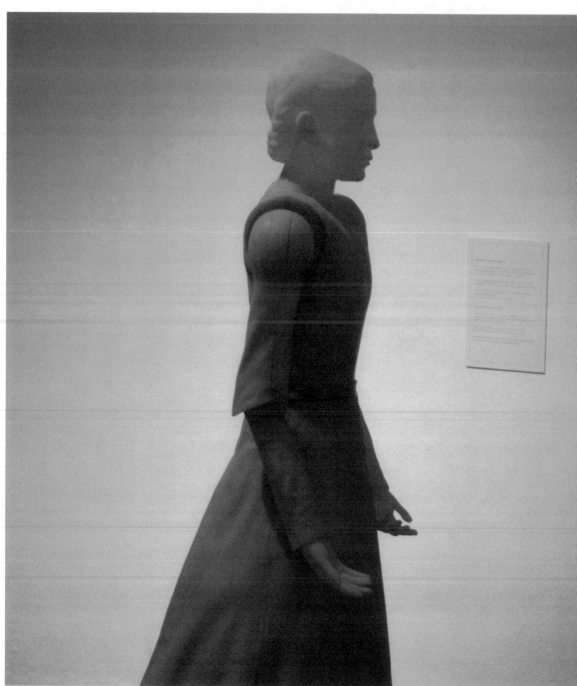

 ISSN 1071-4391 ISBN 978-1-906897-19-2

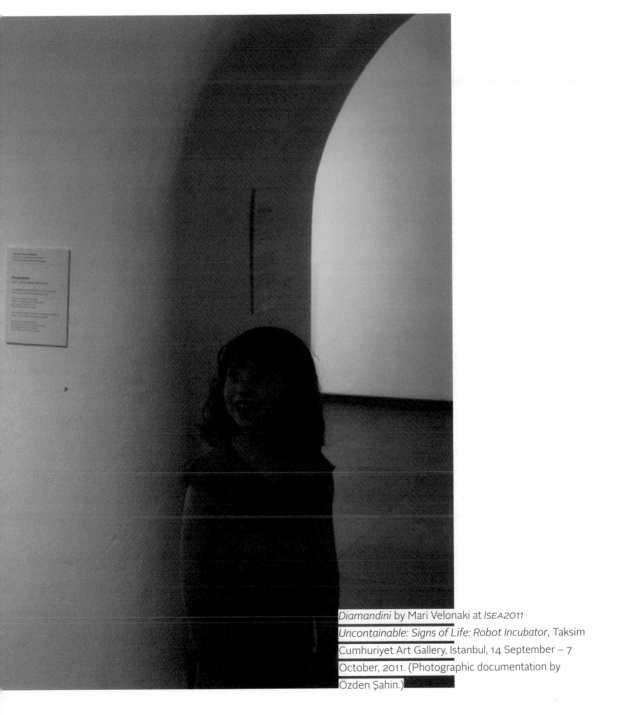

Diamandini by Mari Velonaki at *ISEA2011*
Uncontainable: Signs of Life: Robot Incubator, Taksim
Cumhuriyet Art Gallery, Istanbul, 14 September – 7
October, 2011. (Photographic documentation by
Özden Şahin.)

UNCONTAINABLE
Signs of Life: Robot Incubator

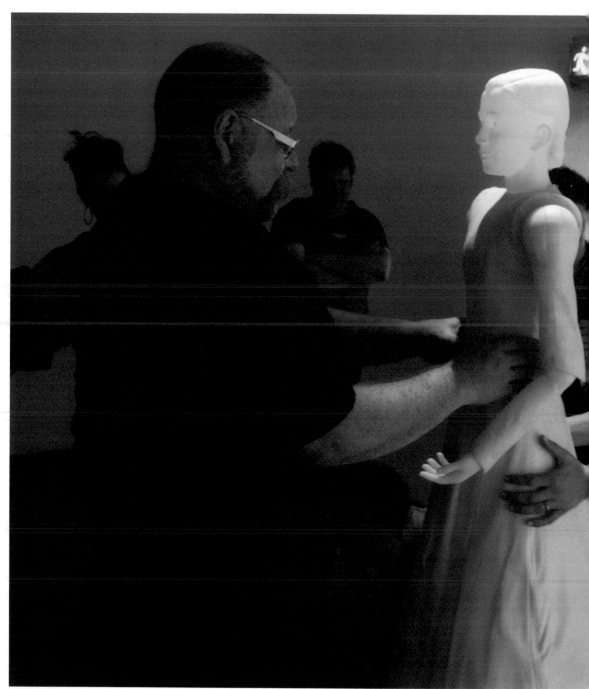

 ISSN 1071-4391 ISBN 978-1-906897-19-2

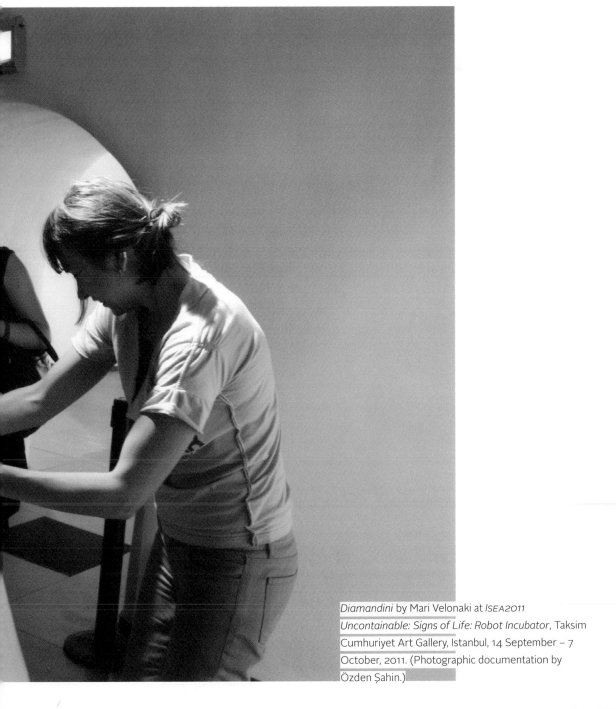

Diamandini by Mari Velonaki at *ISEA2011*
Uncontainable: Signs of Life: Robot Incubator, Taksim
Cumhuriyet Art Gallery, Istanbul, 14 September – 7
October, 2011. (Photographic documentation by
Özden Şahin.)

ISSN 1071-4391 ISBN 978-1-906897-19-2

ISEA2011
UNCONTAINABLE
SIGNS OF LIFE: ROBOT INCUBATOR

KÜRATÖR/CURATOR **KATHY CLELAND**

SANATÇILAR/ARTISTS **KIRSTY BOYLE; JOHN TONKIN; MARI VELONAKI.**

SANAT DİREKTÖRÜ VE KONFERANS BAŞKANI /
ARTISTIC DIRECTOR AND CONFERENCE CHAIR
LANFRANCO ACETI

KONFERANS VE PROGRAM DİREKTÖRÜ /
CONFERENCE AND PROGRAM DIRECTOR
ÖZDEN ŞAHİN

ISSN 1071-4391 ISBN 978-1-906897-19-2

TR Robotlar biyolojik olarak doğmazlar. Robotlar tasarlanır, monte edilir, programlanır ve gelişip çeşitli versiyonlar ve tekrarlamalarla büyürken insan ebeveynleri tarafından kuluçkaya yatırılır. Sanatçılar mekanikten insansıya doğru evrilen, geniş bir robot nesli sergiliyor. Görünüşleri birbirinden çok farklı olsa da robotların hepsi tüm yaşam göstergelerine, ve davranış ve hareketleri aracılığıyla gösterdikleri kişiliklere sahipler.

EN Robots aren't born biologically. They are designed, built, programmed and incubated by their human parents as they develop and grow through different versions and iterations. The artists in this exhibition show a diverse range of evolving robotic progeny from the machinic to the humanoid. Although very different in their appearance, these robots all display emergent signs of life and personality through their behaviour and movement.

KIRSTY BOYLE

Handcrafted in a range of different materials; robots represent an awareness of the relationship between the material, the ecological and the spiritual.

Kirsty Boyle is an Australian artist whose passion for robots has driven her to travel the world in order to work with other like-minded artist and scientists. Her practice is truly interdisciplinary, encompassing skills in sculpture, theatrical performance, film and animation, digital arts and design, mechanical and electrical engineering and artificial intelligence.

During 2002, Kirsty began study under Mr. Tamaya Shobei, a ninth generation Karakuri Ningyo craftsman and last remaining mechanical doll master in Japan. She is currently his only student, and the only woman to have ever been trained in the tradition. Therefore, she is now considered one of the world's foremost authorities on Karakuri.

She has been based in Zurich for the past three years, completing an artist residency at the AI Lab, University of Zurich and is an active member of SGMK (Swiss Mechatronic Art Society). In 2010 she produced *Tree Ceremony*, commissioned by the Museum Tinguely and Kunsthaus Graz for the Robot Dreams exhibition, touring 2010 – 2011.

Tree Ceremony, 2010, Kirsty Boyle, installation of multiple parts: robot (electronics, linden wood, vintage textiles, buffalo hair), bonsai tree, tatami mat, active loud speakers variable dimensions.

ISSN 1071-4391 ISBN 978-1-906897-19-2

Fragment, 2010, Kirsty Boyle, modular robot (electronics, cardboard) variable dimensions.

ISSN 1071-4391 ISBN 978-1-906897-19-2

KIRSTY BOYLE

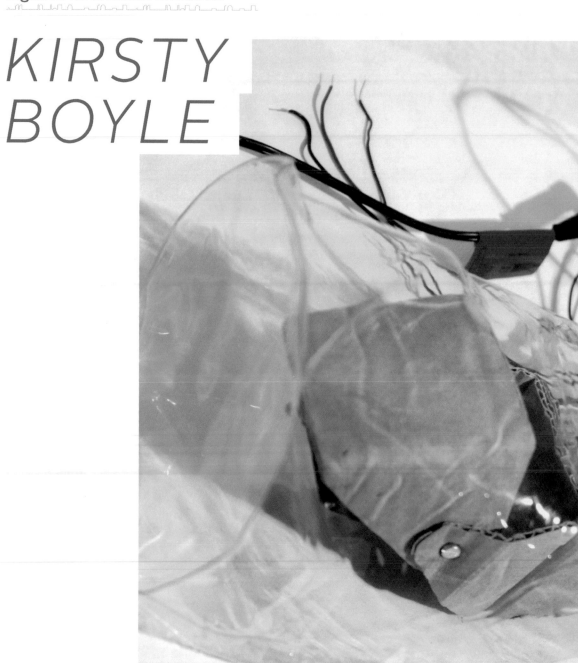

Fragment, 2010, Kirsty Boyle, modular robot
(electronics, cardboard) variable dimensions.
(Photographic documentation by Eser Aygün.)

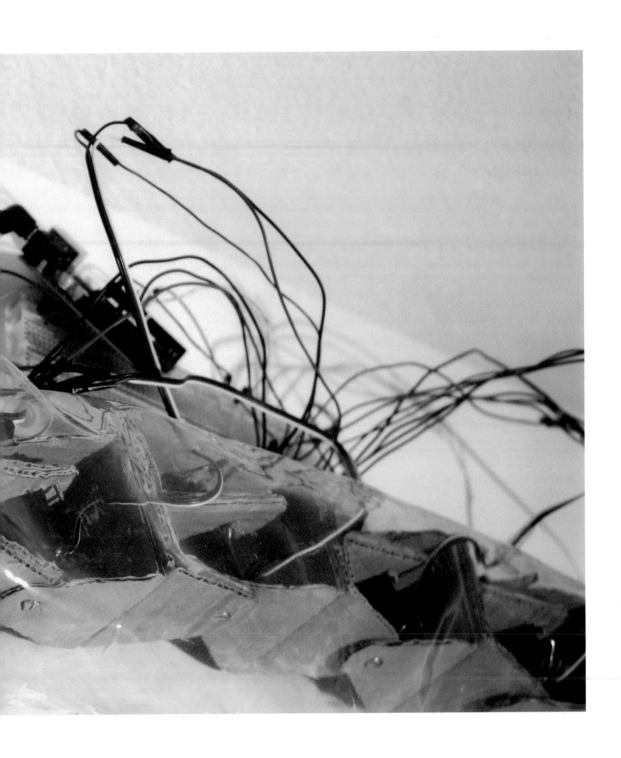

ISSN 1071-4391 ISBN 978-1-906897-19-2

JOHN TONKIN

These dysfunctional robots explore how cybernetics has been used to construct computational models of mental processes; using feedback loops and homeostatic control systems to describe the (mis)workings of the mind.

John Tonkin is a Sydney based media artist who has been working with new media since 1985. In 1999-2000 he received a fellowship from the Australia Council's New Media Arts Board. His work explores interactivity as a site for physical and mental play. Recent projects have used real-time 3D animation, visualisation and data-mapping technologies and custom built and programmed electronics. His works have often involved building frameworks/tools/toys within which the artwork is formed through the accumulated interactions of its users.

John lectures within the Digital Cultures Program, at the University of Sydney and is undertaking a practice based PhD in the School of Media Arts at COFA, UNSW. His current research is around cybernetics, embodied cognition and situated perception. He is building a number of nervous robots that embody computational models of mind and responsive video environments that explore situated models of perception.

nervous robots, 2011, John Tonkin, custom electronics/software.

ISSN 1071-4391 ISBN 978-1-906897-19-2

nervous robots (detail).

JOHN TONKIN

nervous robots, 2011, John Tonkin, custom electronics/software. (Photographic documentation by Ender Erkek.)

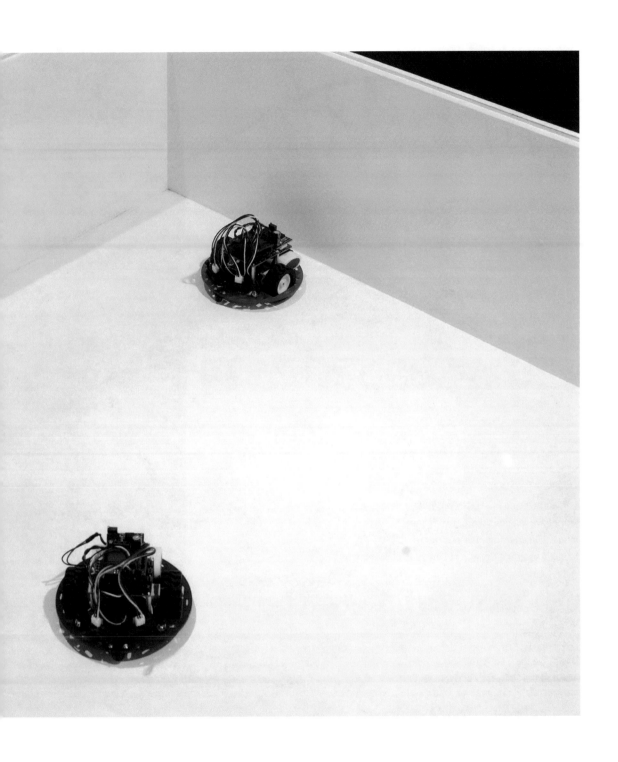

ISSN 1071-4391 ISBN 978-1-906897-19-2

MARI VELONAKI

> Diamandini *is an autokinetic interactive sculpture which progresses through different stages, exploring if intimacy between a human and a robot is possible and acceptable.*

Mari Velonaki is an artist and researcher who has worked in the field of interactive installation art since 1995. Her practice engages participants with digital and robotic "characters" in interplays stimulated by sensory triggered interfaces. Her human-machine interfaces promote intimate and immersive relationships between participants and interactive artworks. She was awarded a PhD in Media Arts at the College of Fine Arts, University of New South Wales in 2003.

Since 2003, Mari has been working as a senior researcher at the Australian Centre for Field Robotics (ACFR). In 2006 she co-founded with David Rye the Centre for Social Robotics within ACFR at the University of Sydney. In 2007 Mari was awarded an Australia Council for the Arts Visual Arts Fellowship in recognition of her work. In 2009 she was awarded a prestigious Australian Research Council Queen Elizabeth II Fellowship (2009–2013) for the creation of a new robot. This research investigates human-robot interactions in order to understand the physicality that is possible and acceptable between a human and a robot. Mari's installations have been exhibited in museums and festivals worldwide.

Diamandini (detail), 2011, Mari Velonaki, interactive robotic installation, dimensions variable. (Photographic documentation by Özden Şahin.)

ORIGINAL CONCEPT & ARTIST/INTERFACE DESIGN
Mari Velonaki
ROBOTIC SYSTEMS DESIGN David Rye
MECHANICAL AND ELECTRONIC DESIGN Mark Calleija
LEAD PROGRAMER Cedric Wohlleber
MECHANICAL FABRICATION Bruce Crundwell

ISSN 1071-4391 ISBN 978-1-906897-19-2

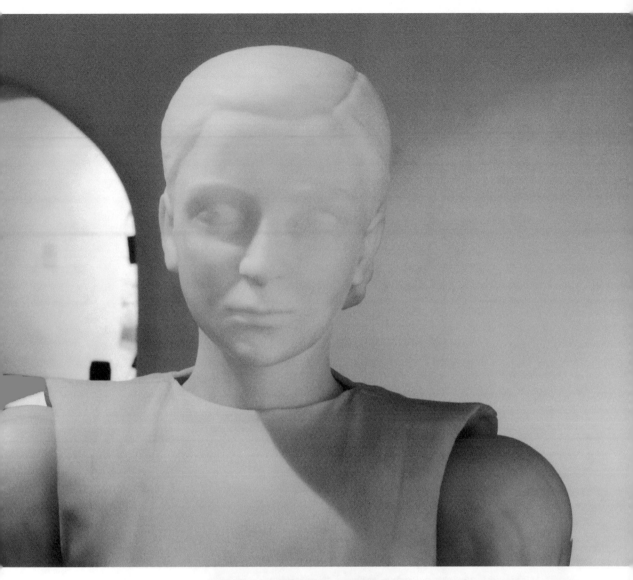

Diamandini, 2011, Mari Velonaki, interactive robotic installation, dimensions variable.

ISSN 1071-4391 ISBN 978-1-906897-19-2

MARI VELONAKI

Birth of *Diamandini* in Istanbul, 2011, Mari Velonaki, interactive robotic installation. *Diamandini : Robot Prototype*'s shell was constructed for the first time for ISEA2011 Istanbul and put together with her multi-directional motion base by David Rye. Mari Velonaki, David Rye, Kirke Godfrey and Mark Calleija (from left to right). (Photographic documentation by Özden Şahin.)

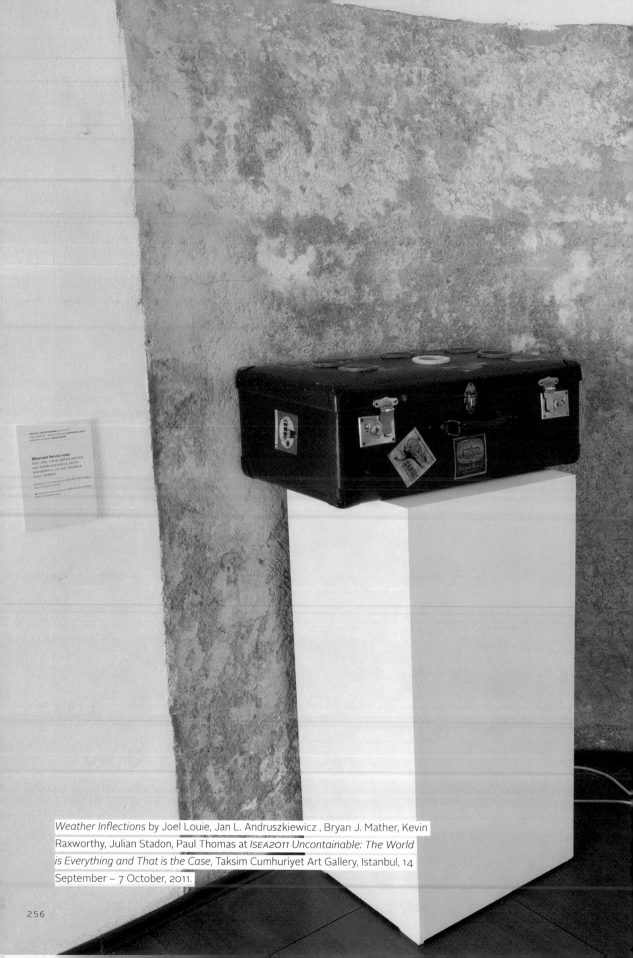

Weather Inflections by Joel Louie, Jan L. Andruszkiewicz , Bryan J. Mather, Kevin Raxworthy, Julian Stadon, Paul Thomas at *ISEA2011 Uncontainable: The World is Everything and That is the Case*, Taksim Cumhuriyet Art Gallery, Istanbul, 14 September – 7 October, 2011.

ISEA2011 UNCONTAINABLE

THE WORLD IS EVERYTHING AND THAT IS THE CASE

TAKSİM CUMHURİYET SANAT GALERİSİ
14 EYLÜL–7 EKİM, 2011
ZİYARET SAATLERİ: 10:00–18:00

SANAT DİREKTÖRÜ/ARTISTIC DIRECTOR **LANFRANCO ACETI**
KÜRATÖRLER/CURATORS **SEAN CUBITT, VINCE DZIEKAN, PAUL THOMAS**

SANATÇILAR/ARTISTS **KAREN CASEY; MARK CYPHER; TINA GONSALVES; MARK GUGLIELMETTI & INDAE HWANG; NIGEL HELYER; JOEL LOUIE, JAN L. ANDRUSZKIEWICZ, BRYAN J. MATHER, KEVIN RAXWORTHY, JULIAN STADON & PAUL THOMAS; MITCHELL WHITELAW.**

SANAT DİREKTÖRÜ VE KONFERANS BAŞKANI /
ARTISTIC DIRECTOR AND CONFERENCE CHAIR
LANFRANCO ACETI

KONFERANS VE PROGRAM DİREKTÖRÜ /
CONFERENCE AND PROGRAM DIRECTOR
ÖZDEN ŞAHİN

UNCONTAINABLE
The World is Everything and That is the Case

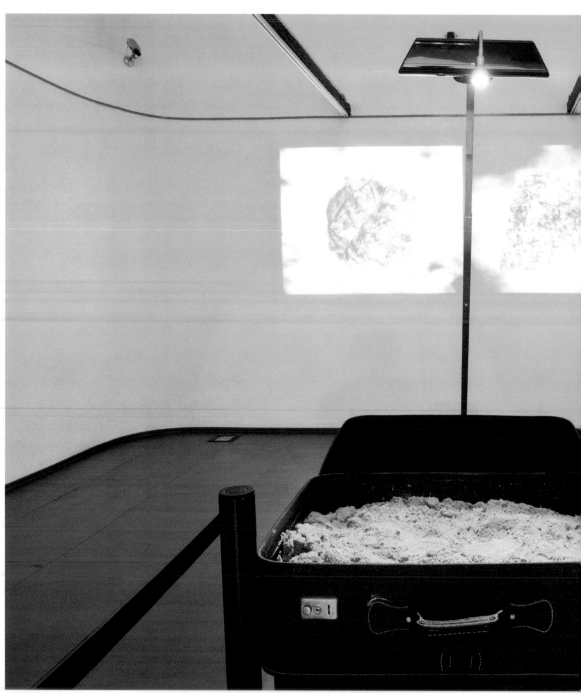

 ISSN 1071-4391 ISBN 978-1-906897-19-2

Propositions 2.0 by Mark Cypher at *ISEA2011 Uncontainable: The World is Everything and That is the Case*, Taksim Cumhuriyet Art Gallery, Istanbul, 14 September – 7 October, 2011. (Photographic documentation by Özden Şahin.)

ISSN 1071-4391 ISBN 978-1-906897-19-2

UNCONTAINABLE
The World is Everything and That is the Case

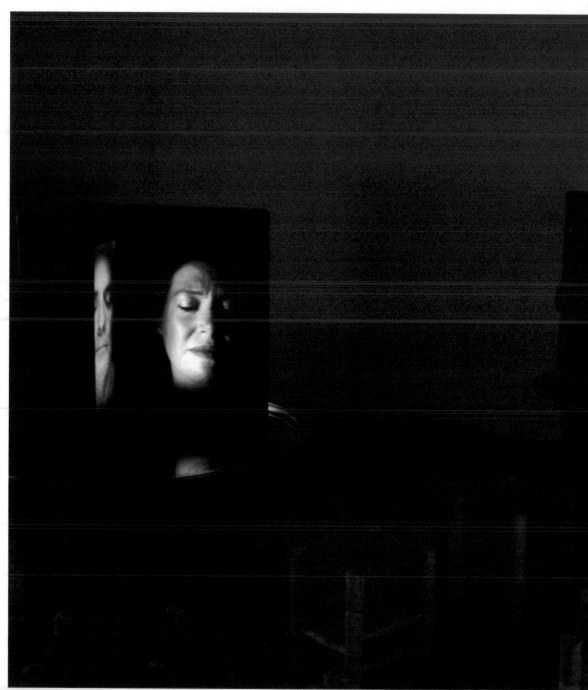

 ISSN 1071-4391 ISBN 978-1-906897-19-2

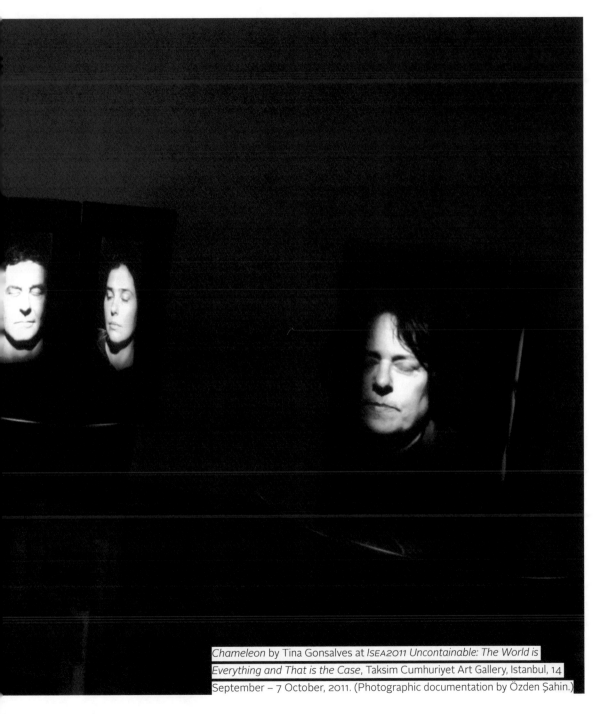

Chameleon by Tina Gonsalves at *ISEA2011 Uncontainable: The World is Everything and That is the Case*, Taksim Cumhuriyet Art Gallery, Istanbul, 14 September – 7 October, 2011. (Photographic documentation by Özden Şahin.)

UNCONTAINABLE
The World is Everything and That is the Case

 ISSN 1071-4391 ISBN 978-1-906897-19-2

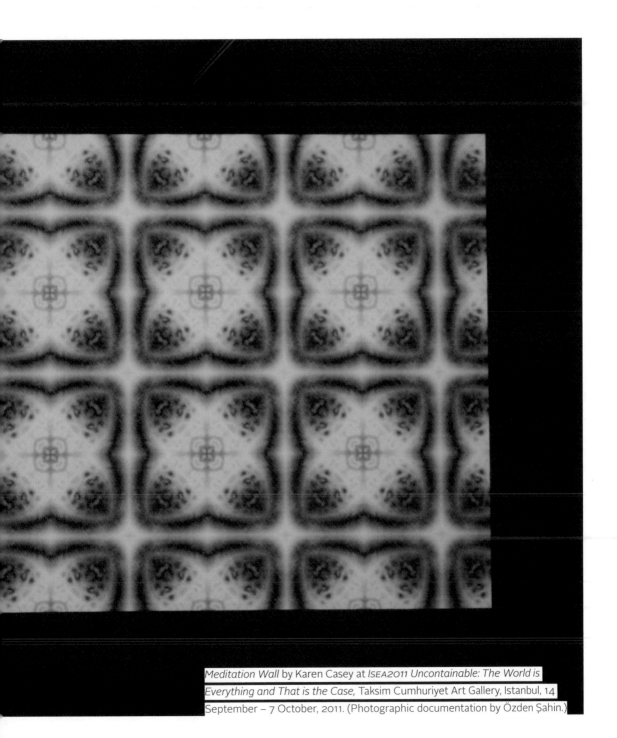

Meditation Wall by Karen Casey at *ISEA2011 Uncontainable: The World is Everything and That is the Case,* Taksim Cumhuriyet Art Gallery, Istanbul, 14 September – 7 October, 2011. (Photographic documentation by Özden Şahin.)

ISEA2011
UNCONTAINABLE
THE WORLD IS EVERYTHING AND THAT IS THE CASE

KÜRATÖRLER/CURATORS **SEAN CUBITT, VINCE DZIEKAN, PAUL THOMAS**

SANATÇILAR/ARTISTS **KAREN CASEY; MARK CYPHER; TINA GONSALVES; MARK GUGLIELMETTI & INDAE HWANG; NIGEL HELYER; JOEL LOUIE, JAN L. ANDRUSZKIEWICZ, BRYAN J. MATHER, KEVIN RAXWORTHY, JULIAN STADON & PAUL THOMAS; MITCHELL WHITELAW.**

SANAT DİREKTÖRÜ VE KONFERANS BAŞKANI /
ARTISTIC DIRECTOR AND CONFERENCE CHAIR
LANFRANCO ACETI

KONFERANS VE PROGRAM DİREKTÖRÜ /
CONFERENCE AND PROGRAM DIRECTOR
ÖZDEN ŞAHİN

ISSN 1071-4391 ISBN 978-1-906897-19-2

TR Taşınabilir müzeden eğreti sokak satıcısı tezgahına, göçmenin yıpranmış bavulu Wittgenstein'ı anımsatıyor: "The World is everything that is the case." Sergideki sanatçılar sanat yapma eyleminin göçebe doğasını inceliyorlar; anlama açılan patikalarla, göç yollarındaki alışverişlerin estetiği arasında küresel bir dolaylama oluşturuyorlar.

EN From the portable museum to the make-shift stand of the street corner trader, the migrant's battered suitcase tied with string acts as an echo of Wittgenstein: "The World is everything and that is the case." 'In each case' the contributing artists explore the migratory nature of artistic practice; acting as a global mediation between the aesthetics of trade along the peregrine, wandering routes that lead towards meaning.

KAREN CASEY

> *I was inspired from the sounds and architecture of Istanbul and the ancient geographical referents of the Australian desert. The artwork was created with specialized software using my meditating brainwaves.*

Karen Casey is an interdisciplinary artist who employs a combination of traditional and new media techniques to explore intersections between the arts, science and society. She has experimented and worked with various analogue and digital media technologies since the early 1990's, while practicing as an installation, photo media and public artist. Karen has exhibited in numerous curatorial and touring exhibitions and her work is widely represented in national galleries and public collections in Australia and internationally. She has received several significant grants, awards and public art commissions and was appointed as Artist-in-Residence for the City of Melbourne, 2003-04.

Following research undertaken at the Brain Sciences Institute, Swinburne University of Technology Melbourne in 2004, Karen initiated 'Art of Mind' and the collaborative development of an interactive interface designed to generate audiovisual effects from Electroencephalographic (EEG) or brainwave data. In 2010 she launched the Global Mind Project with a live 'neuro-art' collaborative performance event *Spectacle of the Mind*, at Melbourne's Federation Square, as part of an ongoing project and her interest in creativity and cognition.

Meditation Wall (detail), 2011, Karen Casey, image capture of brainwave generated media from multi-channel video, 200 × 600 cm.

ISSN 1071-4391 ISBN 978-1-906897-19-2

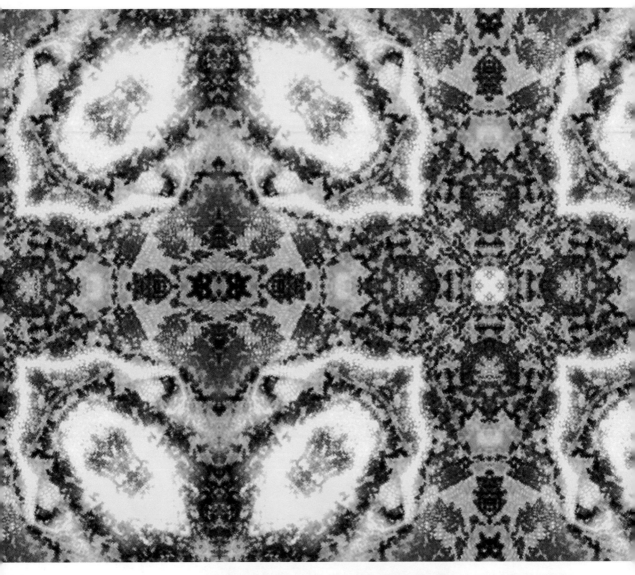

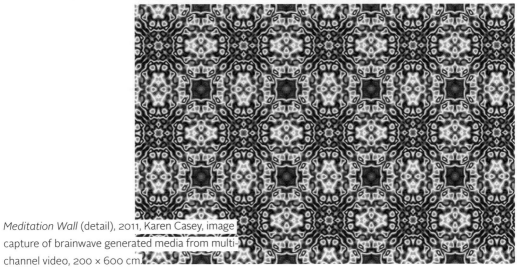

Meditation Wall (detail), 2011, Karen Casey, image
capture of brainwave generated media from multi-
channel video, 200 x 600 cm.

ISSN 1071-4391 ISBN 978-1-906897-19-2

KAREN CASEY

Meditation Wall, 2011, Karen Casey, gallery
installation of brainwave generated media from
multi-channel video, 200 × 600 cm. (Photographic
documentation by Mehveş Çetinkaya.)

MARK CYPHER

The installation Propositions 2.0 will enable participants to interact with and generate different cumulative worlds based upon the manipulation of sand in a suitcase.

Mark Cypher is a new media artist and Academic Chair of Digital Media at Murdoch University, Perth, Western Australia. His practice reflects an ongoing engagement with the practice and discourse of interactivity particularly in relation to actor-network theory.

His artwork has been featured in several international exhibitions including, 404 International Festival of Electronic Arts (Argentina), Salon International De Art Digital (Cuba), Siggraph 2006 (USA), FILE - Festival Internacional de Linguagem Eletrônica (Brazil), NewForms06 (Canada), BEAP -Biennial of Electronic Art (Australia), Haptic 07 (Canada), Bios4, Centro Andaluz de Arte Contemporáneo (Spain) and Electrofringe (Australia).

Propositions 2.0, 2011, Mark Cypher, suitcase containing sand, kinect camera, projector, games engine software, 300 × 300 × 300cm.

ISSN 1071-4391 ISBN 978-1-906897-19-2

Propositions 2.0 (Interaction detail).

ISSN 1071-4391 ISBN 978-1-906897-19-2

MARK CYPHER

Propositions 2.0, 2011, Mark Cypher, suitcase containing sand, kinect camera, projector, games engine software, 300 × 300 × 300cm. (Photographic documentation: Özden Şahin.)

TINA GONSALVES

Exploring the intimacies and vulnerabilities of human emotions through video, wearable technology, emotion sensing interactivity and installation.

Over the last ten years **Tina Gonsalves** has explored the intimacies and vulnerabilities of human emotions through video, wearable technology, emotion sensing interactivity and installation. Her work investigates the intersections of art, technology and science. Gonsalves is currently working with worldleaders in psychology, neuroscience and emotion computing in order to research and produce moving image artworks and interventions that probe and respond to emotions. Poetic installation video works, mobile and wearable technology works respond to pulse, sweat, voice and emotional expressions. Her recent project, *Chameleon*, is a collaboration with neuroscientists, technologists, curators and international research departments. Over two years, via a range of prototypic experiments she is creating an interactive video project that explores emotional contagion.

Her work has been exhibited and awarded extensively internationally. She has been awarded numerous international Artist in Residence programs. She is currently artist in residence at Nokia Research Center, Finland and the Max Planke Institute in Germany and is about to embark on an Asialink Residency based in Beijing.

Chameleon, 2009, Tina Gonsalves. Installation view of *Chameleon 09*, Fabrica, Brighton, UK.

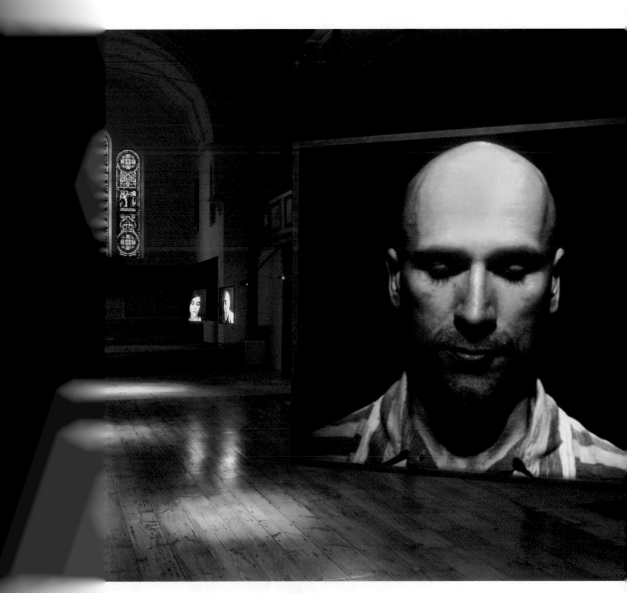

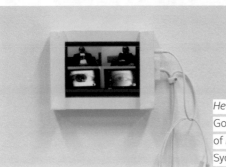

Hear and Now Series, Percolate. 2011, Tina Gonsalves. An installation shot of the documentation of *Percolate*, Gen Art Systems, Australia Council, Sydney, Australia.

...tion view of *Chameleon 07, Superhuman, Revolution of the* ..., RMIT Gallery, Melbourne Australia.

71-4391 ISBN 978-1-906897-19-2

TINA
GONSALVES

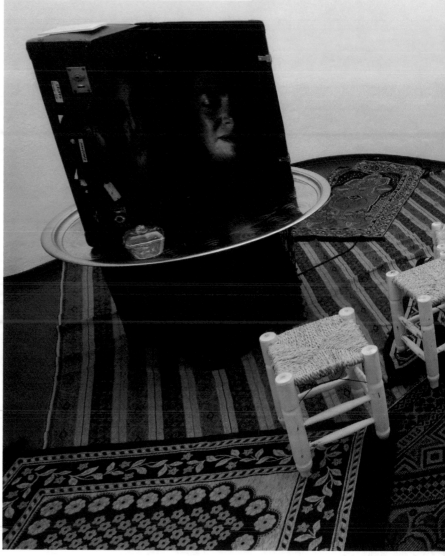

Chameleon, 2009, Tina Gonsalves. Installation
at Taksim Cumhuriyet Art Gallery, Istanbul,.
(Photographic documentation by Ender Erkek.)

ISSN 1071-4391 ISBN 978-1-906897-19-2

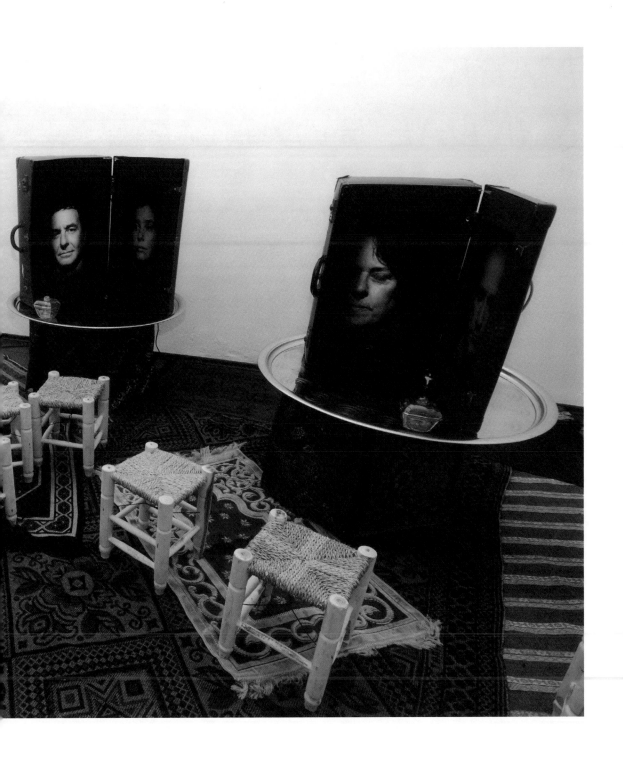

MARK GUGLIELMETTI & INDAE HWANG

Investigating the 'enigma' of artificial life through the creation of a generative world and documentary recorded by an artificial filmmaker. We unpack the human endeavor; life as it is and life as it can be.

Mark Guglielmetti investigates the formations of cultural identity and subjective experience. He uses various media to explore these and related issues - electronic, digital and biological. His work has been exhibited nationally and internationally including the Melbourne International Film Festival 2001, Biennial of Electronic Arts Perth (BEAP) 2004, Ars Electronica 2004, and showcased at the Architectural Biennial in Beijing 2004 as well as in Australian Screen Culture, at the Barbican in London 2004 and Centre Pompidou in 2003.

Recent works and exhibitions include *Intractable* (2010) in the InsideOut Exhibition, Object Gallery, Sydney and DMU Cube Gallery Leicester, England; *Documentary nShape* (2009) at Guilford Lane Gallery in Melbourne; and *Laboratories of thought* (2007) Trocadero ArtSpace, Footscray.

Guglielmetti is beavering away researching the relationship between cinema and artificial life in an attempt to co-evolve an artificial life filmmaker with an artificial life world.

Travelogue: A Recording of Minute Expressions, 2011, Mark Guglielmetti in collaboration with Indae Hwang, software and code.

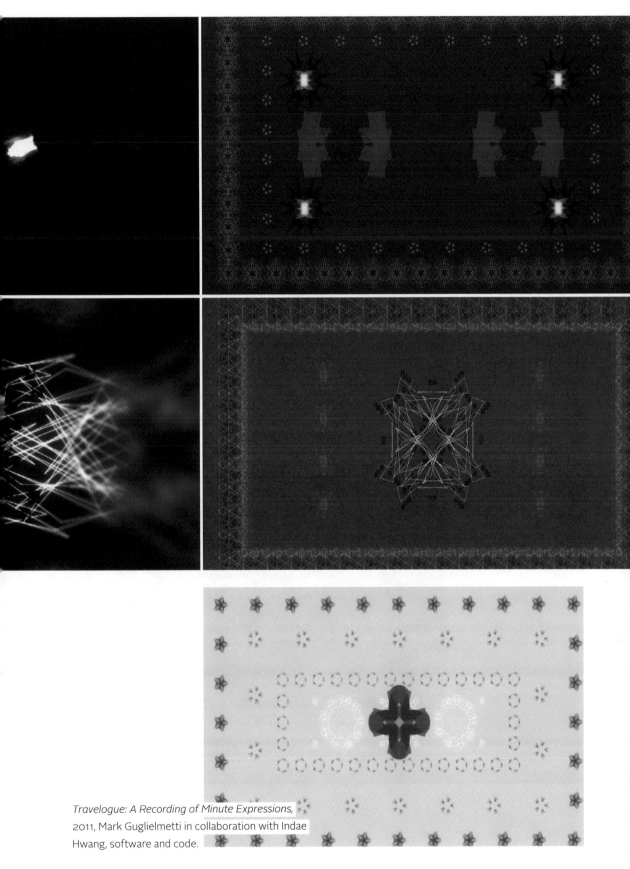

Travelogue: A Recording of Minute Expressions,
2011, Mark Guglielmetti in collaboration with Indae
Hwang, software and code.

MARK GUGLIELMETTI & INDAE HWANG

Travelogue: A Recording of Minute Expressions, 2011,
Mark Guglielmetti in collaboration with Indae Hwang,
software and code.

ISSN 1071-4391 ISBN 978-1-906897-19-2

NIGEL HELYER

Cultural and ideological relationship between two Empires, Britannia and Cathay (China) both of which regarded themselves as the hub of the Universe.

Dr. Nigel Helyer (a.k.a. DrSonique) is an independent interdisciplinary sculptor and sound-artist. He is the director of a small multidisciplinary team *Sonic Objects*; Sonic Architecture which has forged an international reputation for large scale sound-sculpture installations, environmental public artworks, museum inter-actives and new media projects. Nigel is a longstanding collaborator with, and advisor to, the SymbioticA lab of the University of Western Australia, realising such projects as *GeneMusiK*, a biological music remixing system, the insect installation *Host* and the infamous *LifeBoat* – in his role as the Artistic Director.

Helyer's activities include the development of a powerful virtual audio reality mapping system, *Sonic Landscapes* in collaboration with Lake Technology (now Dolby Australia). He is also the Artistic Director of the AudioNomad Research Group, developing the AudioNomad location sensitive environmental audio system at UNSW. He is currently Adjunct Professor in the National Institute of Experimental Art, College of Fine Arts, UNSW. Additionally, he is Honorary Research Fellow in SymbioticA, UWA, Honorary Research Fellow in Institute for Marine and Antarctic Studies UTAS and Visiting Professor in National INstitute for Experimental Arts, COFA, UNSW.

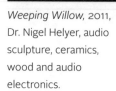

Weeping Willow, 2011, Dr. Nigel Helyer, audio sculpture, ceramics, wood and audio electronics.

ISSN 1071-4391 ISBN 978-1-906897-19-2

Weeping Willow, 2011, Dr. Nigel Helyer, audio
sculpture, ceramics, wood and audio electronics.

ISSN 1071-4391 ISBN 978-1-906897-19-2

NIGEL HELYER

Weeping Willow, 2011, Dr. Nigel Helyer, audio
sculpture, ceramics, wood and audio electronics.

UNCONTAINABLE
The World is Everything and That is the Case

JOEL LOUIE, JAN L. ANDRUSZKIEWICZ, BRYAN J. MATHER, KEVIN RAXWORTHY, JULIAN STADON, PAUL THOMAS

Weather Inflections is an interactive audio installation that collects weather readings from Perth, Australia and converts temperature, humidity, air quality, CO2, CO and ambient light data into a visceral soundscape.

Joel Louie is a PhD Candidate at Curtin University. Joel's research and creative practice seek to explore how our relationship to computing technology is effected and affected through mediation with embodied interaction modalities.

Jan L. Andruszkiewicz completed a BA, Fine Art at Curtin University and a Bachelors degree in Computer Science at Edith Cowan University. He has recently completed an MPhil in Creative Arts at Curtin University.

Bryan J. Mather is a polymath with two specific fields of expertise, Information Technology and Fine Art, and since 1981 he has alternated between these two careers.

Kevin Raxworthy is senior technician in the Studio of Electronic Arts at Curtin University of Technology. Kevin has recently completed an MA in Electronic Art.

Julian Stadon completed BA Fine Arts and MA Electronic Arts at Curtin University. He is currently working as associate lecturer for Open Universities Australia, as Web Development and e-learning researcher for Curtin Art Online, and as RA for NOMAD.

Paul Thomas currently holds a joint position as Head of Painting at the College of Fine Art, University of New South Wales and Head of Creative Technologies, Centre for Culture and Technology, Curtin University of Technology.

Weather Inflections, 2011, Joel Louie, Jan L. Andruszkiewicz, Bryan J. Mather, Kevin Raxworthy, Julian Stadon, Paul Thomas.

SUPPORTED BY CURTIN UNIVERSITY OF TECHNOLOGY (PERTH, AUSTRALIA) & COLLEGE OF FINE ART, UNIVERSITY OF NEW SOUTH WALES (SYDNEY, AUSTRALIA)

 ISSN 1071-4391 ISBN 978-1-906897-19-2

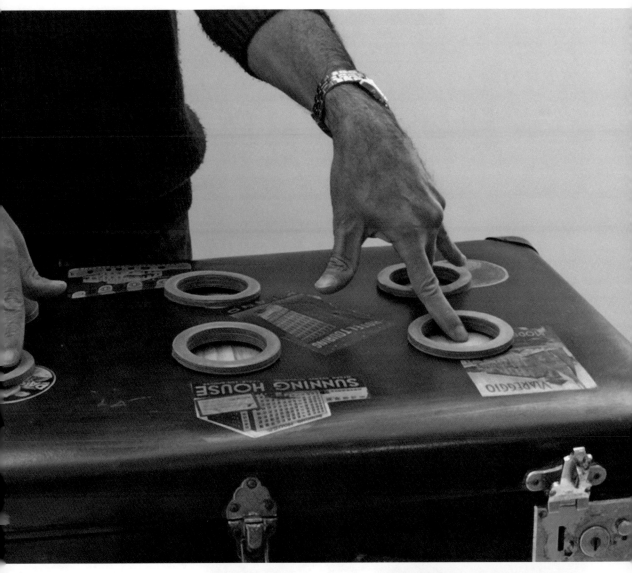

Weather Inflections (detail).

ISSN 1071-4391 ISBN 978-1-906897-19-2

UNCONTAINABLE
&UNTITLED

JOEL LOUIE, JAN L. ANDRUSZKIEWICZ, BRYAN J. MATHER, KEVIN RAXWORTHY, JULIAN STADON, PAUL THOMAS

Weather Inflections, 2011, Joel Louie, Jan L.
Andruszkiewicz , Bryan J. Mather, , Kevin Raxworthy,
Julian Stadon, Paul Thomas.

 ISSN 1071-4391 ISBN 978-1-906897-19-2

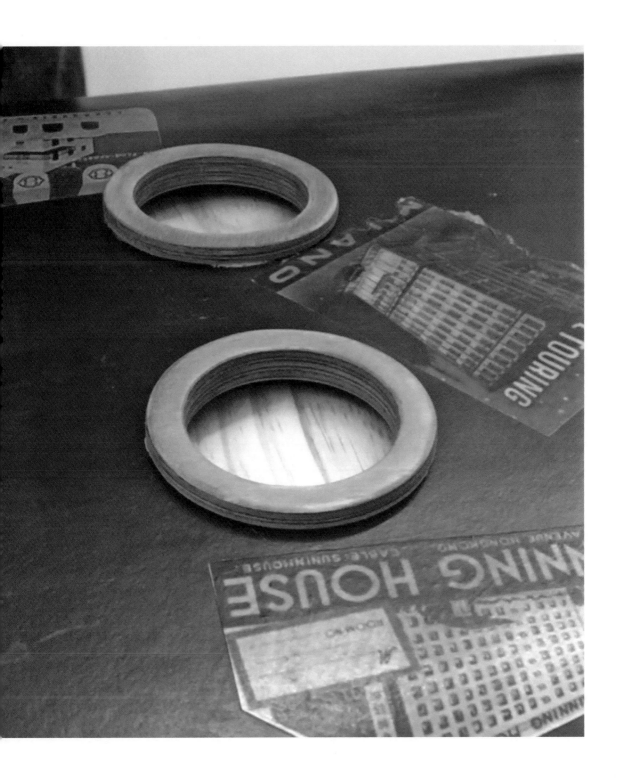

MITCHELL WHITELAW

Generative processes and digital fabrication address growth, materiality, locality and the network. Bowl-like forms are framed by a network diagram in which our familiar hyperconnectivity disintegrates into local islands.

Mitchell Whitelaw is an academic, writer and artist with interests in new media art and culture, especially generative systems and data-aesthetics. His work has appeared in journals including *Leonardo*, *Digital Creativity*, *Fibreculture*, and *Senses and Society*. In 2004 his work on a-life art was published in the book *Metacreation: Art and Artificial Life* (MIT Press, 2004).

His current work spans generative art and design, digital materiality, and data visualisation. He is currently an Associate Professor in the Faculty of Arts and Design at the University of Canberra, where he leads the Master of Digital Design. He blogs at The Teeming Void.

Local Colour (detail), 2011, Mitchell Whitelaw, laser-cut cardboard.

ISSN 1071-4391 ISBN 978-1-906897-19-2

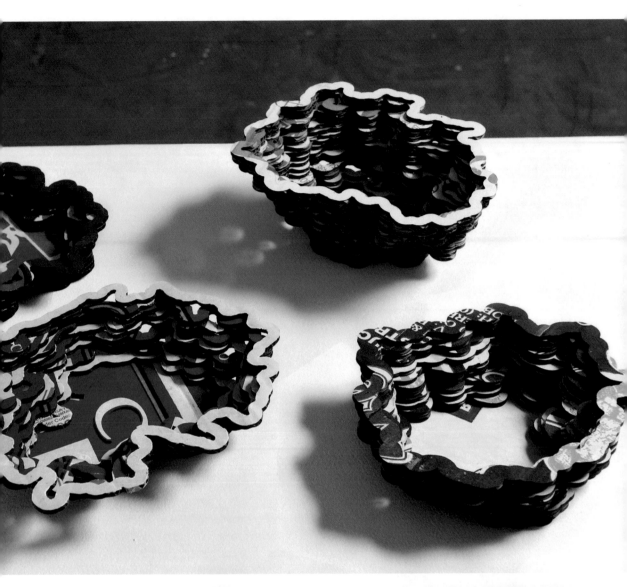

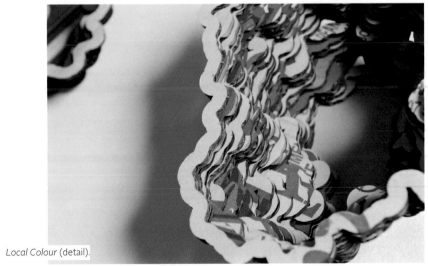

Local Colour (detail).

The Art of Packing
A Curatorial Portmanteau[1]

BY

Vince Dziekan

Associate Dean Research in the Faculty of Art &
Design, Monash University in Melbourne, Australia.

The suitcase lies prone in the middle of the cabin; its epidermis of waterproofed black canvas sags gently in the middle, suggestive of a resigned worldweariness. A cursory topographical analysis serves to simply reiterate its mute presence, there, as a material fact. A paper bracelet adorns the handle grip that I used to manoeuvre the luggage into its present position. A patch of raised edges ripple along the section of the baggage tag where the adhesive backing of this looped strip was forced into contact with itself. Sweeping diagonally across the bar-code printed onto its waxy surface, the ink in this zone of turbulence has been scuffed away, removing from its lateral stream of bands an area that serendipitously resembles the Alexander Archipelago – the group of islands off the southeastern coast of Alaska whose waters we have just left behind. [2] A metonym of the friction that inevitably results from the collision of different worlds; in this case, the active interface between the smoothness of information transfer and the materiality, the living tectonics of physical surfaces set in motion.

To an outside pocket of the case, a single word is embroidered in red thread: *"Cosmopolitan."* The word forges a disjunctive gap between fiction and reality, assigning to this otherwise nondescript unit of mass-produced luggage (manufactured anonymously "somewhere" in provincial China) an unwarranted connotation of worldly sophistication conjured by travel goods from a bygone era of romanticised tourism: the exotically named *Hartmann*

Gibraltarized, or the *Wheary Wardrolette* (designed "for railroad, steamship, motor or airplane travel.")

The suitcase reveals the spatial science of a migratory aesthetic. [3] Today, cultural objects are anchored not by their fixed position in space and time, but by a constant and shifting mobility. Displacement operates as the default condition for a more general theory of relationality. As described by Mieke Bal: "If aesthetics is primarily an encounter in which the subject, body included, is engaged, that aesthetic encounter is migratory if it takes place in the space of, on the basis of, and on the interface with, the mobility of people as a given, as central, and as at the heart of what matters in the contemporary, that is, 'globalized' world". (Bal, 2007: 23-24). While Ulf Hannerz connects anchorless cosmopolitanism with the trade in ideas that circulate through the international networks of the intelligentsia, when noting that: "there is now one world culture; all the variously distributed structures of meaning and expression are becoming interrelated, somehow, somewhere. And people like the cosmopolitans have a special part in bringing about a degree of coherence; if there were only locals, world culture would be no more than the sum of its separate parts." (Hannerz, 1996: 111).

Who better to epitomize this state of affairs than the avant-garde's traveling salesman, Marcel Duchamp? I can imagine the quixotic young artist being accompanied on his transatlantic crossing aboard

the *S.S. Rochanbeau* in 1915 by a trusty flat-bottom steamer trunk of beech wood slat construction and geometrically patterned canvas coating. [4] Or, three years later, once again requiring the services of his "Travelling Wardrobe" for the month-long steamship journey from New York to Buenos Aires: When stood upright and opened, the right half of the hinged trunk is lined with drawers; the other comprised of the main wardrobe compartment, complete with anchor-shaped "Princess" hangars and presser bar, a shoe box and a hidden, extendable ironing board with flat-iron. Perhaps while en route, he would have on occasion gone to his luggage, removed the locking bar that secures the bank of drawers while at sea (carefully re-storing the bar to its hidden compartment mounted behind the top drawer) and rummaged through one of the drawers: setting to one side a strange conglomeration of coloured rubber strips – resembling a Portuguese Man o' War (*Physalia physalis*) that could have been washed ashore on a beach in Barbados – and, instead, cautiously extracting a cardboard portfolio containing conceptual plans and drawings for his latest work: the *Grande verre*, or *The Large Glass (The Bride Stripped Bare By Her Bachelors, Even)*. [5]

Some years later, following upon the eventual assembly of these supplementary notes into what would become known as the *Boîte verte*, Duchamp would undertake to collect together his artistic wanderings from the far-flung reaches of his career by setting out to make "an album of approximately all

the things I produced." [6] He would end up dedicating five years towards realizing this ambitious "portable museum". The extensive range of production associated with the project would be carried out nomadically. Photographic and printing processes were coordinated "on the move" during periods of time travelling between Paris, New York, Hollywood and Cleveland over 1935-36, while the years from 1937-40 would be spent working between Paris and Arcachon, near Bordeaux (which was then part of the occupied zone of France). It was there where he turned his attention to fabricating the three-dimensional replicas and the actual construction of the plywood box itself. The resulting *Boite* – which in many ways resembles a sample kit of a travelling salesman – contains sixty-nine items constituted from an ensemble of seventeen miniature facsimiles of artworks and a set of loose folders containing reproduced prints, or *Feuilles libres*. The *Sculpture de voyage* is found represented in the seventh of these folder alongside photographic reproductions of two other Readymades (*Bottle Dryer* and *Hat Rack*), and the works: *In advance of a broken arm*, *Ready made malheureux* and *Pharmacie*. The photograph used for reproduction documents the bathing cap sculpture's informal installation in his room in Buenos Aires. Duchamp would resort to the labour-intensive *pochoir* [7] technique to recreate the colouration of this "multicolored cobweb," by meticulously adding pigment to the edition of dark grey collotype prints produced for the *Boite*.

Reigning in these runaway thoughts for a moment, I draw my focus back to the case (at hand), and gently peel back its front cover. Packing is indeed an art form. A folding garment compartment is fitted into the upper lid of the suitcase; I hook a suit and some shirts to the metallic bracket that is secured there. Between folds I insert an art print that is backed by common cardboard and sheathed in a sleeve of plastic (in actuality, a photocopy masquerading as a pencil sketch of a vanquished local sporting hero – goaltender Roberto Luongo of the Vancouver Canucks – bought from a Vietnamese street artist outside the Vancouver Art Gallery, whose portfolio included photorealistic renderings of Jimi Hendrix, Barack Obama and Angelina Jolie). Secured with straps, I clip the retractable compartment back into place. I take a more structured approach to dealing with packing the contents that will fill the bottom of the main case: Start by fitting my pair of black Onitsuka Tigers, yin-yang fashion, into the top left corner. Fill each shoe with a combination of socks and small souvenirs (a bear-bell from Juneau; commemorative golf ball from Pebble Beach; fridge magnet from Alcatraz). Enclose the ensemble in a hessian tote bag that bares a rather severe likeness of Gertrude Stein screen-printed below the motto: "You can either buy clothes or you can buy pictures" (bought in the museum store of SFMOMA). Address the dilemma of whether to "roll" or "fold" by rolling up a pair of jeans, then kneading them into the groove that is created by the inner tubing that provides the trolley case with its primary structural reinforcement, as well as doubling as sheath for its retractable pull-arm. Below them, pile together assorted folded pullovers, cardigans and t-shirts. Add or subtract layers as required to ensure that a uniform level is achieved across the entire surface. Then, repeat this process to fill the opposite side of the compartment.

The empty space that remains, resulting from this symmetrical folding along the case's vertical mirroring axis, is set aside for (starting from the base and working upwards):

1) Toiletries case and camera bag;
2) A bottle of Pasa Robles Viognier, wrapped inside a brown carry bag emblazoned with a motif of a zeppelin; [8] and
3) A bubble-wrapped cocoon that nests within it a carved whale-bone sculpture purchased as a memento of our final port of call in Ketchikan.

Today, cultural objects are anchored not by their fixed position in space and time, but by a constant and shifting mobility. Displacement operates as the default condition for a more general theory of relationality.

Any remaining fissures are to be filled, ultimately, with an assortment of loose travel adapters, power supplies and computer cables.

Before packing away my camera, however, I remove its "memory" card. 9 Holding the manipulated charge of hundreds of photographs as packets of digital information, the reconstruction of these arrays of pixels, block by block, reveals the inherent approximations involved in the process of digitization. The degradation latent in the process of "lossy compression" resulting from the technicalities of moving between light and eye, software and screen only exacerbate the *loss in translation* that is inevitable through the act of photography: The impossibility of conveying the phosphorescent quality of blue found in certain ice floats, let alone the animistic personality of the ocean that rises to its undulating surface, or the tonal subtleties of transitory vistas that emerge only momentarily from the littoral zone produced from the meeting of water, shoreline, dissolving veils of mist and seeing (which in this instance, intimately links the act of looking

out on this view of the fog-shrouded coastline of Revillagigedo Island through a window of the cruise ship's onboard gym with the sensation of propelling the vessel through the narrow waterway by tapping out 120 RPM on a bike machine while listening to *TV On The Radio*; my attention split between taking in this passing scene and the visual white noise of CNN, showing, at that moment, an interview with photographer David LaChapelle, interspersed with cuts between interviewer, the artist, and an edited montage of details from his photographic recreation of the *Pieta* using "look alike" models resembling Kurt Cobain and Courtney Love) that insidiously seeps into my peripheral vision from a wall-mounted flat screen monitor.

Deftly I store away the card within the cushioned interior of a small rubberized case that dangles from a key ring latched to a miniature silver replica of the tower of Pisa, and set it aside for the moment. Then, I return the camera to its own battered and worn carry bag, which has been lined with an extra layer of bubble wrap; clip shut. Snuggly fit the camera bag into

the sole remaining cavity in the suitcase. Close its lid and zip shut, fastening the interlocking sliders with a small padlock. Next, fill the outer pocket of the case with an assortment of paperbacks, magazines and a manila folder containing photocopies and hand-written notes. Zip shut and lock. Stand the case upright. Tighten a red Air Canada strap around its midriff. Finally, stow the pouch safeguarding my collection of SD cards into a recycled Qantas flight amenity bag; pull drawstring to seal. Slip this package in the interior security pocket of my Crumpler shoulder bag, where my *iPad*, *iPod* (its playlist including *Bright Eyes'* Conor Oberst warbling the lyrics "Some wander the wilderness. Some drink Cosmopolitans") and document wallet, containing passports, remnants of Canadian, American and Australian currencies, and other sundry forms of travel-related documentation are already found; waiting in readiness to support me negotiate the impending suspended realities, the zones of transience, that will be encountered shortly: ship disembarkation in Vancouver, departure gates, transit lounges, domestic and international flight connections, the pressurized cabin of an A380 and the disappearance of a phantom day somewhere, sometime over the Pacific. **10**

A smooth, aerodynamically silhouetted disc of grey plastic is already attached to the top handle of the trolley case by an elasticized chord. The disc contains an embedded RFID chip designed to track my luggage's journey, paralleling my own, through a series of regulatory and monitoring systems; the testimony of integration between e-ticketing, baggage reconciliation and security architectures buried down in the code. The omnipresent conveyor belt will neutralize the suitcase's travel through these different environments. At multiple junctures along the way, its movement through the system will be arrested, and the contents it carries subjected to non-invasive inspection by X-Ray. The main parts of the common baggage inspection systems used to screen hand-luggage are the generator, the detector and the signal processor unit that intensifies the incoming signals, reproducing them into a visual image. During the course of scanning, as the stream of radiation slices through the materialities that, combined together, constitute the anatomy of the case, some electrons pass through objects while others are absorbed. What physiognomic characteristics are revealed in the pattern that results and what other natures escape or evade being imaged? What if, instead of following the course pre-determined by the mechanics of cold calculation, the stream of controlled light energy were to take a more idiosyncratic, indirect and winding route? Efficiency offset by curiosity; a speculative spectroscopy. What if a more mixed-dimensional form of inspection was possible, with the detection of material types and densities counterbalanced by one for their *qualia*? A chromatic fluctuation of red registering the *gravitas* of an artefact; a variation of luminance designating the lingering *resonance* of a souvenir.

As the beam commences its passage through the suitcase, it bisects the stratified layer of printed matter that has been indiscriminately compiled in the outside pocket, which includes:

1) Spare copy of travel itinerary;
2) In-flight magazine, featuring an article on a current exhibition of Louis Vuitton luxury travel goods at the National Museum of China in Beijing, read while flying over Cascadia;
3) Pocket book (*Settlements of the Doomed: History's forsaken camps & communes*);
4) A second-hand copy of a Lonely Planet guide to Istanbul (that, to my amusement, contained a tri-lingual flyer – in Turkish, German and error-strewn English – for a night club purportedly housed in a fifth century Byzantine tower; deducing this

to have been used by the previous owner as a bookmark); and

5) Assorted reference material, gallery floor plans and written annotations related to exhibition preparations for *The World Is Everything That Is the Case*.

These notes articulate how the exhibition's form and conceit seeks to explore the migratory nature of artistic practice in order to act as a global mediation between the aesthetics of trade and the peregrine, wandering routes that lead towards meaning. How the humble, innocuous suitcase – typified by the portable flat-topped cases of shellac-coated canvas glued to pine, lined on the inside of the floor and lid with newsprint (often decoratively patterned using wooden stamps and ink), wallpaper or thin cloth – will be explored as a space that embodies (contains?) the transformation of cultural practice under globalized aesthetic conditions, occurring across states, borders and demarcation zones of continuous production. Standing as a token for each of the artworks produced by the six contributing artists, the suitcase is self-contained, and its consignment compressed (or "zipped"); the role of curation will be to function as their codec. **11**

As it will transpire, none of the words found, there, in that collection of notes (tabulated in uniformly spaced rows of typographic characters or hurriedly scribbled in my barely legible handwritten scrawl) will rise to the notice of the X-Ray scan. Just as the ideas intimated in these passages of text will elude further interrogation by technological means, so to the experiential residue, the patina of encounters in the world between objects and people, times and places.

The trolley case trips an ultraviolet sensor as it is transported along the conveyor belt into the darkened chamber of the airport's inspection system

on its return to Melbourne. As a controlled pass of radiation rains down as a volumetric whole, all of the flights of imagination, references and foresights, allusions and plans vaporize into a single diluted orange mass. The resulting zone of undifferentiated colour is punctuated by smaller fragmentary shards of green, blue and black (indicative of the mechanical components of a camera and lens, the architecture of a charge-coupled device, a battery). Emerging from the diaphanous layers of semi-transparency, a more deeply saturated orange shape materializes on the screen of the customs inspector; hovering in the vicinity of the centre of the case, its softly abstracted features resemble an arctic puffin. ∎

UNCONTAINABLE
The World is Everything and That is the Case

Illustration, mixed by Vince Dziekan and Shannon Collins (2011). Image sources:

Bar code. Scanned digital image. Courtesy of the author.

Alexander Archipelago, Southeastern Alaska. Sensor: Terra/MODIS. Visualization Date: 2002-02-07. Credit: Jacques Descloitres, MODIS Land Rapid Response Team, NASA/GSFC. Credit: NASA, Visible Earth. Reproduced under stated terms of Use: http://visibleearth.nasa.gov/

Chief Anotklosh of the Taku tribe wearing a woven Chilkan blanket of cedar bark and mountain goat wool and a European-style cap, and holding a carved wooden bird rattle. Photograph by W.H. Case, ca. 1913, Juneau, Alaska. This media file is sourced from Wikimedia Commons, and is in the public domain in the United States and applies in countries and areas that apply the rule of the shorter term for US works where the copyright has expired, often because its first publication occurred prior to January 1, 1923.

ISSN 1071-4391 ISBN 978-1-906897-19-2

NOTES

1. A portmanteau is a type of travel bag common to England and other parts of Europe in the nineteenth century. Derived from the French, *porter* (to carry) and *manteau* (a coat or cover), the word traces back to the mid-sixteenth century in English to describe a bag or carrying case for clothing. A contracted variant of the term, "port" was commonly used in Australia for school bags, but this usage is now out-dated. Further, Lewis Carroll is said to have invented the notion of a *portmanteau word* – a linguistic blend whereby two meanings are packed into a single word – in his book *Through the Looking-Glass*.

2. In the late eighteenth century, European explorers from Russia, Britain, France, and Spain all converged on this uncharted coastline, motivated by the prospects for trade or to protect claims on nearby territorial waters. Ultimately, the British would gain control over what would eventually become the coast of British Columbia, thanks largely to the expeditions of James Cook (1778-79) and George Vancouver, who systematically surveyed the area between 1792-93.
 The main indigenous occupants of the Alexander Archipelago are the Tlingit (translated as "People of the Tides"). Because their lands covered large tracts encompassing major inland rivers that flow into the Pacific, the Tlingit developed extensive trade networks with Athabascan tribes of the continental interior prior to white settlement in the nineteenth century. As with other first nation peoples of the northwest Pacific coast with relatively easy access to bountiful resources, Tlingit culture is characteristically multifaceted and complex. Art and spirituality are interwoven, with common everyday objects, utensils and storage boxes decorated to invest them with spiritual power and historical significance.

3. According to the editors of *Essays in Migratory Aesthetics: Cultural Practices Between Migration and Art-Making*, migratory aesthetics is suggestive of: 'the various processes of becoming that are triggered by the movement of people and peoples; experiences of transition as well as the transition of experience itself into new modalities, new art work, new ways of being'. (Durrant and Lord, 2007: 11-12).

4. Founded in Paris in 1854, the Louis Vuitton fashion house secured worldwide patents on its signature Monogram Canvas in 1896 to protect against counterfeiting. Its recognizable patterning of monogram and graphic symbols, including quatrefoils and flowers, is an illustrative example of the trend of using Japanese and Oriental designs in the late Victorian era.

5. Besides taking these developmental notes on his voyage to Argentina, Duchamp also carried his *Sculpture de voyage* – a soft sculpture made up of different colored rubber strips cut from bathing caps. These strips were cemented together at random junctures allowing for the whole construction to be tied up flexibly with strings attached to the corners of a room. The artist announced the creation of this readymade in a personal letter sent shortly before departing from New York:
 "My dear Jean, Yvonne has written you and you have had the cable announcing that I, and probably Yvonne too, was going to leave for Buenos Aires. – Several reasons, which you know: nothing serious. I have finished the big panel for Miss Dreier and started another more interesting thing for her as well. You remember those multicolored rubber bathing caps – I have bought some, cut them up into small irregular strips, glued them together, not flat, in the middle (up in the air) of my studio, and, attached by strings to various walls and nails of my studio, it makes a sort of multicolored cobweb. I have almost finished it..."
 Transcribed in Ecke Bonk's detailed inventory of the *Boite-en-valise*. (Bonk, 1989: 236-7).

6. Quoted from a letter to Katherine Dreier dated 5 March 1935. As introduced by Bonk, the *Boite-en-valise*: 'is not only a convenient epitome of his work in miniature: it is also the synthesis of his paradoxical principles, of his apparently – but only apparently – contradictory rationale. The manifold overlaps and cross-references in his work as a whole are reflected in the spatial construction of the *Boite* as well as in the arrangement of the reproductions.

His artistic statements and achievements, in all their heterogeneous and many-sided profusion, are presented here by Duchamp as a carefully ordered whole.' (Bonk, 1989: 9).

7. 'Pochoir is a refined stencil-based technique employed to create prints or to add color to pre-existing prints. It was most popular from the late 19th century through the 1930's with its center of activity in Paris. Pochoir was primarily used to create prints devoted to fashion, patterns, and architectural design and is most often associated with Art Nouveau and Art Deco. The use of stencils dates back to as early as 500 C.E. and was also used in Europe from the 1500's onward to decorate playing cards, postcards and to create simple prints. It was, however, the increase in popularity of Japanese prints in the middle of the 19th century that spurred the refinement of the use of stencils culminating in the development of pochoir.' Van Dyk, Stephen H. and Siegel, Carolyn. 'Introduction,' in *Vibrant Visions: Pochoir prints in the Cooper-Hewitt, National Design Museum Library*. http://www.sil.si.edu/ondisplay/pochoir/intro.htm

8. Bonny Doon Vineyard is a winery based in the Santa Cruz, California. Known for its boutique vintages, the winery embraces obscure Rhone and Italian varietals along with principles of biodynamic production. The company's brand identity is a stylized zeppelin, the airship that pioneered aviation in the early twentieth century. Zeppelins were used by Deutsche Luftschiffahrts-AG, or DELAG – who are recognized as the world's first commercial airline – to pioneer passenger aviation prior to the outbreak of World War I. By the 1930s, dirigibles regularly operated transatlantic flights between Germany to North America and Brazil. However, the ill-fated Hindenburg disaster of 1937, along with burgeoning global political and economic issues of the day, brought the golden age of the zeppelin to an abrupt end.

9. Secure Digital (SD) is a non-volatile memory card format that is the storage standard for a wide range of consumer electronic devices, including mobile phones, digital cameras, portable music players, and car navigation systems. The standard was developed by the SD Association, which was formed in 2000 by Panasonic Corporation, SanDisk Corporation and Toshiba Corporation.

10. The need for establishing an international date line was amongst the "discoveries" of Ferdinand Magellan's around-the-world expedition (1519–1522). According to legend, the ship's judiciously maintained logbooks were found to be one-day out of register with the local time at port when the ship returned to Spain from its circumnavigation of the globe (leaderless, following the death of Magellan at the hands of Mauthan natives in the Philippines the year before.)

The voyage illustrates the dawning of the modernized era of globalization. According to Lemert, Elliott, Chaffee and Hsu: "the modern world is... a theory of extended space. Modern space was certainly politically organized, economically driven, and institutionally settled. But it was, and remains, a projected space – a dimension that seems to have outrun traditional ideas of cyclical time in order to inspire, among other aspects, the voyages of discovery that led to the projection of power into distant colonies that made efficiencies of travel of the essence of economic profit." (Lemert, 2010: 65)

ISSN 1071-4391 ISBN 978-1-906897-19-2

REFERENCES

11. A codec is a device or computer program capable of encoding and/or decoding a data stream. The word *"codec"* is a *portmanteau* of 'compressor-decompressor' or, more commonly, 'coder-decoder'. A codec encodes a digital signal for transmission, storage or encryption, or decodes it for playback or editing. Codecs are widely used in videoconferencing, Internet streaming of media and video editing applications.
Both Adrian Mackenzie and Sean Cubitt have written about *codecs* in relation to digital technology and contemporary media culture. Writing about the MPEG-2 codec, which functions as the universal standard for digital video, Mackenzie observes: "...the way the MPEG-2 codec pulls apart and reorganizes moving images goes further than simply transporting images. Transform compression and motion estimation profoundly alter the materiality of images, all the while preserving much of their familiar cinematic or televisual appearance. Like so much software it institutes a relational order that articulates realities that previously lay further apart."

Bal, Mieke. 'Lost in Space, Lost in the Library', in Sam Durrant and Catherine M. Lord (eds.), *Essays in Migratory Aesthetics: Cultural Practices Between Migration and Art-Making* (Amsterdam: Rodopi, 2007).

Bonk, Ecke. Marcel Duchamp, *The Portable Museum: The making of the Boite-en-valise de ou par MARCEL DUCHAMP ou RROSE SELAVY*, transl. David Britt (London: Thames & Hudson, 1989),

Durrant, Sam and Lord, Catherine M. 'Introduction', in: Sam Durrant and Catherine M. Lord (eds.), *Essays in Migratory Aesthetics: Cultural Practices Between Migration and Art-Making* (Amsterdam: Rodopi, 2007).

Hannerz, Ulf. *Transnational Connections: Culture, People, Places* (London and New York: Routledge, 1996).

Lemert, Charles et al (eds.). *Globalization: A reader* (London and New York: Routledge, 2010).

Mackenzie, Adrian. 'Codecs', in Matthew Fuller (ed.), *Software Studies: A Lexicon* (Cambridge, Massachusetts: The MIT Press, 2006).

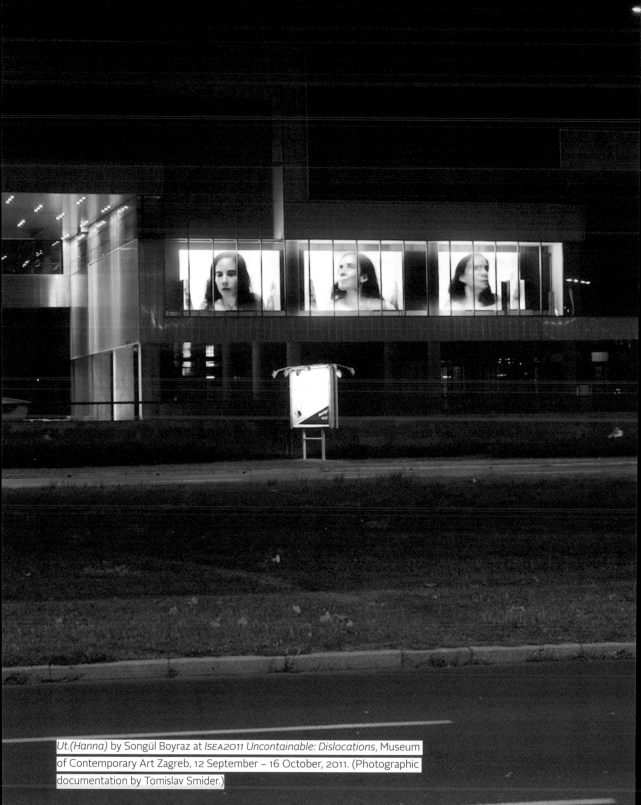

Ut.(Hanna) by Songül Boyraz at *ISEA2011 Uncontainable: Dislocations*, Museum of Contemporary Art Zagreb, 12 September – 16 October, 2011. (Photographic documentation by Tomislav Smider.)

ISEA2011
UNCONTAINABLE

DISLOCATIONS

MUSEUM OF CONTEMPORARY ART ZAGREB
12 EYLÜL–16 EKİM, 2011
ZİYARET SAATLERİ: 19:00–00:00

BAŞ KÜRATÖRLER/ SENIOR CURATORS **LANFRANCO ACETI
& TIHOMIR MILOVAC**

SANATÇILAR/ARTISTS **SONGÜL BOYRAZ; DAVID
COTTERRELL; CHARLES CSURI; MATHIAS FUCHS;
DANIELLE RONEY & JEFF CONEFRY.**

SANAT DİREKTÖRÜ VE KONFERANS BAŞKANI /
ARTISTIC DIRECTOR AND CONFERENCE CHAIR
LANFRANCO ACETI

KONFERANS VE PROGRAM DİREKTÖRÜ /
CONFERENCE AND PROGRAM DIRECTOR
ÖZDEN ŞAHİN

ISSN 1071-4391 ISBN 978-1-906897-19-2

DISLOCATIONS

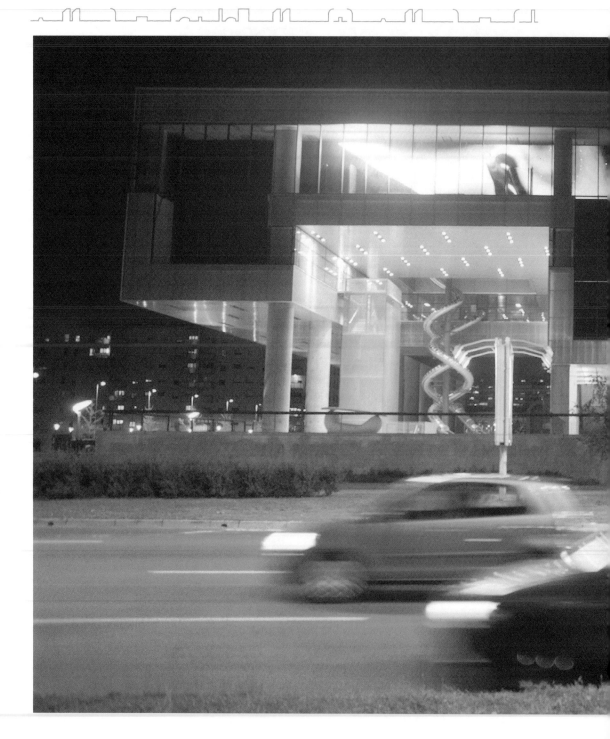

 ISSN 1071-4391 ISBN 978-1-906897-19-2

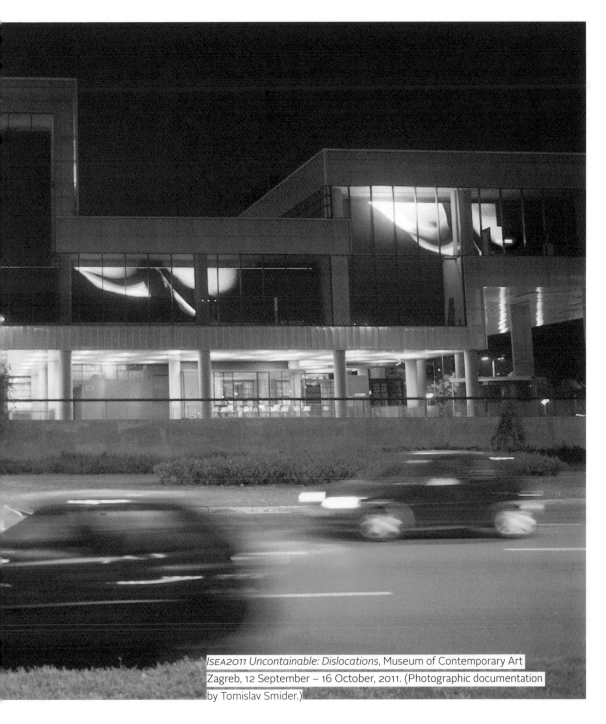

ISEA2011 Uncontainable: Dislocations, Museum of Contemporary Art Zagreb, 12 September – 16 October, 2011. (Photographic documentation by Tomislav Smider.)

ISSN 1071-4391 ISBN 978-1-906897-19-2

ISEA2011
DISLOCATIONS

BAŞ KÜRATÖRLER/SENIOR CURATORS **LANFRANCO ACETI & TIHOMIR MILOVAC**

SANATÇILAR/ARTISTS **SONGÜL BOYRAZ; DAVID COTTERRELL; CHARLES CSURI; MATHIAS FUCHS; DANIELLE RONEY & JEFF CONEFRY.**

SANAT DİREKTÖRÜ VE KONFERANS BAŞKANI /
ARTISTIC DIRECTOR AND CONFERENCE CHAIR
LANFRANCO ACETI

KONFERANS VE PROGRAM DİREKTÖRÜ /
CONFERENCE AND PROGRAM DIRECTOR
ÖZDEN ŞAHİN

 ISSN 1071-4391 ISBN 978-1-906897-19-2

TR Yeniden yorumlamalar, yanlış yorumlar ve bağlantısız bağlamlar; algı ve anlayışta yeni yaklaşımlar yaratarak bireyin hem kendisini hem de insanlığın müşterek özelliklerini yerel gerçekliklerin ve küresel klişelerin ötesinde baştan keşfetmesine yol açar. *Disclocations*, savaştan ve yaşadığımız "yerinden oynamış" gerçeklerden esinlenen veya bunlara gönderme yapan eserler sunuyor.

EN Re-interpretations, mis-interpretations and un-related contexts create new modalities of perception and understanding, leading to the rediscovery of the self and human commonalities beyond local realities and globalized stereotypes. *Dislocations* presents artworks that are inspired by or reference acts of war and the dislocated realities that we live in.

SONGÜL BOYRAZ

Songül Boyraz studied Sculpture at Mimar Sinan University of Fine Arts, Istanbul and Academy of fine Arts Vienna. In many of her works she deals with the human body and its fragmentation. Closely connected with the space created by the medium (video and photography) the concentration on the pars pro toto without any accessories and deception allows her works to tell in detail about the brutality and tragedy inherent in everyday situations.

Boyraz' residences have been MAK, Artists and Architects in Residence Program, Los Angeles in 2005; International Studies and Curatorial Program, New York in 2003; and Japan, Tokyo „No (more) image" in 2001. Her selected exhibitions include - NeoSI: neue Situationistische Inter...nationale, Vienna, in 2011; Galeri Nev, Ankara; Triennale Linz 0.1, Linz, Art Austria; Museumsquartier, Vienna in 2010; International Istanbul Film Festival in 2009; Landwirtschaft, Tiroler Landes Museum Ferdinandeum, Innsbruck in 2007; and International Rotterdam Film Festival, Rotterdam in 2006.

Ut.(Hanna), 2011,
Songül Boyraz.

 ISSN 1071-4391 ISBN 978-1-906897-19-2

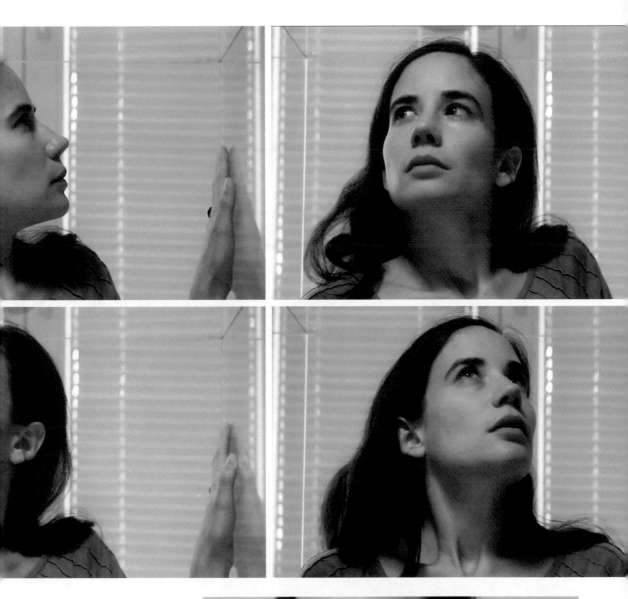

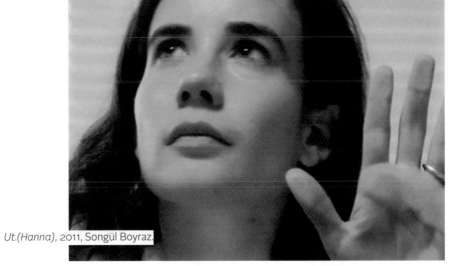

Ut.(Hanna), 2011, Songül Boyraz.

ISSN 1071-4391 ISBN 978-1-906897-19-2

SONGÜL BOYRAZ

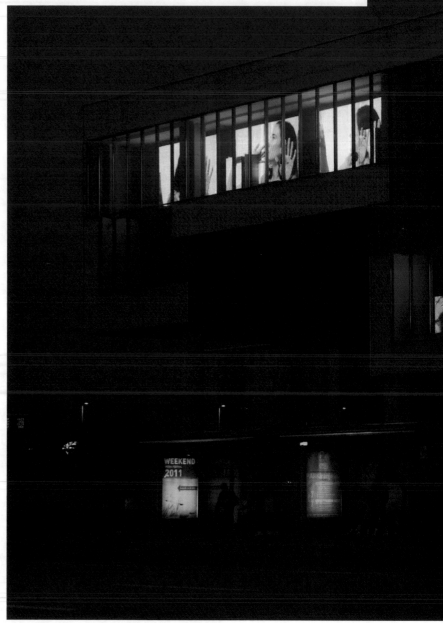

Ut.(Hanna), 2011, Songül Boyraz. Media Facade
of the Museum of Contemporary Art, Zagreb.
(Photographic documentation by Tomislav Šmider.)

 ISSN 1071-4391 ISBN 978-1-906897-19-2

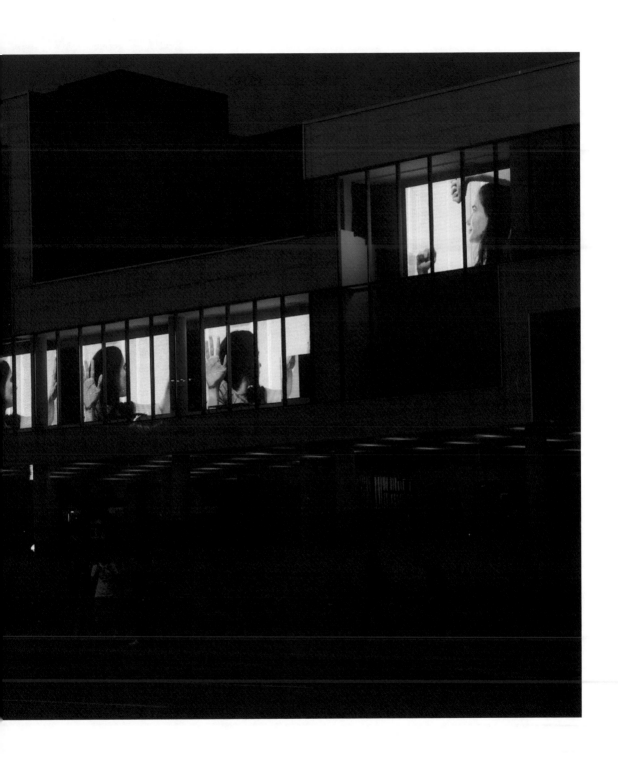

DAVID COTTERRELL

Two journeys through Afghanistan: the first accompanied by the field hospitals and medics. The second, outside the military environment, considered the landscape and communities in the North.

David is an installation artist working across varied media including video, audio, interactive media, artificial intelligence, device control and hybrid technology. His work exhibits political, social and behavioural analyses of the environments and contexts, which he and his work inhabit.

Over the last ten years, his work has been extensively commissioned and exhibited in North America, Europe and the Far East, in gallery spaces, museums and within the public realm. Recent exhibitions include: *Eastern Standard: Western Artists in China* at MASS MoCA, Massachusetts, *War and Medicine* at the Wellcome Collection, *London and Map Games* at the Today Museum of Modern Art, Beijing.

David is a Professor of Fine Art at Sheffield Hallam University, and has also been a consultant to strategic masterplans, cultural and public art policy for urban regeneration, healthcare and growth areas, as well as a council member of AIR (an artists' representative body). He is represented by Danielle Arnaud and is currently developing new work for solo exhibitions at Danielle Arnaud contemporary art (2012) and John Hansard Gallery (2012), with the support of the Philip Leverhulme Prize for research.

Gateway, 2008, David Cotterrell, 1 of 3 C-Type Prints.

ISSN 1071-4391 ISBN 978-1-906897-19-2

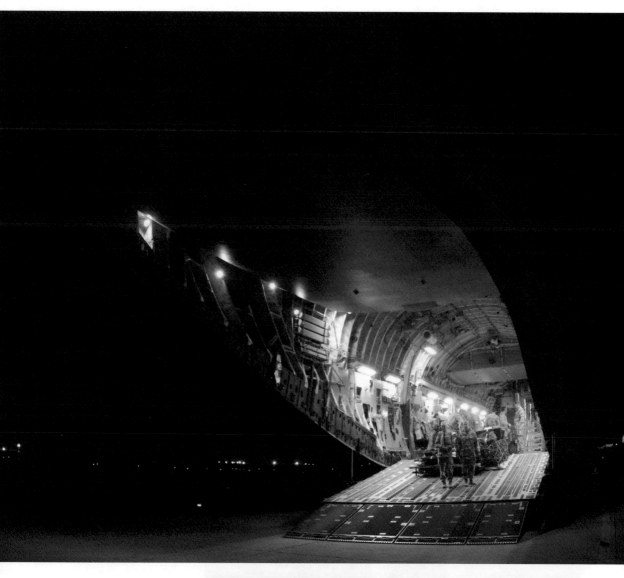

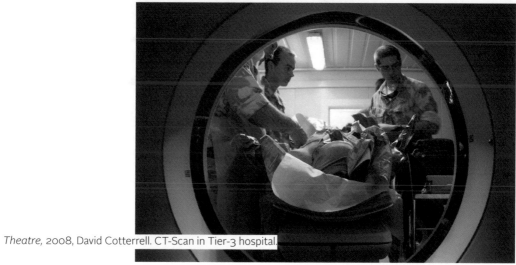

Theatre, 2008, David Cotterrell. CT-Scan in Tier-3 hospital.

ISSN 1071-4391 ISBN 978-1-906897-19-2

DAVID COTTERRELL

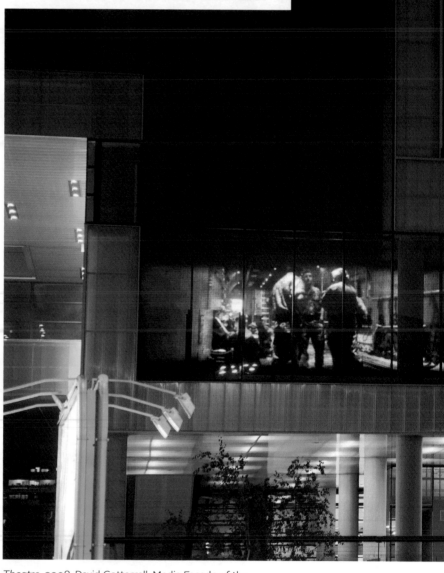

Theatre, 2008, David Cotterrell. Media Facade of the
Museum of Contemporary Art, Zagreb. (Phographic
documentation by Tomislav Šmider.)

 ISSN 1071-4391 ISBN 978-1-906897-19-2

CHARLES CSURI

Random War (2011) realizes Csuri's original 1967 intention - that people experience art as a real-time virtual event. His vision of Random War (1967) as an interactive art object is only being realized as he celebrates his 89th birthday.

Charles Csuri is best known for pioneering the field of computer graphics, computer animation and digital fine art, creating the first computer art in 1964. Csuri has been recognized as the father of digital art and computer animation by the Smithsonian Magazine, and as a leading pioneer of computer animation by the Museum of Modern Art (MOMA) and The Association for Computing Machinery Special Interest Group Graphics (ACM-SIGGRAPH) . Between 1971 and 1987, while a senior professor at the Ohio State University,

Morass, 2012, from *Random War (1967)*, Charles Csuri.

Charles Csuri founded the Computer Graphics Research Group, the Ohio Super Computer Graphics Project, and the Advanced Computing Center for Art and Design, dedicated to the development of digital art and computer animation. Csuri was co-founder of Cranston/Csuri Productions (CCP), one of the world's first computer animation production companies. In 2000, Charles Csuri received both the 2000 Governor's Award for the Arts for the best individual artist, and The Ohio State University Sullivant Award, the institution's highest honor, in acknowledgment of his lifetime achievements in the fields of digital art and computer animation.

ISSN 1071-4391 ISBN 978-1-906897-19-2

Pointing at the Obvious , 2012, from *Random
War (1967)*, Charles Csuri.

ISSN 1071-4391 ISBN 978-1-906897-19-2 LEA VOL 18 NO 5 **UNCONTAINABLE** 3˙17

CHARLES CSURI

Textures of Space, mosaic, Bartex series, 2012,
Charles Csuri. Linux environment and AI software.

 ISSN 1071-4391 ISBN 978-1-906897-19-2

MATHIAS FUCHS

'Creative Games' is a new emerging discipline at the crossroads of Computer Games, Media Art, Architecture, Urban Planning, Heritage and Advanced Digital Technologies.

Mathias Fuchs has pioneered in the field of artistic use of games and is a leading theoretician on Game Art and Games Studies. He is an artist, musician, media critic and currently Professor for Segmented Media Offerings at Leuphana University, Lüneburg. His work has been shown at ISEA94, ISEA2004 and 2011, resfest, Ars Electronica, PSi #11, Futuresonic, EAST, and the Greenwich Millennium Dome.

Mathias Fuchs has been a university lecturer at University of Applied Arts Vienna, The University for Industrial Design in Linz, Universität für Musik und darstellende Kunst in Vienna, Sibelius Academy in Helsinki, the University of Salford in Greater Manchester, at University of Potsdam, and at the University of Lüneburg. Recent publications include *kendinize bir hayat edinin!* (in Ekmel Ertan, *interpasif persona*, Istanbul, 2010); *Sinn und Sound* (Wissenschaftlicher Verlag, Berlin 2011); *Passagen des Spiels II* (Fuchs & Strouhal, eds. Vienna, 2010); *Ludic Interfaces* (in Catlow, Garrett & Morgana, *Artists Re:thinking Games*, Liverpool, 2010).

Borderline, 2011,
Mathias Fuchs.

 ISSN 1071-4391 ISBN 978-1-906897-19-2

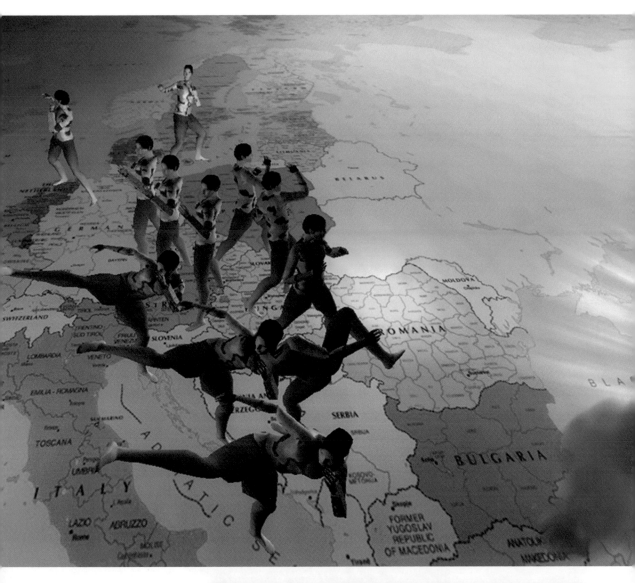

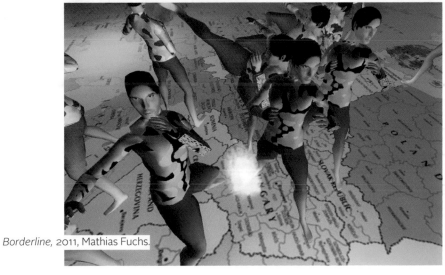

Borderline, 2011, Mathias Fuchs.

ISSN 1071-4391 ISBN 978-1-906897-19-2

MATHIAS FUCHS

Borderline, 2011, Mathias Fuchs, Media Facade
of the Museum of Contemporary Art, Zagreb.
(Photographic documentation by Tomislav Šmider.)

 ISSN 1071-4391 ISBN 978-1-906897-19-2

DANIELLE RONEY, JEFF CONEFRY

Opposing Views: The visualization of conflict and debate through biofeedback, sensor-driven, real-time video programming. A performative architecture presenting new avenues of communicative infrastructures.

Danielle Roney is an artist working with hybridization, immersive environments and interactive media architecture in the context of global identity structures. She presented concepts in transnational, networked public spaces at TEDGlobal 2005 in Oxford, England, with subsequent live interactions from Johannesburg, South Africa to Atlanta 2007. Her work has been exhibited internationally, including the Beijing Off-Biennial, Convergence 2005; Museum of Contemporary Art, Georgia 2008, 2011; and the Museum of Contemporary Photography, Chicago 2009.

Jeff Conefry is a media artist and painter specializing in 3D content development and interactive interface design. His recent projects include, media production and technical systems for the U.S. Pavilion, Venice Biennial of Architecture, pilot asset creation for Bark Bark Studios, and time-based construction animations for building information modeling. His work has been exhibited nationally including the Atlanta Biennial and the Museum of Contemporary Photography, Chicago.

Since 2004, these two artists have collaborated on large-scale installations in Beijing, South Africa, and Venice Italy.

Opposing Views, 2011, Danielle Roney & Jeff Conefry. Sensor detail.

ISSN 1071-4391 ISBN 978-1-906897-19-2

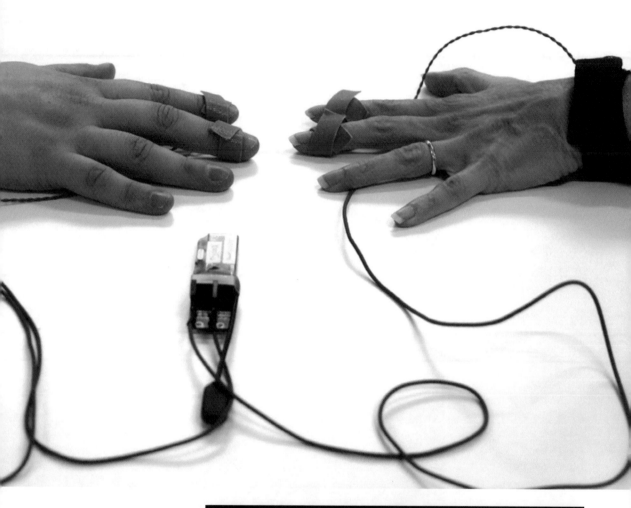

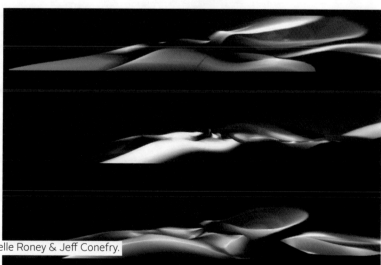

Opposing Views, 2011, Danielle Roney & Jeff Conefry.
Panoramic screen captures.

DANIELLE RONEY, JEFF CONEFRY

Opposing Views, 2011, Danielle Roney &
Jeff Conefry, Media Facade of the Museum
of Contemporary Art, Zagreb. (Phographic
documentation by Tomislav Šmider.)

 ISSN 1071-4391 ISBN 978-1-906897-19-2

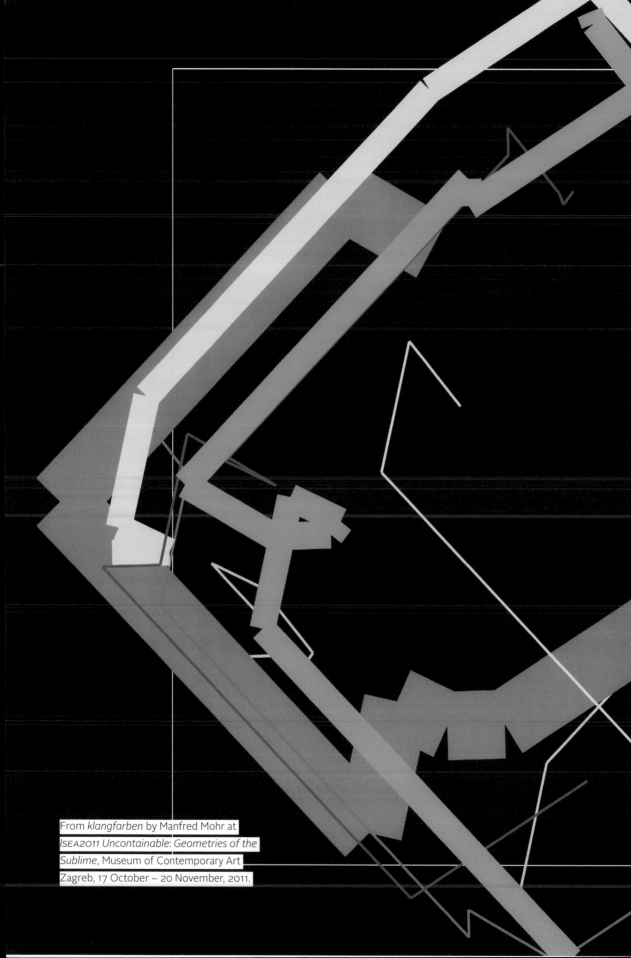

From *klangfarben* by Manfred Mohr at
*ISEA2011 Uncontainable: Geometries of the
Sublime*, Museum of Contemporary Art
Zagreb, 17 October – 20 November, 2011.

ISEA2011
UNCONTAINABLE

GEOMETRIES OF
THE SUBLIME

MUSEUM OF CONTEMPORARY ART ZAGREB
17 EKİM–20 KASİM, 2011
ZİYARET SAATLERİ: 19:00–00:00

BAŞ KÜRATÖRLER/ SENIOR CURATORS **LANFRANCO ACETI
& TIHOMIR MILOVAC**

SANATÇILAR/ARTISTS **PAUL BROWN; CHARLES CSURI;
MANFRED MOHR; ROMAN VEROSTKO.**

SANAT DİREKTÖRÜ VE KONFERANS BAŞKANI /
ARTISTIC DIRECTOR AND CONFERENCE CHAIR
LANFRANCO ACETI

KONFERANS VE PROGRAM DİREKTÖRÜ /
CONFERENCE AND PROGRAM DIRECTOR
ÖZDEN ŞAHİN

ISSN 1071-4391 ISBN 978-1-906897-19-2

GEOMETRIES OF THE SUBLIME

 ISSN 1071-4391 ISBN 978-1-906897-19-2

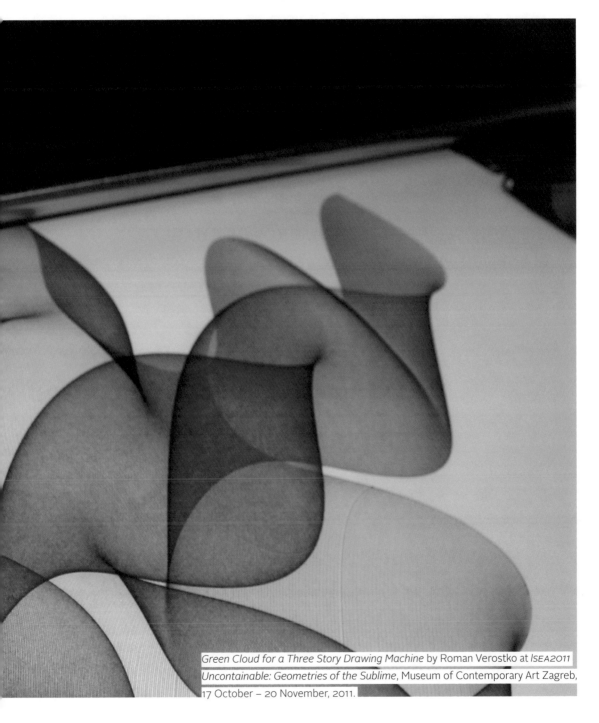

Green Cloud for a Three Story Drawing Machine by Roman Verostko at *ISEA2011 Uncontainable: Geometries of the Sublime*, Museum of Contemporary Art Zagreb, 17 October – 20 November, 2011.

ISEA2011
GEOMETRIES OF THE SUBLIME

BAŞ KÜRATÖRLER/SENIOR CURATORS **LANFRANCO ACETI & TIHOMIR MILOVAC**

SANATÇILAR/ARTISTS **PAUL BROWN; CHARLES CSURI; MANFRED MOHR; ROMAN VEROSTKO.**

SANAT DİREKTÖRÜ VE KONFERANS BAŞKANI /
ARTISTIC DIRECTOR AND CONFERENCE CHAIR
LANFRANCO ACETI

KONFERANS VE PROGRAM DİREKTÖRÜ /
CONFERENCE AND PROGRAM DIRECTOR
ÖZDEN ŞAHİN

ISSN 1071-4391 ISBN 978-1-906897-19-2

TR *Geometries of the Sublime* sergisinin sanatçıları; kaosun içinden süblim ve kusursuz formlar arayarak dijital teknoloji, sanat ve bilimde yaptıkları deneylerle 20. yüzyılın ikinci yarısını şekillendirdiler.

EN *Geometries of the Sublime* artists have characterized the second half of the 20th century and experimented with digital technology, art and science – searching through chaos for perfect forms and the sublime.

PAUL BROWN

> *The emphasis of 4^15 is on human cognition. I am primarily interested in the "evolution" of surface and the relationship between the resulting artwork and human cognitive processes.*

Paul Brown is an artist and writer who has specialised in art, science & technology since the late-1960s and in computational & generative art since the early 1970s. His early work included creating large-scale lighting works for musicians and performance groups like Meredith Monk, Music Electronica Viva and Pink Floyd. He has an international exhibition record that includes the creation of both permanent and temporary public artworks and has participated in shows at major venues like the TATE; the Victoria & Albert and ICA museums in the UK; the Adelaide Festival, Australia; ARCO in Spain; the Substation (as part of the Singapore SeptemberFest) and the Venice Biennial. His work is represented in public, corporate and private collections in Australia, Asia, Europe, Russia and the USA and in 1996 he was the first artist working in the digital domain to win the Fremantle Print Award. He is an honorary visiting professor of art and technology and artist-in-residence at the Centre for Computational Neuroscience and Robotics, University of Sussex, UK and also Australia Council Synapse Artist-in-Residence at the Centre for Intelligent System Research, Deakin University, Australia.

4^15 – Studies in Perception, 2006, Paul Brown, kinetic painting, size variable.

ISSN 1071-4391 ISBN 978-1-906897-19-2

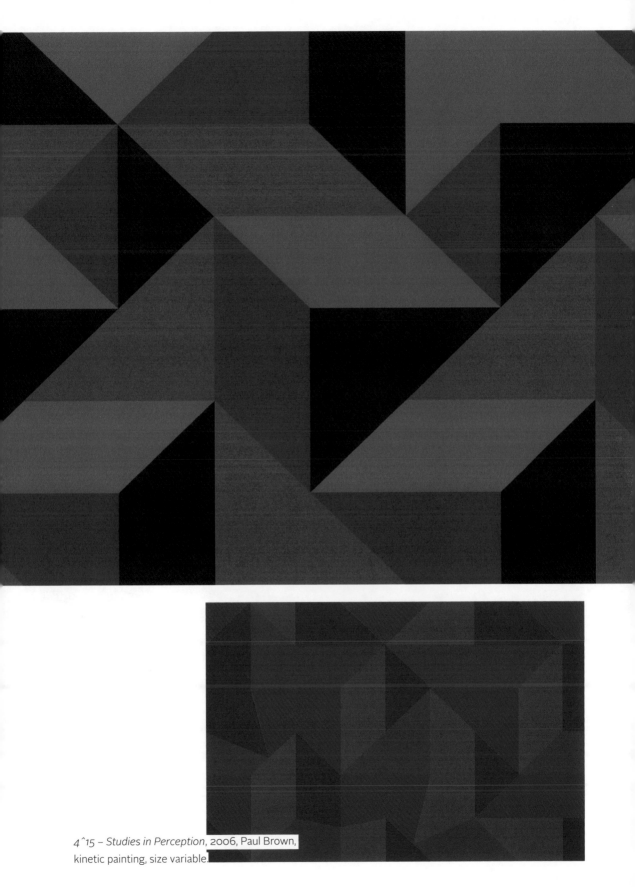

4^15 – Studies in Perception, 2006, Paul Brown,
kinetic painting, size variable.

ISSN 1071-4391 ISBN 978-1-906897-19-2

PAUL BROWN

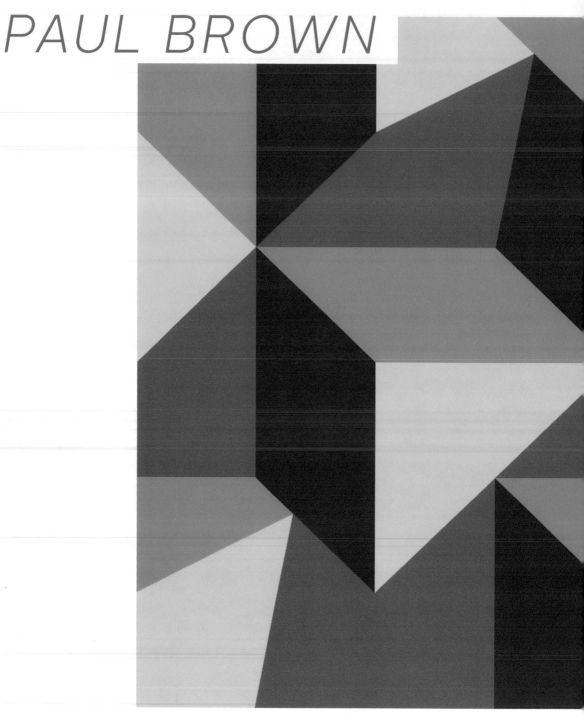

4^15 – Studies in Perception, 2006, Paul Brown,
kinetic painting, size variable.

ISSN 1071-4391 ISBN 978-1-906897-19-2

MANFRED MOHR

An abstract entity is a door to the unknown of understanding human thinking. It is the purest form of transmitting aesthetic information bringing interpretation to a new level of communication.

Manfred Mohr is considered a pioneer of digital art. After discovering Prof. Max Bense's information aesthetics in the early 1960's, Mohr's artistic thinking was radically changed. **Within a few years,** his art transformed from abstract expressionism to computer generated algorithmic geometry. Encouraged by the computer music composer Pierre Barbaud whom he met in 1967, Mohr programmed his first computer drawings in 1969.

Some of the collections in which he is represented: Centre Pompidou, Paris; Joseph Albers Museum, Bottrop; Mary and Leigh Block Museum of Art, Chicago; Victoria and Albert Museum, London; Ludwig Museum, Cologne; Wilhelm-Hack-Museum, Ludwigshafen; Kunstmuseum Stuttgart, Stuttgart; Stedelijk Museum, Amsterdam; Museum im Kulturspeicher, Würzburg; Kunsthalle Bremen, Bremen; Musée d'Art Moderne et Contemporain, Strasbourg; Daimler Contemporary, Berlin; Musée d'Art Contemporain, Montreal; McCrory Collection, New York; Esther Grether Collection, Basel.

From *Space.color. motion*, 2002, Manfred Mohr. Still image from self-built PC executing the 6-D animation program that uses a unique set of parameters which determines the sub-structure and color set.

ISSN 1071-4391 ISBN 978-1-906897-19-2

From *klangfarben*, 2007, Manfred Mohr. PigmentInk
on paper 40cm × 40cm.

MANFRED MOHR

From *Space.color.motion*, 2002, Manfred Mohr,
Media Facade of the Museum of Contemporary Art,
Zagreb. (Phographic documentation by Tomislav
Šmider.)

 ISSN 1071-4391 ISBN 978-1-906897-19-2

ROMAN VEROSTKO

Screen images for "Geometries of the Sublime" transform the poetry of algorithmic pen & ink drawings into a poetry of architectural light.

Roman Verostko, a founding member of the algorists, is best known for his richly colored algorithmic pen and brush drawings. Primarily a painter in his pre-algorist work, he also created electronically synchronized audio-visual programs in the 1960s. In the 1970s he followed a course in *Fortran* at the Control Data Institute and exhibited his first fully algorist work, *The Magic Hand of Chance,* in 1982. His generative software controls 14 pen plotter stalls achieving exquisite penmanship and expressive brush strokes guiding both ink pens and brushes with plotters. His recent show at the DAM in Berlin, "Algorithmic Poetry", celebrates nature via visual forms generated with brushes and ink pens driven with his algorithms.

Distinctions: 2009 SIGGRAPH Distinguished Artist Award for Lifetime Achievement; Artec '95, Recommendatory Prize, Nagoya, Japan; Golden Plotter Award, Germany, 1994; Professor Emeritus, MCAD, 1994; *Prix Ars Electronica*, Honorable Mention, 1993; Director, ISEA 1993; Bush Fellow, Center for Advanced Visual Studies, MIT, 1970; Outstanding Educators of America, 1971, 1974.

Green Cloud for a Three Story Drawing Machine, 2011, Roman Verostko, algorithmic pen & ink drawing on paper, 8 hour video document of the line by line drawing process for a 3 story wall.

 ISSN 1071-4391 ISBN 978-1-906897-19-2

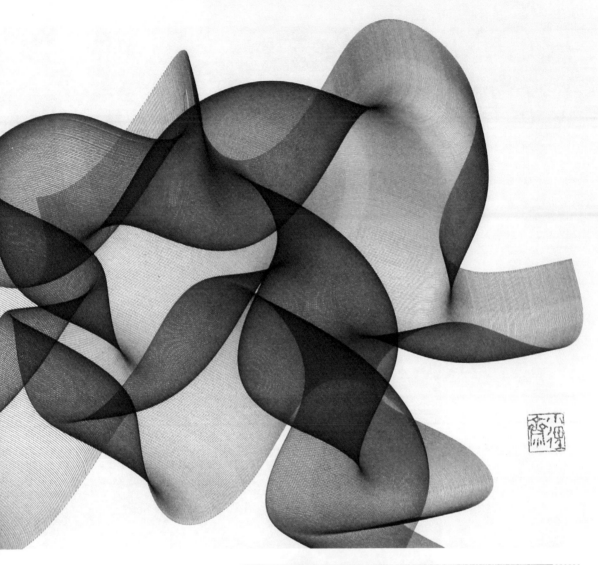

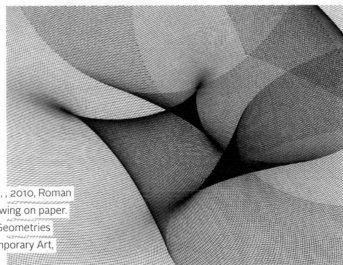

Algorithmic Poetry, Autumn Reverie, , 2010, Roman
Verostko. Algorithmic pen & ink drawing on paper.
Detail for light show projection in "Geometries
of the Sublime," Museum of Contemporary Art,
Zagreb, 2011.

ISSN 1071-4391 ISBN 978-1-906897-19-2

ROMAN VEROSTKO

Green Cloud for a Three Story Drawing Machine,
2011, Roman Verostko, Media Facade of the Museum
of Contemporary Art, Zagreb. (Photographic
documentation by Tomislav Šmider.)

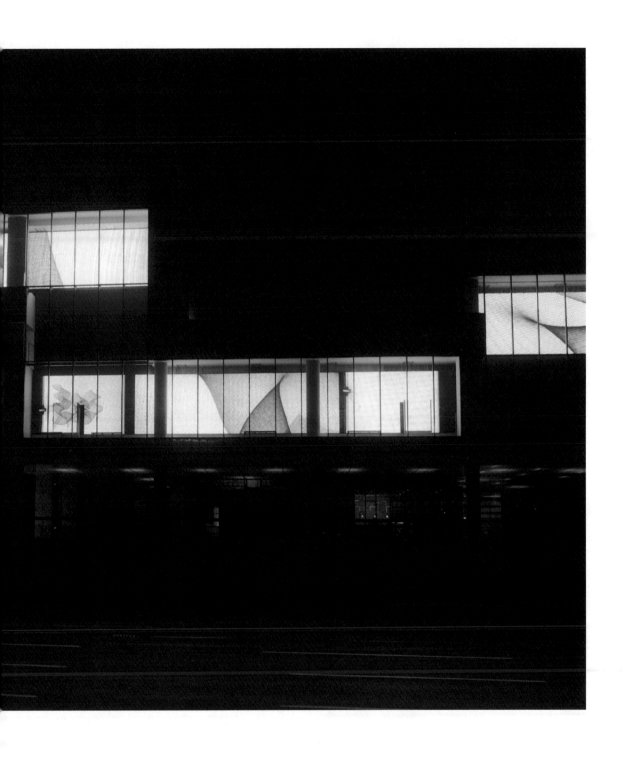

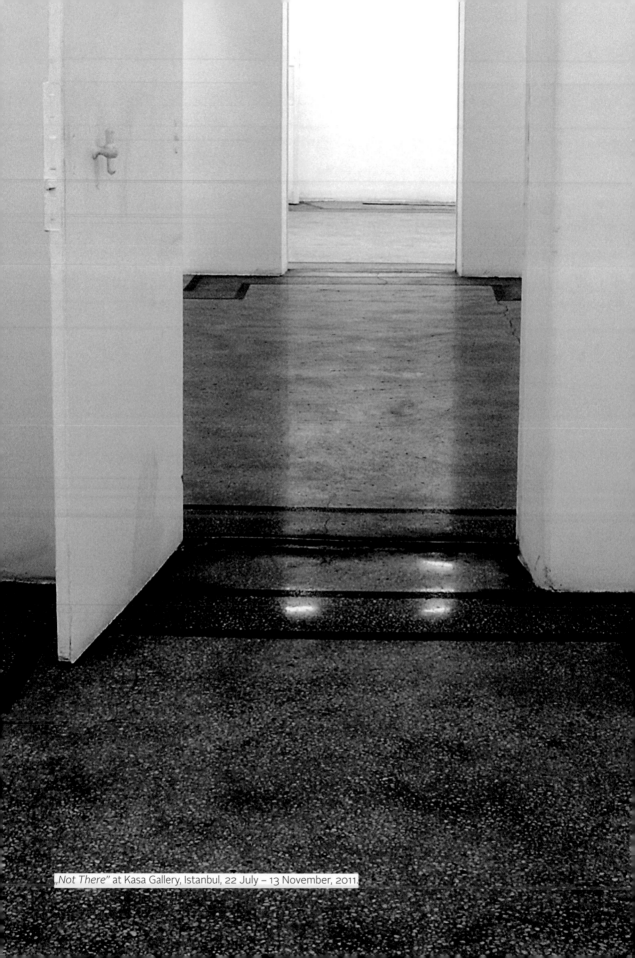

„Not There" at Kasa Gallery, Istanbul, 22 July – 13 November, 2011.

ISEA2011
UNCONTAINABLE
„NOT THERE"

KASA GALERİ
22 TEMMUZ–13 KASIM, 2011
ZİYARET SAATLERİ: 10:00–17:00

BAŞ KÜRATÖR/SENIOR CURATOR **LANFRANCO ACETI**

SANATÇILAR/ARTISTS **MANIFEST.AR.**

SANAT DİREKTÖRÜ VE KONFERANS BAŞKANI /
ARTISTIC DIRECTOR AND CONFERENCE CHAIR
LANFRANCO ACETI

KONFERANS VE PROGRAM DİREKTÖRÜ /
CONFERENCE AND PROGRAM DIRECTOR
ÖZDEN ŞAHİN

ISSN 1071-4391 ISBN 978-1-906897-19-2

ISEA2011
„NOT THERE"

BAŞ KÜRATÖR/SENIOR CURATOR **LANFRANCO ACETI**

SANATÇILAR/ARTISTS **MANIFEST.AR.**

SANAT DİREKTÖRÜ VE KONFERANS BAŞKANI /
ARTISTIC DIRECTOR AND CONFERENCE CHAIR
LANFRANCO ACETI

KONFERANS VE PROGRAM DİREKTÖRÜ /
CONFERENCE AND PROGRAM DIRECTOR
ÖZDEN ŞAHİN

 ISSN 1071-4391 ISBN 978-1-906897-19-2

TR *„Orada Değil"* sergisinin eserleri fiziksel olarak galeride veya herhangi bir gerçek mekandda bulunmuyor. Cep telefonları aracılığıyla çeşitli yerlerden sanal olarak görünen eserlerin sergilendiği bazı yerler: Venedik Bienali, San Marco meydanı, Samek Sanat Galerisi ve Kasa Galeri.

EN *„Not There"* presents works that are not physically in the gallery but are visible through mobile phones – they do not physically exist in real spaces, but appear virtually in a variety of locations: the Giardini of the Venice Biennial, Piazza San Marco, the Samek Art Gallery and the Kasa Gallery in Istanbul.

MANIFEST.AR

Manifest.AR cyberartist group invites you to come to the Kasa Gallery and view our Venice Biennial artworks, even though you are „Not There"

Manifest.AR is an international artists group working with emergent forms of mobile augmented reality as interventionist public art, using this new art medium to transform public space and challenge institutional structures. Geolocating 3D computer graphic artworks at selected sites, they respond to and overlay the physical locations with new meanings, pushing the boundaries between the real and the virtual.

Collectively and individually, Manifest.AR members exhibit and intervene around the world. After their pathbreaking intervention at MoMA NY in 2010 they set their sights on the Venice Biennial, creating the artworks that are mirrored in the Kasa Gallery exhibition „Not There" during the ISEA Istanbul Festival. Participating artists are: Tamiko Thiel, John Craig Freeman, Lily and Honglei, Will Pappenheimer, Naoko Tosa, Mark Skwarek, Sander Veenhof, John Cleater.

Manifest.AR Venice
Biennial 2011
Intervention, 2011,
Manifest.AR, augmented
reality.

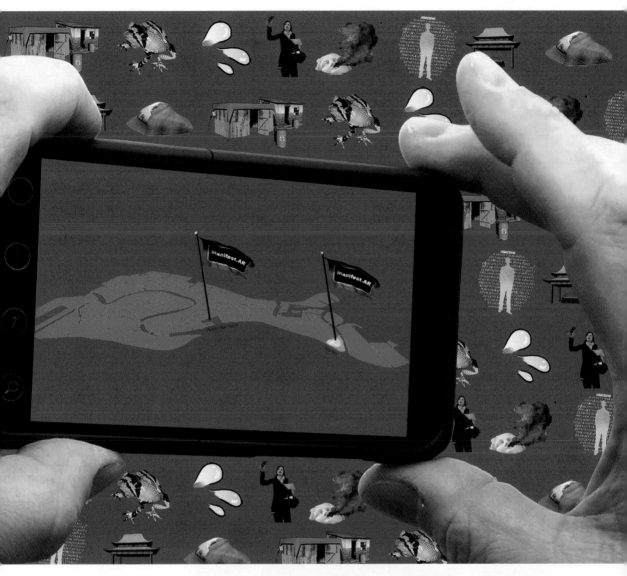

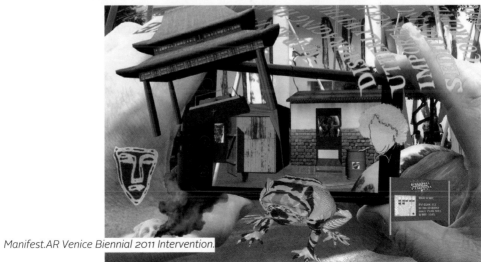

Manifest.AR Venice Biennial 2011 Intervention.

ISSN 1071-4391 ISBN 978-1-906897-19-2

„NOT THERE"

MANIFEST.AR

Manifest.AR Venice Biennial 2001 intervention artworks, seen in the Kasa Gallery exhibit *„Not There"*, 2011, augmented reality. Top row left to right: *Battling Pavilions* by Sander Veenhof, *Sky Pavilions* by John Cleater, *Island of Hope* by Mark Skwarek, *Historia* by Naoko Tosa. Bottom row left to right: *Water wARs: Squatters Pavilion* by John Craig Freeman, *Colony Illuminati* by Will Pappenheimer & Virta-Flaneurazine, *The Crystal Coffin* by Lily and Honglei, *Shades of Absence* by Tamiko Thiel.

ISSN 1071-4391 ISBN 978-1-906897-19-2

Goddess of Hope @ Istanbul

458m

Please make your message

Please make your message using ... 10m

The Crystal Coffin

by Lily-Honglei
ManifestAR
The Kasa Galeri

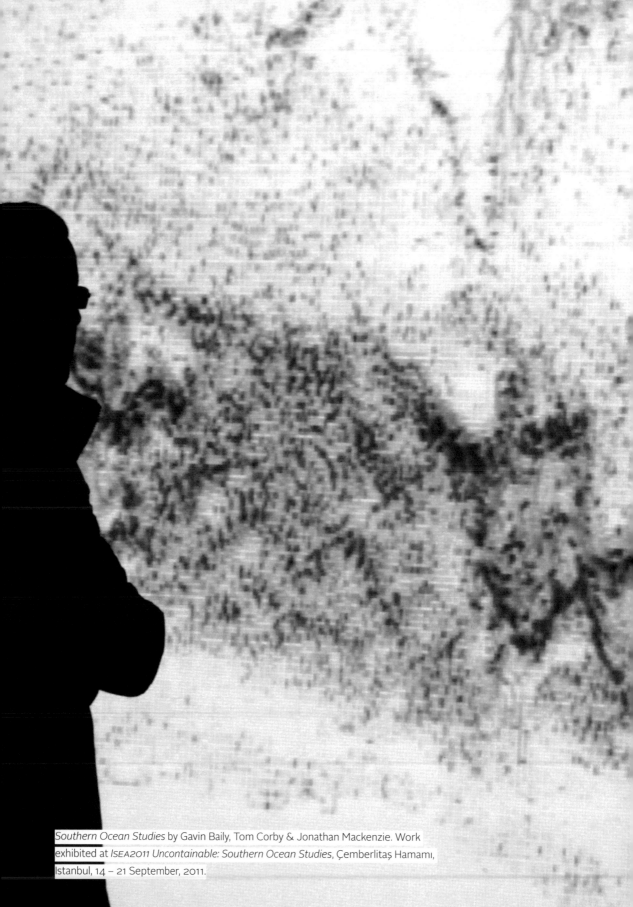

Southern Ocean Studies by Gavin Baily, Tom Corby & Jonathan Mackenzie. Work exhibited at *ISEA2011 Uncontainable: Southern Ocean Studies*, Çemberlitaş Hamamı, Istanbul, 14 – 21 September, 2011.

ISEA2011
UNCONTAINABLE

SOUTHERN OCEAN STUDIES

ÇEMBERLİTAŞ HAMAMI
14–21 EYLÜL, 2011
ZİYARET SAATLERİ: 06:00–00:00

BAŞ KÜRATÖR/SENIOR CURATOR **LANFRANCO ACETI**

SANATÇILAR/ARTISTS **GAVIN BAILY, TOM CORBY &
JONATHAN MACKENZIE.**

SANAT DİREKTÖRÜ VE KONFERANS BAŞKANI /
ARTISTIC DIRECTOR AND CONFERENCE CHAIR
LANFRANCO ACETI

KONFERANS VE PROGRAM DİREKTÖRÜ /
CONFERENCE AND PROGRAM DIRECTOR
ÖZDEN ŞAHİN

SOUTHERN OCEAN STUDIES

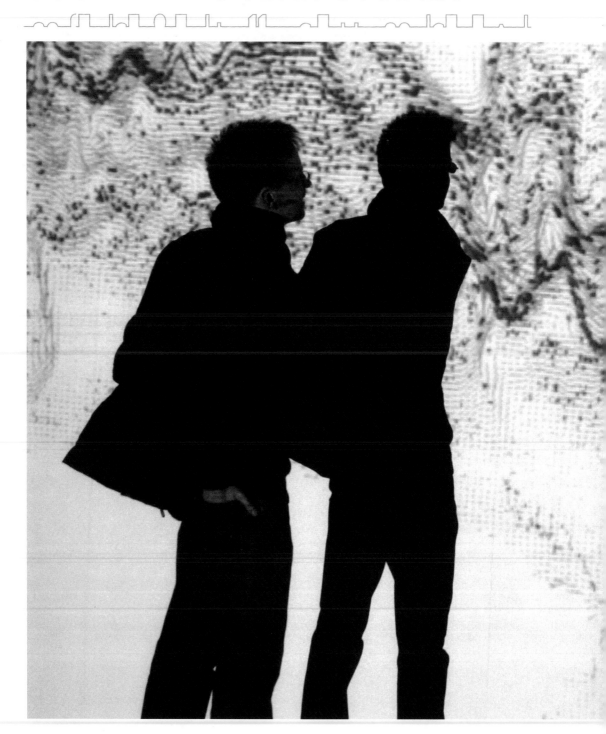

 ISSN 1071-4391 ISBN 978-1-906897-19-2

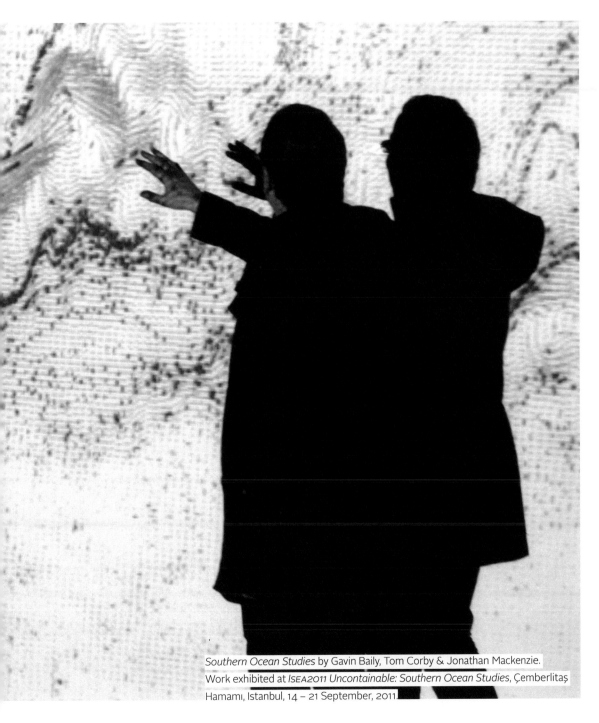

Southern Ocean Studies by Gavin Baily, Tom Corby & Jonathan Mackenzie. Work exhibited at *ISEA2011 Uncontainable: Southern Ocean Studies*, Çemberlitaş Hamamı, Istanbul, 14 – 21 September, 2011.

ISEA2011
SOUTHERN OCEAN STUDIES

BAŞ KÜRATÖR/SENIOR CURATOR **LANFRANCO ACETI**

SANATÇILAR/ARTISTS **GAVIN BAILY, TOM CORBY & JONATHAN MACKENZIE.**

SANAT DİREKTÖRÜ VE KONFERANS BAŞKANI /
ARTISTIC DIRECTOR AND CONFERENCE CHAIR
LANFRANCO ACETI

KONFERANS VE PROGRAM DİREKTÖRÜ /
CONFERENCE AND PROGRAM DIRECTOR
ÖZDEN ŞAHİN

ISSN 1071-4391 ISBN 978-1-906897-19-2

TR *Güney Okyanusu Çalışmaları* ölçü ve hesabın ötesinde, ama bilimsel çerçeveden de kopmadan ekolojik çeşitliliğin ve doğanın dinamiklerine duyarlılık geliştirerek bir deneyim üretmeyi hedefliyor.

EN *The Southern Ocean Studies* seeks to develop a sensibility to the dynamics of ecological complexity as pattern and felt experience rather than quantity and measure whilst respecting the underlying science.

GAVIN BAILY, TOM CORBY & JONATHAN MACKENZIE

Southern Ocean Studies is a collaborative project with the British Antarctic Survey to explore how climate data and models can be used to develop different ways of representing environmental change.

Baily, Corby and Mackenzie have been working together for over 10 years, through an art practice that explores environmental and social issues. **Their fine art research practices has been supported by the British Council, Arts Council England, the Arts and Humanities Research Council and the Wellcome Trust.**

Gavin Baily is an artist and developer, and founder of TraceMedia. **He has worked on arts, visualisation and research projects in various commercial and academic contexts.**

Tom Corby is the deputy Director of the Centre for Research in Art and Media at the University of Westminster. **His research explores how artists and designers can employ digital information as an expressive medium.**

Jonathan Mackenzie has worked for over twenty years on research projects that overlap art, science and computing. **He is particularly interested in algorithms as creative tools, and in complexity science.**

Southern Ocean Studies, 2010, Gavin Baily, Tom Corby & Jonathan Mackenzie, installation of oceanographic simulation, rectangular projection.

ISSN 1071-4391 ISBN 978-1-906897-19-2

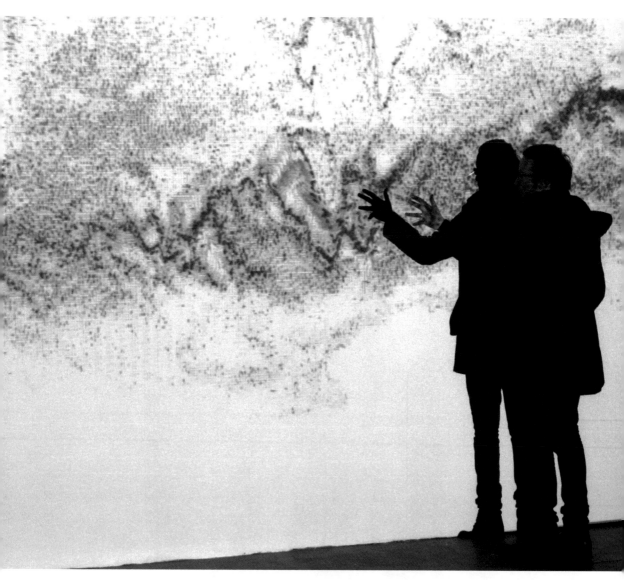

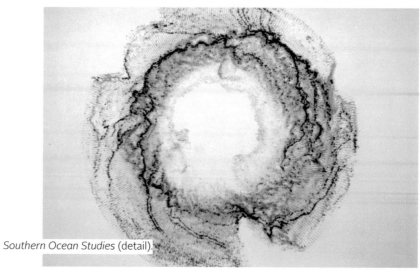

Southern Ocean Studies (detail).

GAVIN BAILY, TOM CORBY & JONATHAN MACKENZIE

Southern Ocean Studies, 2010, Gavin Baily, Tom Corby & Jonathan Mackenzie, installation of oceanographic simulation, rectangular projection.

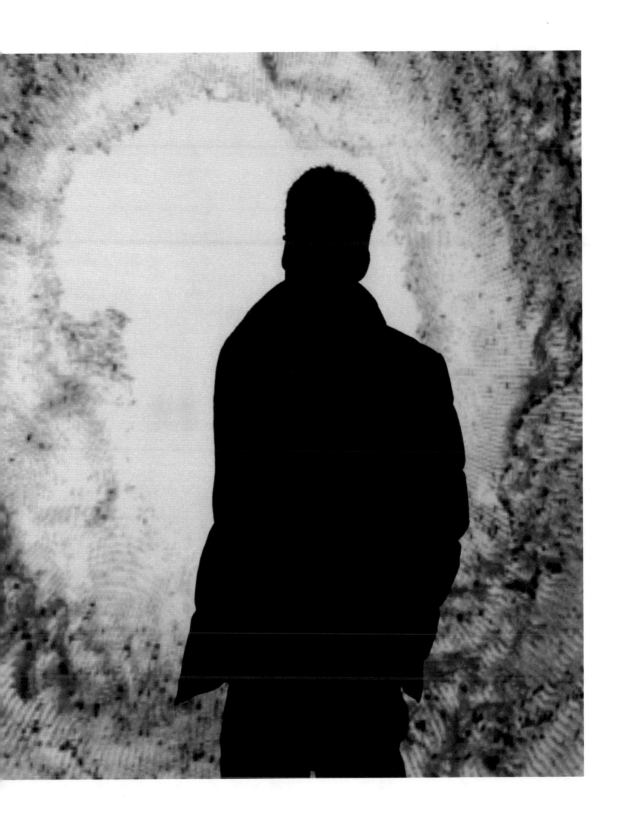

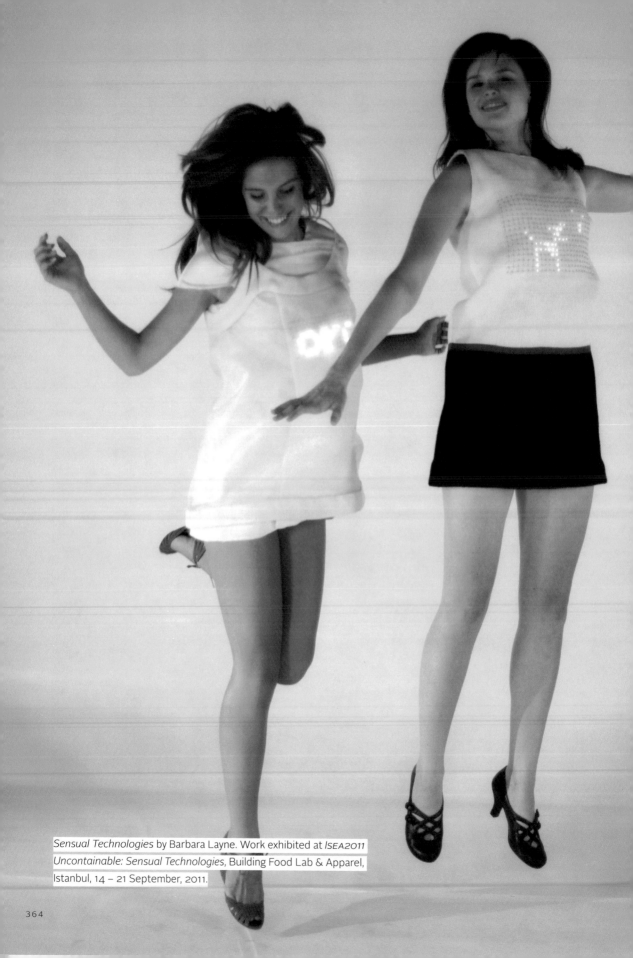

Sensual Technologies by Barbara Layne. Work exhibited at *ISEA2011 Uncontainable: Sensual Technologies*, Building Food Lab & Apparel, Istanbul, 14 – 21 September, 2011.

ISEA2011
UNCONTAINABLE

SENSUAL
TECHNOLOGIES

BUILDING FOOD LAB & APPAREL
14 EYLÜL–21 EYLÜL, 2011
ZİYARET SAATLERİ: 10:00–18:00

BAŞ KÜRATÖR/ SENIOR CURATOR **LANFRANCO ACETI**

SANATÇILAR/ARTISTS **JANIS JEFFERIES & BARBARA LAYNE.**

SANAT DİREKTÖRÜ VE KONFERANS BAŞKANI /
ARTISTIC DIRECTOR AND CONFERENCE CHAIR
LANFRANCO ACETI

KONFERANS VE PROGRAM DİREKTÖRÜ /
CONFERENCE AND PROGRAM DIRECTOR
ÖZDEN ŞAHİN

ISSN 1071-4391 ISBN 978-1-906897-19-2

ISEA2011
SENSUAL
TECHNOLOGIES

BAŞ KÜRATÖR/SENIOR CURATOR **LANFRANCO ACETI**

SANATÇILAR/ARTISTS **JANIS JEFFERIES &
BARBARA LAYNE.**

SANAT DİREKTÖRÜ VE KONFERANS BAŞKANI /
ARTISTIC DIRECTOR AND CONFERENCE CHAIR
LANFRANCO ACETI

KONFERANS VE PROGRAM DİREKTÖRÜ /
CONFERENCE AND PROGRAM DIRECTOR
ÖZDEN ŞAHİN

 ISSN 1071-4391 ISBN 978-1-906897-19-2

TR *Duyusal Teknolojiler* beden ve duyusal/algısal teknolojiler arasındaki ilişkiyi performans ve dinamik giysiler üzerinden araştırıyor. Enstelasyon, duyusal ve yaratıcı yeni teknolojilerin yenilikçi etkileşimini araştırıyor.

EN *Sensual Technologies* explores the relationship between the body and sensual/sensing technologies through performance and dynamic garments. The installation offers an interrogation of practices that are indebted to the innovative exchange between the sensual, visceral and new technologies.

JANIS JEFFERIES & BARBARA LAYNE

Sensual Technologies introduces garments that explore the relationship between the body and sensual/sensing technologies through performance and dynamic garments.

Janis Jefferies is an artist, writer and curator, Professor of Visual Arts in the Department of Computing, Goldsmiths University of London, Director of the Constance Howard Resource and Research Centre in Textiles and Artistic Director of Goldsmiths Digital Studios. GDS is dedicated to collaborations among practicing artists, cultural and media theorists, and innovators in computational media, who together are expanding the boundaries of artistic practice, forging the future of digital technologies and developing new understanding of the interactions between technology and society.

Barbara Layne is a Professor at Concordia University in Montreal and is a founding member of the Hexagram Institute for research-creation in media arts. As the Director of Studio subTela , Layne lectures and exhibits internationally and her work has been supported with numerous grants including the Canada Council for the Arts, SSHRC , Hexagram, and the Conseil des arts et des lettres du Quebec. She is the Principal Investigator of several infrastructure grants from the Canadian Foundation for Innovation.

Currente Calamo from *Sensual Technologies*, 2011, Barbara Layne. The suite of garments feature handwoven LEDs in a flexible message board.

ISSN 1071-4391 ISBN 978-1-906897-19-2

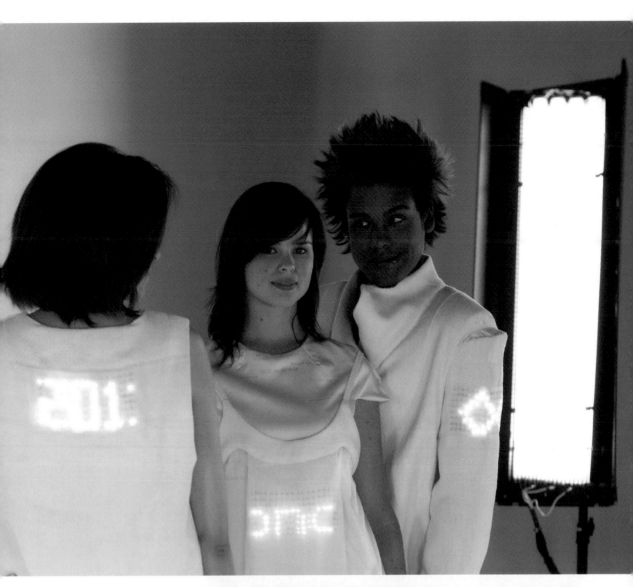

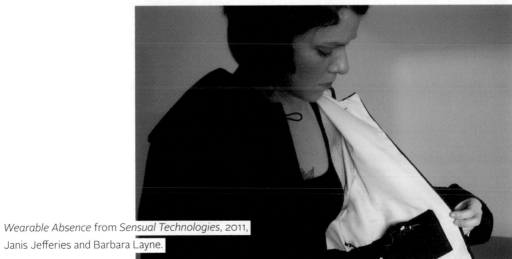

Wearable Absence from *Sensual Technologies*, 2011, Janis Jefferies and Barbara Layne.

JANIS JEFFERIES & BARBARA LAYNE

Wearable Absence from *Sensual Technologies*, 2011, Janis Jefferies and Barbara Layne. Sensors embedded in the garments detect body states and present media files through devices embedded in the garment.

ISSN 1071-4391 ISBN 978-1-906897-19-2

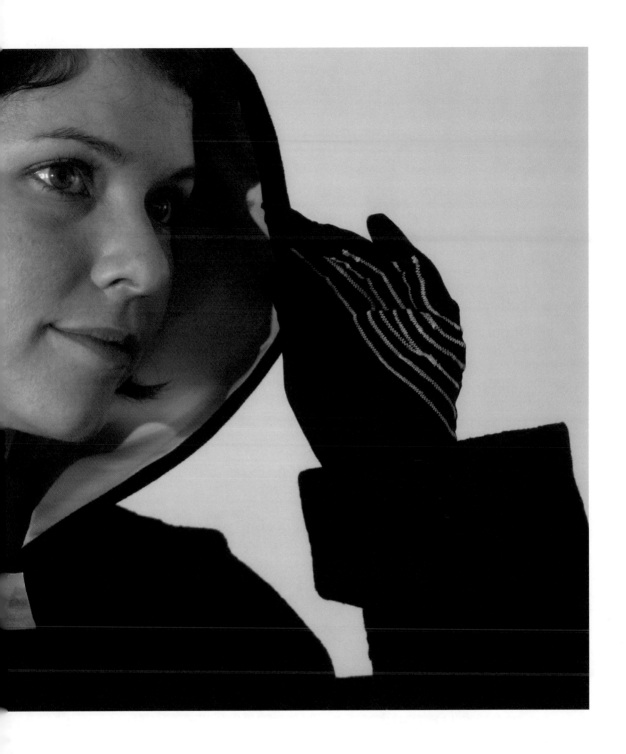

ISEA2011 Artist Lounge, Nuru Ziya Suites, Istanbul, 14-21 September, 2011. Nuru Ziya Lounge is directed by Stephen Kovats and favors art gatherings with a view to forge new alliances and synergies.

ISEA2011 UNCONTAINABLE

ISEA2011 ARTIST LOUNGE

NURU ZİYA SUITES
14 EYLÜL–7 EKİM, 2011

ETKİNLİK LİDERLERİ/EVENT LEADERS **LANFRANCO ACETI & STEPHEN KOVATS**

SANAT DİREKTÖRÜ VE KONFERANS BAŞKANI /
ARTISTIC DIRECTOR AND CONFERENCE CHAIR
LANFRANCO ACETI

KONFERANS VE PROGRAM DİREKTÖRÜ /
CONFERENCE AND PROGRAM DIRECTOR
ÖZDEN ŞAHİN

ISSN 1071-4391 ISBN 978-1-906897-19-2

ISEA2011 ARTIST LOUNGE

ISEA2011 Artist Lounge, Nuru Ziya Suites, Istanbul, 14-21 September, 2011.

 ISSN 1071-4391 ISBN 978-1-906897-19-2

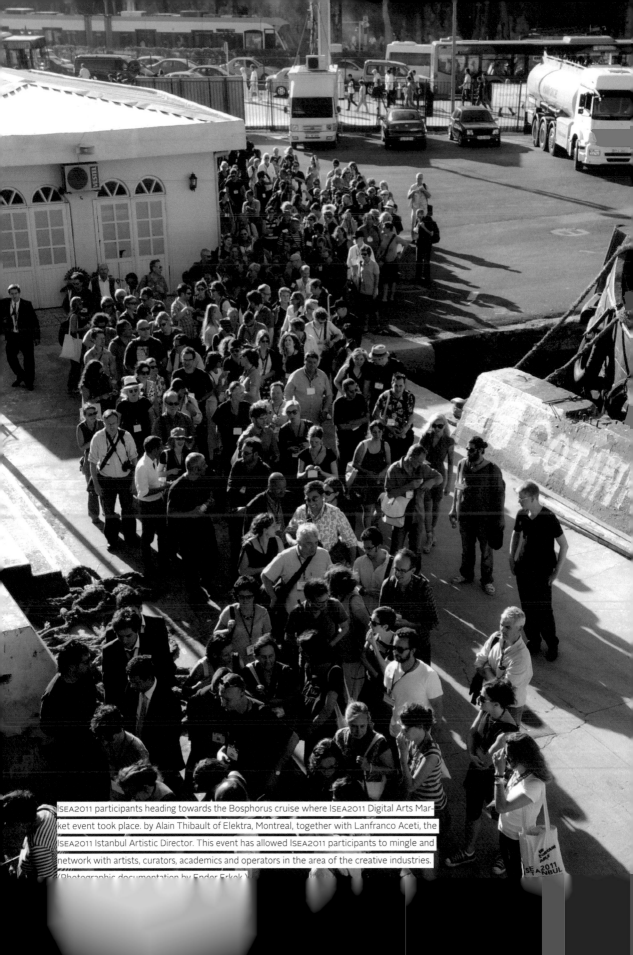

ISEA2011 participants heading towards the Bosphorus cruise where ISEA2011 Digital Arts Market event took place. by Alain Thibault of Elektra, Montreal, together with Lanfranco Aceti, the ISEA2011 Istanbul Artistic Director. This event has allowed ISEA2011 participants to mingle and network with artists, curators, academics and operators in the area of the creative industries. (Photographic documentation by Ender Erkek.)

ISEA2011
UNCONTAINABLE

ART MARKET

BOSPHORUS CRUISE
14 SEPTEMBER, 2011 - 17:00 - 20:00
19 SEPTEMBER, 2011 - 20:30 - 23:30

ETKİNLİK LİDERİ/EVENT LEADERS **LANFRANCO ACETI &
ALAIN THIBAULT**

SANAT DİREKTÖRÜ VE KONFERANS BAŞKANI /
ARTISTIC DIRECTOR AND CONFERENCE CHAIR
LANFRANCO ACETI

KONFERANS VE PROGRAM DİREKTÖRÜ /
CONFERENCE AND PROGRAM DIRECTOR
ÖZDEN ŞAHİN

ART MARKET

 ISSN 1071-4391 ISBN 978-1-906897-19-2

ISEA2011 Artistic Director and Conference Chair Lanfranco
Aceti speaking at the Digital Arts Market event with Alain
Thibault of Elektra, Bosphorus, 14 September 2011.

ISSN 1071-4391 ISBN 978-1-906897-19-2

ART MARKET

 ISSN 1071-4391 ISBN 978-1-906897-19-2

ISEA2011 Digital Arts Market Bosphorus cruise, Istanbul, 14 September 2011. (Photographic documentation by Ender Erkek.)

ISSN 1071-4391 ISBN 978-1-906897-19-2

ART MARKET

ISEA2011 Digital Arts Market Bosphorus cruise, Istanbul, 19 September 2011.

(Photographic documentation by Özden Şahin.)

ISSN 1071-4391 ISBN 978-1-906897-19-2

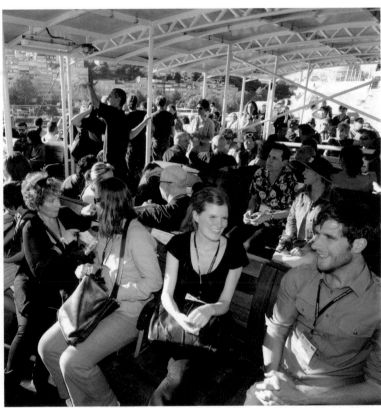

ISEA2011 Digital Arts Market Bosphorus cruise, Istanbul, 14 September 2011.

(Photographic documentation by Ender Erkek.)

ART MARKET

ISSN 1071-4391 ISBN 978-1-906897-19-2

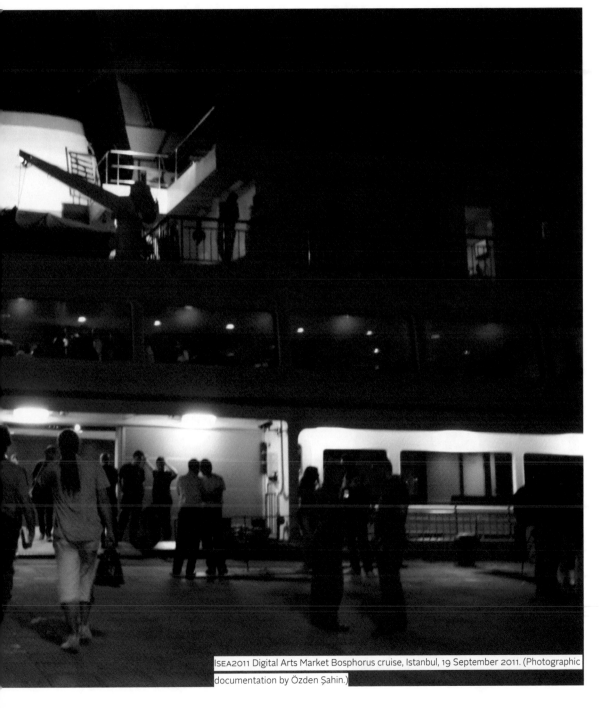

ISEA2011 Digital Arts Market Bosphorus cruise, Istanbul, 19 September 2011. (Photographic documentation by Özden Şahin.)

ISSN 1071-4391 ISBN 978-1-906897-19-2

Lanfranco Aceti 2011/2012

IN CONVERSATION WITH

Herman Bashiron Mendolicchio

2011

The 2011 calendar of **Lanfranco Aceti**, who teaches at **Sabanci University, Istanbul**, and is visiting professor at **Goldsmiths College, University of London**, and works as an artist and curator, is marked, above all, by two big projects: the artistic direction of the 17th edition of **ISEA** and the re-launching of the *Leonardo Electronic Almanac* (**LEA**).

It's easy to realize – especially for those who work in the field - that we are talking about two of the most important projects at the intersection of art, science, technology and communication.

From the 14th to the 21st September 2011, Istanbul will host the **International Symposium on Electronic Art (ISEA), 17th edition**. Lanfranco Aceti steers this macro event where hundreds of proposals in different formats will come together. If on the one hand the symposium's academic aspect strives to remain ISEA's fulcrum - thanks to a broad selection of panels and paper sessions - on the other hand we can find many different happenings and gatherings like workshops, screenings, discussion forums and networking events: e.g. inside an hammam or on those ferries that every day cross the Bosporus. The relationship of ISEA2011 with the city of Istanbul, with its rhythms and its special features, seems to be very deep. There is no intention to create a neutral and flat event, but an occasion where the participation, the collaboration and the harmony between the participants and the city develop in a fluent way. The collaboration with the Istanbul Biennial, with no doubt, is an highlight to point out.

ISSN 1071-4391 ISBN 978-1-906897-19-2

The other challenge on which **Lanfranco Aceti** is working at the moment is the ***Leonardo Electronic Almanac* (LEA)**'s re-launching. With the first issue just released and one more in preparation, Aceti and his collaborators want to re-launch LEA as a very ambitious project: a platform that goes beyond the notion of magazine, but that can function as a center of aggregation and research as well.

In the midst of these projects' organization, **Lanfranco Aceti** - that I warmly thank - has managed to cut out a space of time to accord me this interview.

Herman Bashiron Mendolicchio: Let's start with you: Lanfranco Aceti is an artist, curator and new media theorist that works between Istanbul and London. The moving through disciplines and different cities is a constant in our actual time. What's your personal experience?

Lanfranco Aceti: I'm a son of globalization. A lot of people may think of this in a negative way, but there are a lot of interesting aspects to globalization and one of these is that it favors people's empowerment. I'm from Cassino, Italy, a city that was destroyed during the Second World War and for this reason it hasn't a particular urban connecting fabric. I have always felt trapped in the environment of this little provincial town and when I was 14 I began to travel. First I went to Great Britain and once I returned realized that the world was bigger than previously thought. This gave me a sense of what was possible and made me understand that there is nothing that a person can't do with hard work. And that it is possible to achieve one's dreams.

Today there are many emerging countries - those once that were defined as the economies of the third world - where there is a young generation that wants to achieve their dreams. This is the same drive that Italy had in the Sixties and that now seem to have been lost. Looking at things from this part of the world, from Istanbul, it seems that Europe is in a decadent phase that is not only economic, but primarily cultural. I'm getting more convinced of this everyday.

I can say that the fact of leaving Italy and moving to different countries has been more an obligation than a personal choice. My city of adoption is London and I feel, in a sense, more loyal to Great Britain than Italy. What's the reason? Because my Ph.D. and my studies have been financed by Great Britain and not Italy. Istanbul also plays a big part in my life since I have lived in the city for over four years and have met some wonderful people.

In the context of today's global phenomena what I can say is that the transition and displacement between different cities - I have lived between Boston, New York, London, Glasgow, Rome and Istanbul - has become a part of me. I have taken from Italy the cultural heritage, the capacity to move and think in a creative way, formalist structures from well-defined exercises e.g. Latin and Greek in school, the architectural environments... but was also influenced

I wanted to provide the opportunity for a reciprocal new engagement and recognition within the fine art structure itself.

by all the other places I have lived in. The sum of all these experiences shapes the person that I am. The global world is changing, there is Internet, digital media, the fast displacements between cities and a different and more intense competition. I always say to my students that they have to choose at which level they want to compete. I have always desired to compete at an international level and achieve goals in that arena.

Herman Bashiron Mendolicchio: Among your several activities, in addition to the ISEA artistic direction that we will come back to, we find you as *Leonardo Electronic Almanac* (LEA)'s Editor in Chief as well. What are the history and goals of LEA?

Lanfranco Aceti: The re-launch of LEA has been an uphill battle. The magazine was going in a wrong direction and there was an international level competition to bring back this magazine from the comatose situation in which it was. Just in the period when I arrived to Istanbul, there was the call for the new LEA Editor in Chief. While I was preparing the LEA proposal, I applied to host ISEA at Sabanci University as well. I thought that the most important outcome from the synergies developed from both

projects (ISEA and LEA) was to ensure a long lasting legacy. I wanted to ensure that after 2011 LEA would not be 'just a magazine' (there is already a variety of magazines like *Rhizome, Digicult, Neural*, that offer big contributions and are shaping contemporary electronic art at an international stage) but a project that developed a different academic forum at the intersection of art, science and technology.

I wanted to realize a magazine that works first as a research and aggregation center and then as a publication. Finally this is taking shape. LEA will offer the possibility to create a series of high quality outputs, not only with **ISEA** (with the support of **Sabanci University Goldsmiths**) but also through future collaborations with international partners (museums, artists, universities, etc.).

We presented, through the LEA Digital Platform curated by Vince Dziekan, Christiane Paul and myself, a series of curated exhibitions online. Simultaneously, we will have a physical exhibition space at **Kasa Gallery** Istanbul, to complement the online shows with their physical manifestations.

ISSN 1071-4391 ISBN 978-1-906897-19-2

So, thanks to these elements, we will have a vast articulate structure that should continue to flourish - after ISEA - and make important contributions to research in cultural studies, curatorial studies and fine arts.

There will be the possibility, at an artistic, technologic and critical level, to realize exhibitions - online and in physical galleries – as well as create opportunities for research and collaborations with a range of departments, universities and artistic organizations like **FACT** Liverpool**, MoMA, Friesland, Arts Council** in Australia or other art organizations Singapore, China and Latin America.

The *Leonardo Electronic Almanac* has required two years of hard work, not only in creating the magazine itself - the creative work, the editorial work, etc. - but also in the administration and in negotiating between a range of partnering institutions. We have had inherited problems, legal and regarding copyright, that we have fortunately overcome. I can say that LEA has been both a professional and a personal conquest.

The first issue of the revamped LEA, *Mish Mash*, is just online and the second, I can tell you as a preview, will be a special issue with **Simon Penny**. My goal is to produce 4 issues every year, plus the catalogs. It's important to say that there is a core team in *Leonardo Electronic Almanac* that has worked and continues to work hard. There are also a lot of people that gravitate, that have collaborated and that support us. In particular there are two people that deserve a special mention for having worked above and beyond the call of duty: **Özden Şahin, Deniz Cem Önduygu**.

Herman Bashiron Mendolicchio: To assume the artistic direction of ISEA2011 means to assume a role of great responsibility. What's the right way to face this assignment and how do you face it?

Lanfranco Aceti: You need a lot of patience, attention to detail and flexibility. One of the things I wanted to do is bring a large international event on digital and electronic arts to Istanbul and have it be officially linked to the Istanbul Biennial. The fact that the exhibition *Uncontainable* and the many other initiatives of ISEA2011 will be part of the 12th Istanbul Biennial Official Parallel Program is a great achievement. There has been a break between the digital arts and the fine arts and I want to put them together again, I want to delete the definitions based on the instrument/medium and to look forward to what the common component is: the artistic element.

I did not want to present a marginalized digital and electronic arts exhibition and symposium, but instead wanted to provide the opportunity for a reciprocal new engagement and recognition within the fine art structure itself. This collaborative engagement was my primary goal. There is also the intention to promote electronic artists to curators, international press, collectors and audiences in attendance during the Biennial.

Herman Bashiron Mendolicchio: ISEA2011 proposes itself as a macro-event that goes beyond the classic academic symposium. Not only panels and paper sessions, but also expositions, workshops, projections, discussion forums, and even a networking event on a boat cruising the Bosporus. Which ideas and parameters did you follow to build ISEA2011?

Lanfranco Aceti: Madness! The truth is that I sat down and I wondered: I have been to innumerable events, conferences, etc., what do I want to achieve

every time I am in attendance? And the answer has been: I feel glad every time I return home and that there are new projects to realize, new contacts that have been established, exchanges of ideas with new people and the possibility to develop future collaborations, research, exhibitions, etc. with them. So we have said that these are the most important points that we have to realize and for two years we have fought for that. What we want is an event that can give rise to future developments for the delegates. Obviously the fact that it's in Istanbul favors us. The city has a very special charm that can only enhance our hard work.

Herman Bashiron Mendolicchio: The 17th ISEA edition takes place in the Mediterranean city of Istanbul. A city in a constant movement and in a continuous geopolitical, economical, cultural and artistic growth. We must remind to the reader, as we said, that ISEA2011 coincides with the opening of the Istanbul Biennial. What kind of relationship has been established between ISEA, Istanbul and what the city offers?

Lanfranco Aceti: I have to say that we managed to do what I would never have imagined. We managed to move fluidly through the barriers and definitions, between Islam and secularism. We have ignored these constrictions and stereotypes and worked with everybody to realize a big event. The city has responded in kind. Istanbul is a wonderful city and what we have tried to do was to work with the city, with both its limitations and the fascinating elements that characterize it. I believe that this will give to the participants of ISEA a different view of the city, beyond its traditional stereotypes. Istanbul is expanding, with huge skyscrapers and rows of new constructions.

The fact that I also work as director of Kasa Gallery – with its great tradition and history – has allowed me to develop an international exhibition program.

Herman Bashiron Mendolicchio: ISEA represents one of the world events of major interest in the electronic and digital art field. What news or surprises do we have to expect in Istanbul? What's new from an aesthetic and formal point of view that Istanbul and ISEA can give us about contemporary artistic practices?

Lanfranco Aceti: There are several innovations and fundamental changes that are happening in the city. I do not expect that new aesthetics will be created, but perhaps the new approaches that will come from Istanbul will be based on its tradition of re-combinatory possibilities and unusual collages of ideas, concepts and technologies that escape traditional definitions. In Istanbul there is a contemporary usage of technology that surpasses many other places in the Mediterranean. The city will be able to offer clues on the great impact that technology is having and on how it is changing cultural attitudes and therefore aesthetic perceptions. This I believe will be an important outcome.

Herman Bashiron Mendolicchio: Hundreds of people will participate in ISEA2011. What are the strategies for the papers' publications and in which way do you think to materialize the results of this intense week of the symposium?

Lanfranco Aceti: We are preparing two, or more, catalogs. All the papers will be published and we are getting ready to transfer them to online platforms like Kindle, Amazon, iTunes, etc. This is an electronic art symposium and the fact that the publications of the previous editions are not available electronically for me has always been a big problem and it's what we want to avoid this time. The rest will depend on

ISSN 1071-4391 ISBN 978-1-906897-19-2

This is a sharing structure that can help to open and widen the circle of academic collaborations and open new possibilities for production of academic outputs at an international level.

the participants' willingness to produce outcomes. We are preparing the proceedings, catalogs and then there will be the special editions of the *Leonardo Electronic Almanac* on particular themes of interest i.e. robotics, censorship, Mediterranean, emigration, new forms of education.

Every panel, forum, etc. will have the possibility to submit for a special issue of the *Leonardo Electronic Almanac*. I want to offer the possibility to have senior editors, editors and junior editors involved in these issues, focusing on young researchers who are at the beginning of their academic careers. They will be able to participate, work and learn together with other people who are more experienced editors and academics.

This is a sharing structure that can help to open and widen the circle of academic collaborations and open new possibilities for production of academic outputs at an international level.

Herman Bashiron Mendolicchio: ISEA2012 is expected in the United States. How do you see the future of research, study, artistic creativity, of relationship between art, technology, science and communication in this moment of global crisis and heavy cuts to culture? Will we survive?

Lanfranco Aceti: Ovviamente. Of course, we will survive. There are no doubts. We will survive if we have teeth and claws and fight in an intelligent manner the battles that have to be faced. I'm not at all a pessimist, I am a realist. We had to make difficult choices for ISEA - because of the global crisis. But I have to say that the strategy we have chosen to adopt has worked successfully. In the last *Leonardo Electronic Almanac* editorial, I wrote that today we need more to attack than to resist. We need to move the world of art, science and technology towards a new series of partnerships, synergies and collaborations. What's important is not to be dependent on public funds. It is no longer possible to think that to realize change it is possible to simply wait for financing and support from beleaguered institutions. If you want to implement change one needs to face the difficulties in a realistic way, conscious that there will be battles,

but also knowing that these battles can be won. I do not believe that, in times like this, it is possible to survive by sitting on a chair and writing a couple of critiques online. I believe the only way to win the battle is by 'doing something' and that by being proactive and evolving we can ensure that the arts continue not only to grow but to thrive.

2012

Herman Bashiron Mendolicchio: A year is gone by and I have a question, ISEA2011 Istanbul was a success, 1500 attendees, over 100 artists, 90 panels, 70 workshops, hundreds of papers, what is happening now?

Lanfranco Aceti: Well, thanks to the support of Kasa Gallery we have completed the catalog, over 400 pages, which will be available on Amazon for international distribution. The catalog will also be available in small PDF sections online on the *Leonardo Electronic Almanac*. The proceedings are also appearing and we have finished formally with ISEA.

Now there are a series of new initiatives that we are launching. LEA has a strong publication outcome that during 2013 will see a wide range of publications. We are publishing volumes that are around 200 pages each, like *Touch and Go* for example in collaboration with Kasa Gallery, Sabanci University, Goldsmiths College and other organizations. I have also been able to develop a new research center, Operational and Curatorial Research (OCR) in contemporary art, design, science and technology and the Museum of Contemporary Cuts (MoCC).

The research center is going to be developing an ambitious art agenda of international collaborations. I believe this is perhaps the real legacy of ISEA – it gave me the perspective to develop a new ambitious collaborative agenda and

ISSN 1071-4391 ISBN 978-1-906897-19-2

ACKNOWLEDGEMENTS

This interview has been previously published on Digicult's project journal *Digimag* Issue 67 (September 2011): http://www.digicult.it/en/digimag/issue-067/lanfranco-aceti-lea-isea-and-other-challenges .

to adopt hybrid models that are functional to the art world and its economics today.

Herman Bashiron Mendolicchio: Talking about an ambitious art agenda, what is the trend that you are setting as director of Kasa Gallery?

Lanfranco Aceti: I wish to have artworks that are exciting, original, and attempt to move beyond the boundaries of what are the traditional media in art. We are preparing an exhibition in Kasa Gallery titled *Tiny, Nano, Micro, Small* that will showcase some of the best artists that use nanotechnology as a medium. It is my intention to strictly link the research aspect to the exhibition and commercial aspects of the gallery, operating not like a traditional university gallery, but as a competitive commercial gallery. The focus of course will be and will always remain that of nurturing new talent and display practices that are unusual and less mainstream.

Herman Bashiron Mendolicchio: Now you are 'only' working as an academic, artist and curator and director of Kasa Gallery, director of MoCC (the Museum of Contemporary Cuts), and director of OCR the new research center you have founded? How do you manage all of these activities?

Lanfranco Aceti: I eat spinach! I am teasing. It is hard work – constantly moving on to the next thing, the next project, the next activity. I also have an excellent team of people: Özden, Deniz, John, Zeynep, Jonathan, Çağlar who put up with my energy and my tendency to generate work... I think I will have to create a project where we can all sit on the beach of Bodrum in the South of Turkey – an international gathering – where we can all talk about art and sip white wine... Perhaps then I will focus on rest. Or perhaps I will start working to generate multiple outputs. Old habits die hard. ∎

About Editors & Curators

Lanfranco Aceti
artistic director & conference chair

Lanfranco Aceti works as an academic, artist and curator. He is Visiting Professor at Goldsmiths College, department of Art and Computing, London; teaches Contemporary Art and Digital Culture at the Faculty of Arts and Social Sciences, Sabanci University, Istanbul; and is Editor in Chief of the *Leonardo Electronic Almanac* (The MIT Press, *Leonardo* journal and ISAST). He was the Artistic Director and Conference Chair for ISEA2011 Istanbul and works as gallery director at Kasa Gallery in Istanbul. He has a Ph.D. from Central Saint Martins College of Art and Design, University of the Arts London. His work has been published in *Leonardo*, *Routledge* and *Art Inquiry* and his interdisciplinary research focuses on the intersection between digital arts, visual culture and new media technologies. He is the founder and director of the LEA digital media platform and of the research center ORADST (Operational Research in Art, Design, Science and Technology).

Lanfranco Aceti is specialized in contemporary art, inter-semiotic translations between classic media and new media, contemporary digital hybridization processes, avant-garde film and new media studies and their practice-based applications in the field of fine arts.

He has worked as an Honorary Lecturer at the Department of Computer Science, Virtual Reality Environments at University College London. He has exhibited works at the Institute of Contemporary Art (ICA) in London and done digital interventions at TATE Modern, the Venice Biennial, Neue Nationalgalerie, the ICA and the Irish Museum of Modern Art.

Previously an Honorary Research Fellow at the Slade School of Fine Art, Dr. Aceti has also worked as an AHRC Postdoctoral Research Fellow at Birkbeck College, University of London, School of History of Art, Film & Visual Media and as Visiting Research Fellow at the Victoria and Albert Museum.

ISSN 1071-4391 ISBN 978-1-906897-19-2

Özden Şahin
conference & program director

Özden Şahin received her BA from Boğaziçi University in 2007 and her MA in Cultural Studies from Sabancı University in 2009. Her thesis entitled *Censorship on Visual Arts and Its Political Implications in Contemporary Turkey: Four Case Studies from 2002-2009* sought to explore cultural manifestations of recent art censorship in Turkey through the narratives provided by artists. Her main research interests are visual culture and new media art curation.

Ozden currently works at Sabancı University Kasa Gallery as the Vice-Director and In-house Curator, developing and executing the annual exhibition and publication program.

In 2011, she was the Conference and Program Director of ISEA2011 Istanbul: The 17th International Symposium on Electronic Art, the leading world conference and exhibition for art, media and technology.

Since 2009, she has been working as the Co-Editor at the *Leonardo Electronic Almanac* (The MIT Press, *Leonardo* journal and ISAST), the peer-reviewed, electronic arm of the leading art-science-technology journal *Leonardo*.

ISSN 1071-4391 ISBN 978-1-906897-19-2

Andrea Ackerman
associate editor

Andrea Ackerman is an artist, writer and theorist living and working in New York. At Yale she studied physics and biophysics and afterwards graduated from Harvard Medical School, with a concentration in neuroscience. She trained and practiced as a psychiatrist and Freudian psychoanalyst. She gradually turned to a career as an artist. Ackerman creates digital artworks that mediate our relationship to the synthetic in a deep, sensuous and complex way. Her series of synthetic landscapes culminated in the 3D computer animation *Rose Breathing*, in which a synthetic rose, whose petals are reminiscent of flesh, rhythmically opens and closes in human-like respiration. *Rose Breathing* has been shown in galleries, museums and public screens internationally, and is in the permanent collection of the San Jose Museum of Art. Ackerman is currently working on an interactive 3D computer animation, incorporating real time fluid effects to intensify the sensuous experience of interactivity.

Ackerman writes theoretical papers on aesthetic theory. Her most recent paper, "Some Thoughts Connecting Deterministic Chaos, Neuronal Dynamics and Aesthetic Experience," was published in the inaugural issue of the newly re-launched Leonardo Electronic Almanac (2011). In this paper, she proposes a new formal aesthetic theory, arguing that it is the properties of deterministic chaos and complexity, as the native dynamics of the brain/mind, that are fundamental to the creation of aesthetic experience. Ackerman is currently working on a further elaboration of this aesthetic theory.

Ackerman lives and works in New York , NY with her family. She has taught 3D computer modeling (Maya) at Pratt Institute, was a Co-director of ISEA2011, and is an editor of Leonardo Electronic Almanac.

ISSN 1071-4391 ISBN 978-1-906897-19-2

Mehveş Çetinkaya
conference and exhibition organizer

Mehveş Çetinkaya is working on a PhD study on the effects of financial investments made in design in large companies and how these investments affect the companies' brand recognition levels. She holds an MA in Visual Communication Design from Sabanci University in Istanbul, Turkey and a BSc in Industrial Product Design from Istanbul Technical University in Turkey, where she currently continues her PhD study. Mehves's general research interests cover design and branding relationships in SMEs and large companies, design and innovation and design thinking. She is part of research projects both in Business & Design Lab/Gothenburg University and in Istanbul Technical University and has presented several works in national and international conferences.

ISSN 1071-4391 ISBN 978-1-906897-19-2

The Australian Center of Virtual Art
guest curator

The Australian Centre of Virtual Art was
established in 2007 to help promote the work of
selected artists working in digital, hybrid and virtual
mediums. This project has been assisted by the
Australian Government through the Australia Council
for the Arts, its arts funding and advisory body.

Kathy Cleland
guest curator

Dr. Kathy Cleland is a curator, writer and researcher specialising in new media art and digital culture. She is Director of the Digital Cultures Program at The University of Sydney, an innovative cross-disciplinary program that critically investigates the social and cultural impacts of new digital media technologies. Her curatorial projects include the Cyber Cultures exhibition series which toured to over 20 venues in Australia and New Zealand (2000 – 2003), the Mirror States exhibition (2008) at MIC Toi Rerehiko, Auckland, NZ and Campbelltown Arts Centre, Sydney, and *Face to Face: portraiture in a digital age,* an exhibition that toured Australia and Asia (2008-2011). Kathy is a founding member of Robot Cultures, a research initiative set up by the Digital Cultures Program and the Social Robotics Centre at the University of Sydney, and her current area of research is the investigation of audience responses to robotic and screen-based entities. Her exhibition *Signs of Life: Robot Incubator* is part of the exhibition program at ISEA2011 in Istanbul. She is on the Organising Committee and is Chair of the Curatorium Committee for ISEA2013 Sydney.

ISSN 1071-4391 ISBN 978-1-906897-19-2

Ian Clothier
guest curator

Ian Clothier is Director of Intercreate Research Centre (intercreate.org), Founder and Co-director of SCANZ residency, symposium and exhibition and Senior Academic at Western Institute of Technology at Taranaki New Zealand. His art projects intersect art, technology, science and culture. Recent creative projects include the integrated systems *The Park Speaks* and *Haiku* robots and the hybrid cultural *Making History,* a project of his internet micronation, *The District of Leistavia.* He has had thirteen solo shows and been selected for exhibition at institutions in twelve countries including three ISEA exhibitions – What if at Puke Ariki Museum New Zealand; ISEA2009 Belfast Ireland exhibition; *Taranaki culture* at Puke Ariki; ISEA2008 Singapore symposium; *net.*NET at The JavaMuseum; for Finger Lakes Environmental Film Festival (upstate New York, USA); ISEA2006 San Jose exhibition; Graphite at the University of Otago NZ; the First International Festival of Electronic Art in Rio de Janeiro; *Fair Assembly* at

ZKM; New Forms Festival in Vancouver; ISEA2004 Tallinn/Helsinki exhibition; *ReJoyce* in Dublin and *Wild 2002* in the Tasmanian Museum. He was awarded a Converge Artist Fellowship at the University of Canterbury in 2005 for an augmented reality project. Written work has been published in respected journals, *Leonardo, Convergence and Digital Creativity* and he has delivered papers to conferences and symposia worldwide.

Curatorial experience includes the current exhibition; *Inter:place* at Puke Ariki Museum 2010; selection panel member for *SCANZ 2011: Eco sapiens; SCANZ 2009: Raranga Tangata; Solar Circuit Aotearoa New Zealand 2006; WITT-wide* an exhibition covering work by staff of all departments of Taranaki's Institute of Technology at Taranaki in 2009; *Interactive City* selection panel for ISEA2006; and several gallery positions held between 1984 and 1992.

ISSN 1071-4391 ISBN 978-1-906897-19-2

Sean Cubitt
guest curator

Sean Cubitt is Director of the Program in Media and Communications at the University of Melbourne and Honorary Professor of the University of Dundee. He is also Professor of Film and Television Studies at Goldsmiths College Department of Media and Communications. His publications include *Timeshift: On Video Culture* (Comedia/Routledge, 1991), *Videography: Video Media as Art and Culture* (Macmillans/St Martins Press, 1993), *Digital Aesthetics* (Theory, Culture and Society/Sage, 1998), *Simulation and Social Theory* (Theory, Culture and Society/ Sage, 2001), *The Cinema Effect* (MIT Press, 2004) and EcoMedia (Rodopi, 2005). He was the co-editor of *Aliens R Us: Postcolonial Science Fiction with* Ziauddin Sardar (Pluto Press 2002) and *The Third Text Reader* with Rasheed Araeen and Ziauddin Sardar (Athlone/Continuum 2002) and *How to Study the Event Film: The Lord of the Rings* (Manchester University Press, 2008). He is an editor of *Cultural Politics* and serves on the editorial boards of a dozen journals including *Screen, Third Text, Visual Communication, Futures and The International Journal of Cultural Studies*. His article on early video art won the 2006 CAA Award for best article. He is the series editor for Leonardo Books at MIT Press. His current research is on public screens and the transformation of public space and on genealogies of digital light.

Vince Dziekan
guest curator

Dr. Vince Dziekan is Associate Dean (Research) in the Faculty of Art & Design at Monash University in Melbourne, Australia. In addition, he is affiliated with the Foundation for Art & Creative Technology (FACT) in Liverpool, UK as a FACT Associate, and most recently was appointed Digital Media Curator of the *Leonardo Electronic Almanac* (LEA). His research focuses on the impact of digital technologies on curatorial design and the implications of virtuality on exhibition-based practices. This interdisciplinary investigation has been articulated recently in *Virtuality and the Art of Exhibition* (forthcoming publication, Intellect Books, UK). He has exhibited widely in solo and group exhibitions and through independent curatorial practice. He exhibited his demonstration exhibition, *The Ammonite Order, Or Objectiles for an (Un) Natural History* at Ormeau Baths Gallery in Belfast, Northern Ireland as part of the ISEA2009 juried exhibition. He is research leader of the Photography & Video Research Cluster at Monash Art & Design, Adjunct Programme Advisor for FACT ATELIER (FACT, Liverpool), series editor of *Transdiscourse* (in collaboration with Z-Node; ZHdK, Zurich University of the Arts), and member of the international advisory committee of *ReWire* 2011 (MediaArtHistories conference, Liverpool) and the Virtual NGV steering committee (National Gallery of Victoria, Melbourne).

ISSN 1071-4391 ISBN 978-1-906897-19-2

Tihomir Milovac
guest curator

Tihomir Milovac is an art historian, currently Museum Advisor and Head of the Experimental and Research Department at the Museum of Contemporary Art in Zagreb. Since 1984 as a museum curator he has curated numerous of solo, group and thematic exhibitions with Croatian and artists abroad (with a preference for the former East Europe). His focus is engaged in new, contemporary phenomena in visual arts, especially in new media and at defining the role of art in contemporary societies. In the museum praxes he develops curatorial role as a producer, working with the artists on their new productions. In 2006 he was co-author of the Museological conception for the MCA Zagreb Collection permanent display. He is a member of CIMAM (Executive Board member 2007 – 2010).

Helen Sloan
guest curator

Helen Sloan has been Director of SCAN, Digital and
Interdisciplinary Arts Agency since its launch in
2003. SCAN is a networked organization and creative
development agency working on arts projects and
strategic initiatives in arts organisations, academic
institutions and further aspects of the public realm.
Helen's career spans over twenty years during which
she has curated, commissioned and convened over
200 exhibitions, new works, and events. She has
written and researched a number of key strands
in digital arts including wearable technologies, the
intersection between art and science, and arts
policy. She has directed festivals such as Across
Two Cultures in Newcastle 1996 (an early event on
the overlapping practice of creative thinking in arts
and science), Metapod, Birmingham 2001 - 2, and
Bournemouth's festival, Public Domain 2010. Current
areas of interest are digital arts and place, high-speed
networks and online resources/spaces, models of
practice and the creative economy, and climate

ISSN 1071-4391 ISBN 978-1-906897-19-2

Paul Thomas
guest curator

Associate Professor Paul Thomas has a joint position as the Head of Painting at the College of Fine Art, University of New South Wales and Head of Creative Technologies at the Centre for Culture and Technology at Curtin University. Paul was the co-chair of the Transdisciplinary Image Conference 2010. In 2000 Paul instigated and was the founding Director of the Biennial of Electronic Arts Perth. Paul has been working in the area of electronic arts since 1981 when he co-founded the group Media-Space. Media-Space was part of the first global link up with artists connected to ARTEX. Paul's current research project "Nanoessence" explores the space between life and death at a nano level. The project is part of an ongoing collaboration with the Nanochemistry Research Institute, Curtin University of Technology and SymbioticA at the University of Western Australia. The previous project "Midas" involved research at the nano level the transition phase between skin and gold. Paul has recently completed working on an intelligent architecture public art project for the Curtin Mineral and Chemistry Research Precinct. Paul is a practicing electronic artist whose work can be seen on his website Visiblespace.

Artist Index

ISSN 1071-4391 ISBN 978-1-906897-19-2

Acknowledging the kind collaboration of

Acknowledging the kind collaboration of

Goldsmiths
UNIVERSITY OF LONDON

ISSN 1071-4391 ISBN 978-1-906897-19-2

Acknowledging the kind collaboration of

SCAN

ZERO